D0566280

Hieronymus Bosch

MASTER ARTISTS LIBRARY

Series directed by
Antonio Paolucci

This edition published in 1998 by SMITHMARK Publishers,
a division of U.S. Media Holdings, Inc.,
115 West 18th Street, New York, NY 10011.

SMITHMARK Books are available for bulk purchase for sales promotion and premium use.
For details write or call the manager of special sales,
SMITHMARK Publishers, 115 West 18th Street, New York, NY 10011.

Library of Congress Cataloging-In-Publication Data Is Available
ISBN: 0-7651-0865-8

Printed in Italy

10 9 8 7 6 5 4 3 2 1

Graphic design: Auro Lecci
Layout: Nina Peci
Prepress: Fotolito Toscana
Printed by: Grafedit

Hieronymus Bosch

Erik Larsen

SMITHMARK

Portrait of Hieronymus Bosch from *Recueil d'Arras* code, Bibliothèque de la Ville d'Arras.

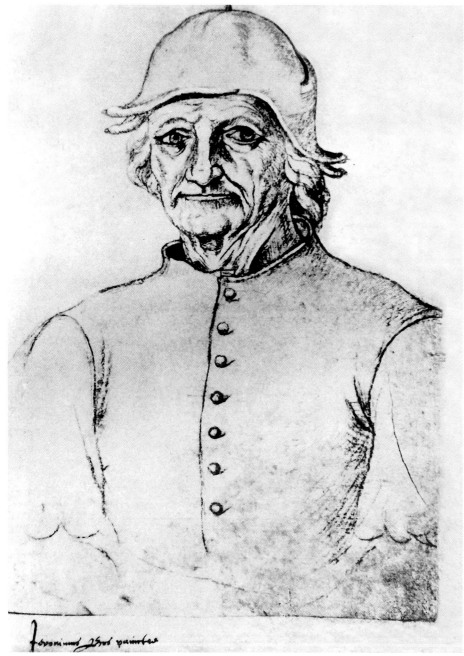

Hieronymus Bosch's period of artistic activity can be placed between the years 1470 and 1516 (year of his death), thus straddling the end of the fifteenth and the beginning of the sixteenth century. His hometown was 's Hertogenbosch (in French, Bois-le-Duc), which today is in the Netherlands. He lived in 's Hertogenbosch all his life, with the possible exception of some undocumented trips to Utrecht, and possibly to one or more Flemish cities in the southern Netherlands. At the time, 's Hertogenbosch was a flourishing commercial center, belonging politically to the Duchy of Brabant, of which it was the most northern chief agglomeration. The others—Brussels, Antwerp, and Louvain—are located to the south, in what is today Belgium. Because of its geographic position, close to the provinces of Holland and Utrecht, and the Maas and Rhine rivers, the prosperity of the town was assured. It also derived wealth from the manufacture of cloth and linen goods, as well as the fabrication of cutlery. Its merchants acted as intermediaries between Antwerp, with which 's Hertogenbosch entertained close economic relations, and the northern territories of the dukes of Burgundy, who were at the same time dukes of Brabant, such as Delft, Utrecht, and Haarlem, and very likely also with the Rhineland. The town thus formed the point of convergence of different trends and local cultures. We shall have to remember this concurrence of circumstances when later examining the possible sources of Bosch's art. Thus, while 's Hertogenbosch is now a fairly quiet provincial locality, one counted 2,351 homes there in 1472 and 2,733 families in 1480—which constituted a considerable population for the period. Jacob Eyckius devoted a few distichs to it in his *Century of Belgian Towns* (*Urbium belgicarum centuria*, Antwerp, Plantin, 1651), although the agglomeration could not boast of a princely court, a university, or a bishopric.

We have here a cultural entity that was on the one hand conservative and removed from the main artistic currents of the time, such as we encounter in Bruges, Ghent, Brussels, and Antwerp in Flanders, or in Haarlem and Delft in the North, or in Germany. Provincial 's Hertogenbosch could not compete with these more cosmopolitan centers in this respect. On the other hand, there was nevertheless a vigorous cultural life that drew its strength from deep-seated religiosity. We can consider the great cathedral of Saint John to be the outward symbol of this state of mind. According to Tolnay, "it was the most important Gothic church in the whole land." The original church burned down at the end of the fourteenth century, and was replaced by a building in stonemasonry, which was not completed until the sixteenth century. In style, the cathedral was conceived in pure Brabançon Gothic, a soaring structure quite different from the far less impressive regional brick churches. As was customary in the later French Gothic style, the capitals of the columns, as well as the flying buttresses supporting the roof, were decorated with carved figures, monsters, and fantastic creatures, following a long-established tradition that often relied for its sources upon prototypes imported from as far away as China. We may find here one of the fonts of inspiration for Bosch's bizarre and grotesque creations. In any event, the building yards of a great church were, wherever they occurred, centers of intense artistic activity.

In spite of its lack of a university or religious seminary, the town was well known in the outside world for its famous Latin school. The practice of Latin and Greek, as well as the acquaintance with the authors of antiquity, led to a flourishing of Chambers of Rhetoric (*Rederijker Kamers*), whose purpose was to foster poetry and present dramatic performances for its members, as well as occasionally for the general public. 'S Hertogenbosch counted no fewer than five of these literary associations in its midst. Their interest in letters was not restricted to the classics, although some rhetoricians drew their inspiration chiefly from ancient Olympus and attempted the creation of a superficial Arcadia in imitation of it. We may cite in this context the *Pegasides* of Houwaert, and the *Olympiad* of Van der Noot. Certain dramatic pieces were based on autochthonous Netherlandish tradition, such as the *Elckerlyc* by a certain Dorland. Hugo von Hofmannsthal's *Everyman*, highly regarded in our own day, is no more than an adaptation of the old Flemish model. We ignore what specific plays or poetry owe their origin to the Chambers of 's Hertogenbosch, but they all shared the spark and stimulation of their time, because of the invention of printing, which coincides with them. The whole of Europe was then in intellectual fermentation, and the burgeoning Renaissance sounded the knell of the by now outmoded great medieval philosophical systems. Beginning with William of Ockham (born in the Surrey village of that name in 1300; died in Munich in 1349), scholastic philosophy born from the union of Greek philosophy and Christian revelation withered away under the onslaught of experimental science. The questions that were asked changed: the Why? had to give way to the How? As Anne Fremantle put it: "No longer was there passionate inquiry into such problems as why God became man, but rather, men wanted to know how the rainbow is put together and how it is colored." Ockham's and his followers' theories were quite audacious and in complete opposition to the propositions enounced by Saint Thomas Aquinas. In short, while an orthodox Thomist holds that in God alone essence and existence are identical, and that since God is the only existence, nothing can exist apart from Him, Ockham avers that we cannot know that God exists. Either we can assume His existence, or His nonexistence. In the first possibility, we incline to theism, and in the other, to atheism. The position can be summed up in modern terms in the little anecdote ascribed to Bertrand Russell. When the convinced agnostic was asked what he would do if after his death he was received in paradise by God, he answered that he would tell Him: "My Lord, why did you not furnish me with sufficient evidence while I was on earth?"

Such discussions, while seemingly arid, had their affect upon individual attitudes during the early and high Renaissance. They led to fragmentation and dissolution. Thus, the Great Schism (1378–1417), with rival popes in Rome and Avignon, undermined ecclesiastical authority. Individuals were encouraged to seek a personal relationship with God without interference from the clergy, and to stray from the "official" (i.e., Thomist) philosophy by reading and possibly accepting a different philosophical emphasis. A strong anticlerical bias appears to have been present in Bosch's hometown during his lifetime, and comes to the fore in many of his paintings.

Aside from these ratiocinations, one encounters yet another trend: a strong tide of mysticism, which found its causes in great public miseries that sorely hit Europe during the fourteenth and fifteenth centuries. Among them were the Hundred Years' War, famines, the Black Death in England and Germany, and consequent discontent among the poor. Others gained from the circumstances, primarily because a scarcity of laborers—due to the decima-

tion brought about by the various plagues—enabled them to form a middle class and disregard their feudal obligations. Such material independence spread over to the religious field, and, given the weakened authority of the clergy, surfaced in the form of belonging to religious organizations, which, though Catholic in name, interpreted the faith more freely than would have been possible in earlier times. Friars such as the Dominicans and the Franciscans had brought a first breeze of democracy and representative government to an absolutist Church. Mysticism found its first important spokesman and defender in Master Eckhart of Hochheim (near Gotha), who was born about 1260, taught in Paris, and received his doctorate from Boniface VIII in Rome. After his return to Cologne, his doctrines were opposed by the archbishop. After his death in 1327, Pope John XXII condemned part of his propositions, which were later warmly commended by Martin Luther. Jan Ruysbrock and Gerard de Groot followed in the master's footsteps, and Nicolas Cusanus (1401–64), later bishop of Brixen and Cardinal, espoused platonism in his later writings and almost got into difficulties with the Church for positions that could have been construed as pantheism—which he denied. Out of this religious turmoil flowed puritanistic trends, which found their realization in religious orders without vows, such as the Brothers and Sisters of the Common Life. They originated in Holland in the fourteenth century and preached a return to a simpler and more personal form of religion, almost pre-Protestant in conception, which they called *Devotio Moderna*. Theologically, their approach was based very closely on the *Imitation of Christ*, generally attributed to Thomas a Kempis (born 1380 in Kempen, near Cologne; died 1471 as the Superior of the Order of the Augustinians at Agnetenberg, near Zwolle). This famous German mystic exercised great influence during and after his lifetime, and played an important part in the religious revival of the fifteenth century. Two houses of the Brothers and Sisters of the Common Life were established in 's Hertogenbosch, as well as numerous convents and monasteries. Indeed, the number of religious foundations in Bosch's hometown was such that a few years after Bosch's death, one out of every nineteen persons in the city belonged to a religious order. Such a high proportion was uncommon in the Netherlands in the period, and seems, for purely economic reasons, to have attracted considerable enmity among the lay population. Again, a reflection of this attitude has been read into some of Bosch's paintings by a number of critics and commentators. However, there is no reason to believe that the faith of the citizenry was inordinately shaken by this state of affairs. The moral authority of the Church was one thing, but criticism of its servants—be they clergy, monks, or lay brothers—something else, which was well within the purview of the faithful. Religion and commerce continued to intermingle in spite of inevitable frictions.

Another element that influenced the relationship of the people with religion was the persecution of witchcraft. The concept of the supernatural and its effects on mankind is as old as the world. Shamans practiced magic in the caves of southern France and northern Spain, through wall paintings about 15,000 years ago, and similar paintings on stone in Africa might even antedate them considerably. Closer to us, the Greco-Roman Olympus, with its gods and half-gods, fulfilled man's needs for myths and idealized his emotions and desires. However, with the exception of Zoroastrianism, founded in Persia in the sixth century B.C., the basic division in two major principles, good and bad, symbolized by light and dark, was absent until the advent of Christianity. The Furies might have chastised sinners. There were ghosts and curses, amulets and necromancy. Witches might have brewed concoctions, and practiced white or black magic. A person might have been accused of having

the "evil eye." But there was no evil in it. The main enemies against whom imperial Rome was on the watch were diviners and sorcerers, not so much because they studied the stars and investigated nature, but because they could possibly use such knowledge—or the pretension of it—in the political sphere. Foretelling the future of the empire, or the length of life of the head of state, was deemed a public danger and had to be eliminated.

It was reserved to the early Church to bring about the polarization between the loving God and the fallen angel, whom the "Church, beginning to need an opponent, could divinely hate" (Charles Williams). The notion of the devil as incarnation of evil began to take form, and with it the strife against all those who were thought to take his orders and follow his commands. Witches and sorcerers, all persons accused and found guilty of practicing magic, had to expect the strictures of ecclesiastical as well as civil authorities. Curiously enough, the so-called Dark Ages harbored a great number of doubters of these superstitions in high places, and as early as the times of Charlemagne, his Salic Law sought to protect innocents from false accusations. Convicted witches were to be heavily fined (no question as yet of torture or death by burning), but when found not guilty had recourse against the accuser, who in turn was condemned to serious penalties. The law of the Church abided by the rule of the "quality of disbelief." This meant that examination in cases of witchcraft almost always contained the phrase "if thou hast believed or taken part in." Thus, it was the belief in it rather than the alleged happening that was punishable, and this concept was included in the Rules of interrogatories by about 1234 in the *Canon Episcopi*.

The situation had deteriorated considerably by the beginning of the fifteenth century. Two great French trials, that of Joan of Arc, burned in 1431, and that of her companion in arms, Gilles de Rais, marshal and peer of France, executed in 1440, mark a turning point. Previously moderated by the desire of the bishops to hold accusations of sorcery within limits, the new tendency actively fostered investigation of all possible and impossible allegations, and freely used torture to obtain confessions. The punishment was death in the most horrible forms, usually by burning, and the Church—by then in the cloak of the Apostolic Inquisition, as well as the accuser—shared in the financial assets of the victims. Thereby, the path was opened to easy enrichment for some, and hysterical satisfaction for the masses. The Inquisition went on for several centuries, and was not abolished in Spain until 1830.

Two priests, James Sprenger—who in 1452 became a Dominican novice in Basel, Switzerland—and Henry Kramer, collaborated in the codification of the recognition and punishment of witchcraft defined as a pact between humans and the devil. The book, one of the most appalling ever written, was entitled *Malleus Maleficarum*, or Witches' Hammer, and published around 1490. Pope Innocent VIII promulgated a bull, declaring the jurisdiction of the authors in the Germanic countries—obviously a reward for their zeal. In fact, Father Sprenger was made general inquisitor for Germany and provincial of his order for the German provinces.

These two psychopathic priests, with their detailed explanations of the forms that sorcery could take, their preoccupation with sex in its most abnormal perversions, and febrile imaginations inflamed by hysteria, were to become for years the source of a netherworld that Catholics had to accept as reality. Witches, sorcerers, wizards, *succubi, incubi,* and many others were believed to exist and perform the most abhorrent deeds, from killing infants, boiling them in cauldrons, and partaking of their flesh, and a whole litany of unspeakable horrors: all this on the basis of confessions extracted by the most inhuman torture.

This state of affairs could intrude at any moment upon rich or poor, man or woman; everyone was at the mercy of some greedy, vengeful, or simply envious informer. People lived in constant insecurity and terror. Their thus inflamed fantasies created hallucinations that readily accepted, or even improved upon, those fed to them daily from the pulpit. These delusions claimed, until their extinction, hundreds of thousands of innocent victims.

It is therefore understandable that such an environment could stimulate a normally fecund artistic invention in the case of a painter so inclined. For example, a "temptation" of any hermit or saint might become an occasion for letting the imagination roam as to what inducements the devil might invent to get his way with the holy man.

Hieronymus Bosch and later, Pieter Breugel the Elder, were perhaps more susceptible to the general tension than were their contemporaries. Bosch reacted by inventing forms and phantasmagoric creatures that exceeded the then-known norms. Consequently, he was first known for his "diableries". We will have more to say about this aspect of his art later. It certainly constituted a non-negligible element in the cultural background of his time.

The Artist: His Life

Very little is known about Bosch's life, and the few documents available provide a scant outline, without revealing anything about his training or sources. We know that he came from a family established in 's Hertogenbosch since at least 1399. At that time, a furrier named Jan van Aaken acquired the freedom of the city and died there in 1418. From 1423 to 1434, another Jan van Aaken is mentioned several times in the archives of the cathedral. It is now assumed that he was perhaps a painter, and the grandfather of Hieronymus. Thus, van Aaken was the patronymic of the family and indicates its origin from the German city of Aachen (Aix-la-Chapelle in French). Our painter must have borrowed the surname Bosch, with which he signed his works, from his hometown, and used the abbreviated form. It is in a document dating from 1504 that he is referred to for the first time as "Jeronimus van Aaken, called Bosch, painter who lives in Bois-le-Duc."

The first mention of Hieronymus occurs in 1474. He then signed, together with his father Anthonis Janss(oon) die Maelre (the painter), a promissory note amounting to 25 Rhenish guilders, the sum to be repaid in three installments. Our artist is there identified as Jeronimus, called Joen. The next document dates from 1475–76. It is from the records of the Brotherhood of Our Lady, concerning a meeting with the sculptor Adriaan van Wesel "to discuss and determine the design and means whereby the altarpiece should be commissioned. Thonys the painter and his sons were also present." We can take for granted that Thonys and Antonius are the same person. Furthermore, we learn that the father plied his trade together with his sons. Hieronymus is not specifically mentioned, nor is the exact number of his siblings. The new altarpiece had been finished in 1477 and replaced the old one, of which in 1480–81, "Jeroen die maelre" bought the wings. This is the first indication of Hieronymus as an independent painter. It also seems to suggest that he was not without means. His father died about this time. On January 3, 1481, our master gave his brother Goossen a quarter share of a house and grounds in the "Bossche Markt." As his brother Jan and sister Herberta made identical settlements on December 29, 1480, and January 18, 1481, one must infer that the siblings thereby settled their father's estate among them-

selves. Hieronymus is referred to in this document as Jheronimus *dictus* Joen, *pictor, filius quondam* Anthonii de Aken, *pictoris*. This is the first mention of Bosch being officially connected to the patronymic Van Aken.

Another document of 1480 refers to him as being married, and a document of 1531 is connected with the settlement of his wife's estate, mentioning her as the widow of "Jheronimus van Aken." Her name was Aleyt Goyaerts van den Meervenne. She was born in 1453, seems to have been older than Hieronymus, and was independently wealthy. In 1481, there was a lawsuit between Bosch and Aleyt's brother over family property. Some authors assume that Bosch and his wife lived in the house named *in 't Root Cruys* (the Red Cross) at the cloth market, but this is uncertain.

We have proof of a connection of Bosch and his father with the Brotherhood of Our Lady since 1475–76. In 1486–87, he became a member and continued to be closely associated with it for the remainder of his life. The brotherhood was an organization comprising both lay and religious members, and primarily devoted to the veneration of the Virgin. At the Cathedral of Saint John at the time, there was a famous miracle-working image of the Virgin, the *Zoete Lieve Vrouw*, which attracted devotees from all over 's Hertogenbosch and the adjacent lands. The brotherhood maintained a chapel there, the Chapel of Our Lady, and freely commissioned works of art to embellish it. The membership was well-to-do, if not rich, and paid for music and performers to enhance the daily masses and higher feast days. In 1478, they replaced the chapel with a new and more splendid one to provide more space and a better setting for the large new wooden altarpiece, finished in 1477, to which we have referred above. Most of the Van Aken-Bosch family seem to have been members, and Hieronymus received a number of commissions from the Brotherhood after having been inducted himself. The new chapel had been designed and built by the church architect Allaert Du Hameel, who is also known as the author of a number of engravings after Bosch's designs; it seems that our artist has painted the scene of Abigail before David on one of the outer wings of the 1477 altarpiece. As it does not exist anymore, we can only deplore the lost opportunity to study a documented work.

All further references to Bosch are derived from mentions in the register of the Brotherhood. Thus, in 1488 he was co-opted to the Committee of the Organization, and henceforth furnished a number of designs, such as in 1493–94 for a stained-glass window in the new chapel, in 1511–12 for a crucifix, and in 1512–13 for a chandelier. It must be stated that the artist did not take any pecuniary advantage of his position. The fees he charged were nominal ones, and went primarily to his helpers to pay their expenses. No further mention in the register shed any new light upon the artist. A reference from 1487–88 has been misinterpreted as an inscription in the painter's guild, and thereby obtaining the quality of "master." In fact, there existed no autonomous painters' guild in 's Hertogenbosch (see Marijnissen, 1987, *Training and Sources*, nn. 22, 23). Mosmans (1947, p. 28) publishes a document dating from 1508–9, where, in addition to Jheronimus, the master builder Jan Heyne is actually described as *meester*. In view of the circumstances, this appellation seems to have been an honorary one. In 1494, there were seventeen professions and trades in 's Hertogenbosch, which combined to form seven *natien off ghilden* (nations or guilds), but there was no mention of either painter or sculptors. Hieronymus must have obtained his freedom to manage a workshop and train apprentices and journeymen in some other manner and much earlier, probably from the same association that had already awarded the same privileges to this fa-

ther and brothers before him. As one cannot find any mention of painters and sculptors in the seven nations recorded in 1494, an agreement similar to that of the Guild of Saint Luke in Florence, that united painters, sculptors, cabinetmakers, apothecaries, and greengrocers under one roof, seems to be excluded.

Neither Bosch's father nor any of his brothers has ever been recorded with the title *meester*. Because of the unlikelihood of an unregulated existence of a craft in the medieval climate of the times, one must conclude that a trade association existed in town, which had jurisdiction over painters. The title *maelre* appears to be the watershed, permitting these artisans to exercise their profession and set up a workshop with helpers. Who awarded the title of "painter"?

The only remaining possibility is the freemasons. In big cities, they were grouped in permanent guilds, often together with the mortar makers and the plasterers, as in Paris. But on the whole, masons differed from members of other guilds because a large proportion of them were nomadic. They wandered from church to church, from castle to castle. When they settled in a smaller town such as 's Hertogenbosch, they formed a lodge (German, *Bauhütte*), and their organization had to be more elastic and provisional than the more static guilds in places where they were permanently settled. According to German records of the fifteenth century, they were relegated to a separate category, because "men of subtle craft, as freemasons and others, conspire together to refuse statutory wages and so insist upon a rise" (Wyclif, ca. 1380).

The rebuilding of the Saint John Cathedral lasted more than a century. We know that the masons used to carve figures—mainly grotesqueries—in stone, and were therefore artistic kin to painters, woodcarvers, and the like. It seems probable that they accepted such artisans as associate members, and thus offered them an organizational roof—the more so, as the new cathedral must have attracted other artisans to carve and polychrome statues, produce stained-glass windows, and so forth. Some of these chores fell to painters, and others were certainly done by other craftsmen. The book illuminators are a case in point. Without the freemasons' lodge offering them economic and legal protection, it would have been difficult for all these *gens de métier* to function in the medieval environment. Although documentation is lacking (most probably destroyed in wars or upheavals, such as the iconoclasm of the sixteenth century), the hypothesis is that in the absence of appropriate guilds, all artisans laboring in the artistic fields were attracted by the economically strongest group—which was the freemasons, who, in turn, would not have been averse to accept the membership fees of companions whose interests paralleled theirs. We shall, in any case, adopt it as a working thesis, in the absence of any other satisfactory explanation.

Carel van Mander writes in his *Schilder-Boeck* (Painters' Book), published in Haarlem in 1604: "[Bosch] was born in 's Hertogenbosch, but I have not been able to establish the dates of his life and death." We can do a bit better than he. The register of the Brotherhood of Our Lady contains, under 1516, the mention: "*Obitus fratrum anno 1516 Hieronymus Aquen alias Bosch insignis pictor.*"

As for his birth, for which no written document has been yet found, we possess a portrait design in the *Recueil d'Arras*, inscribed with his name. It also inspired a copper engraving in the set of portraits issued by Lampsonius in 1572. There is little doubt that this constitutes his likeness in old. Bosch appears here a man, advanced in years, lean, with a stringy neck, thin lips, and a penetrating gaze. Given the fact that formerly people appeared older

in their portraits than they do now, this man must be in his sixties. This agrees also with his date of death. He therefore must have been born in 1450 or thereabouts. As for the beginning of his career, we have seen that he cosigned a promissory note with his father in 1474. He should therefore have been of an age when he was financially responsible and had the necessary means to meet obligations on his own. Otherwise, his cosignature does not make sense. This points to an age of twenty or more, and that he was earning money with his craft.

I am therefore inclined to put the beginning of his painterly career at around 1470, which agrees with a birthdate of around 1450. By the age of twenty, he should have finished the apprenticeship and been a journeyman for several years. His independence and the establishment of his own workshop could be dated from around 1480, the time of his father's death, and when Hieronymus was first mentioned as Jeroen die maelre.

During the preceding decade, 1470–80, he evidently collaborated with his father in the latter's workshop. Given the absence of a guild in 's Hertogenbosch and therefore lack of restrictions in this respect, he obviously must have accepted and executed commissions on his own by then, and signed his works with his father's permission.

Sources of Bosch's Art

Bosch was a prolific painter. We know this from the number of Boschian compositions that have survived, as well as from documents describing works that have not come down to us—altogether a very respectable output. We shall have to say more about authenticity when we come to the section "Oeuvre." In the meantime, suffice it to state that as early as about fifty years after the artist's death, imitations of both painting and of his signature were in circulation. Our best authority is a Spanish writer, Felipe de Guevara, who in his *Comentarios de la Pintura*, dating from around 1560, stated that "countless numbers of paintings of this kind" (painted monsters and various imaginary subjects) were imitated during Bosch's lifetime. They "are signed with the name of Hieronymus Bosch but are in fact fraudulently inscribed: pictures to which he would never have thought of putting his hand but that are in reality the work of smoke and shortsighted fools who smoked them in fireplaces to lend them credibility and an aged look." Guevara also informs us: "Among those imitators of Hieronymus Bosch, there is one who was his pupil and who, either out of reverence for his master or to increase the value of his own works, signed them with the name of Bosch rather than his own."

In fact, we know of twenty works signed in very elaborate Gothic script, of which only eight, at the most, seem to be by the master himself. All others are inscriptions of helpers or imitators. The name of the pupil whom Guevara specifically cites remains unknown.

The task of circumscribing the master's oeuvre has been rendered more difficult by the growing uncertainty with respect to the attributions of many works that used to be considered authentic only two decades ago, and have since been shifted into the "doubtful" category. One asserts now that no dated paintings of Bosch's exist, or that documents regarding commissions received by the artist of works are still extant. As to dates, a version of *The Cure of Folly* appeared on the Brussels art market during World War II, which was signed and dated 1516, the year of Bosch's death. Hulin de Loo accepted it as the original of the

composition. I ignore its current whereabouts (Larsen, 1950, p. 4 and Appendix II). In 1504, Philip the Fair, duke of Burgundy, paid "a Jeronimus van Acken, called Bosch, painter who lives in Bois-le-Duc" 35 pounds on account for a Last Judgment to be 9 feet high and 11 feet wide, depicting both paradise and hell. An inventory of paintings belonging to Margaret of Austria, governess of the Low Countries from 1507 to 1519, drawn up in 1516, records a panel representing Saint Anthony, "*qui est fait de Jheronimus Bosch.*" Given the number of small representations of the theme, we ignore whether the painting has survived in any of the known versions. Another, in the inventory of the artistic property of the Archduchess, drawn up in 1524-30 describes again a "St. Anthony," this time in more detail. The background consisted of "*le fond de bocaige et estranges figures de personnages.*" Was this the same Saint Anthony as in 1516? Or did the governess own two Bosch paintings of the same subject matter? To this day, the archives have not yielded a clue that permits positive identification. We are aware that, during Bosch's lifetime, works by Bosch entered the famous collection of Cardinal Grimani in Venice, others were highly valued by Antwerp collectors, and that Philip II of Spain became one of his most powerful and admiring patrons. Last but not least, the Cathedral of Saint John in his hometown owned several of his works, now lost.

Despite this widespread reputation, what eludes us is the survival of a single work that can be related to a document ad hoc. When we have documents, the corresponding works do not exist any more; and the surviving paintings lack any kind of evidence (contracts, payments, etc.) that can be directly traced to the artist himself. It therefore may be said that there are no works by Bosch established by corroborative evidence, and all attributions, as well as the chronology of his oeuvre, are based on purely subjective judgment.

Add to this the fact that Bosch's fame springs mainly from his diabolic scenes, a world of dreams and nightmares; the number of these that are really his own works has been doubted by the aforementioned Felipe de Guevara in his writings dating from around 1560. He states: "I dare to maintain that Bosch never in his life painted anything unnatural, except in terms of hell or purgatory, as I have mentioned before. Granted, he endeavored to find for his fantastic pictures the rarest objects, but they were always true to nature; thus, one can consider it a safe rule that any painting (even though provided with his signature) that contains a monstrosity or something else that goes beyond the confines of naturalness, is a forger or imitation, unless—as I said before—the picture represents hell or a part of it." Certainly, many of his works are, as Van Mander described them in 1604, chiefly "wondrous and strange fantasies...often less pleasant than gruesome to look at."

Those inventions are, however, only part of Bosch's artistic production. Fray José de Sigüenza, another writer and critic and also a Spaniard, published only a year later than Carel van Mander his vast *History of the Order of Saint Jerome.* This is what one of our great contemporary art historians has to say about him: "[He] is rarely read, and his praises as an art critic are unsung. Yet what this historian had to say in 1605 about one of the greatest northern painters of the early sixteenth century towers over much that has been said about Hieronymus Bosch in recent times" (Wolfgang Stechow, 1966).

We will return to certain points made by Sigüenza later. For the moment, it behooves us to quote the Spanish author as to the three categories into which he divides Bosch's painting, as far as content. "The first [category] comprises devotional subjects such as the events that form the life of Christ and his passion, the adoration of the kings, and the carry-

ing of the cross; in the first of them, he expresses the pious and sincere attitudes of the wise and virtuous, and here one sees no monstrosities or absurdities; in the second, he shows the envy and rage of the false doctrine, which does not desist until it has taken away the life and innocence, which is Christ, and here one does see the Pharisees and scribes with their furious, cruel, and snarling faces, who in their habits and actions convey the fury of these passions. Several times he painted the Temptations of Saint Anthony (and this is the second category of his paintings) as a subject with which he could reveal singular meanings....Besides these pictures, there are others, very ingenious and no less profitable, although they seem to be more macaronic (the Spaniard alludes here to the Italian founder of macaronic writing, Coccajo—pseudonym for Teofilo Folengo [1491–1544]. *His Liber Macaronices* [1517] appeared one year after Bosch's death), and these constitute the third category of his work."

When perusing the abundant twentieth-century literature concerning Bosch, one is astonished to see how little importance is attached to the first, traditional category. It is as if the critics were distinctly uncomfortable with the fact that the master of the devilries, interpreter—according to them—of a profound significance, and deep philosophical as well as theological meaning, produced a series of purely conventional panels of run-of-the-mill religious subjects, like everyone else at the time. Taking as a basis a few of the traditional paintings, such as his *Adoration of the Magi* (Cat. No. 1), the *Epiphany* (Cat. No. 2), *Christ on the Cross* (Cat. No. 7), *The Seven Deadly Sins* (Cat. No. 5), and *Madonna* (Cat. No. 3), we possess a starting point for attempting to place Bosch stylistically among his contemporaries.

The first question always asked is: under whom did Bosch study? Given the absence of a painters' guild whose registers would provide the answer, we must proceed by assumption. The simplest and most logical assumption would be that it was his father who provided the apposite instruction not only for Hieronymus but also for those of his brothers who followed in their father's footsteps. In the Cathedral of Saint John in 's Hertogenbosch are two large tempera paintings on canvas, representing the standing figures of the Madonna and Child and Saint John the Baptist, respectively. They were originally intended as folding wings over a big clock, which was dated 1513 (?). Both paintings are in a bad state of conservation and were heavily restored in 1949. It is very possible that the date on the clock was placed there on the occasion of a mechanical restoration, thus, much later than its original inception. Although the paintings are weak in execution, as far as one can judge from what are basically ruins, Tolnay (1989, Cat. 34a) thinks that the types of the faces are Boschian, and that the canvases could have been executed after cartoons extant in the Bosch studio. In both paintings, the folds are heavy and reminiscent of Burgundian sculpture. The founder of this style was another Dutchman, Claus Sluter, a sculptor who was probably from Haarlem, and who died in Dijon around 1406. We find some of his youthful works in Brussels, where they decorate the face of the Brussels City Hall. In light of these archaic traits, we think it more appropriate to ascribe the authorship of these two paintings to an older artist who might also be responsible for the similarity of the design of the faces with Boschian patterns. Who else but his father Anthonis comes to mind in this connection? It is thus that we can imagine that Bosch's father painted, and where we can find one of the sources for Hieronymus's style.

Flemish painting of the fifteenth century, thus southern Netherlandish painting, owed its main characteristics to a combination of contributions, northern ones, based on Dutch and German influences, to which was joined the southern branch of artists formed in the

school of Tournai. The brothers Van Eyck hailed from Maaseik, today in the Belgian province of Limbourg, close to the Dutch and German borders. At the same time, Robert Campin, called the Master of Flémalle, was active in Tournai. The second generation—Petrus Christus, Dierk Bouts, and Ouwater—were native Dutchmen who settled in Bruges and Louvain, and Rogier van der Weyden represented the southerners in Tournai and Brussels (I do not want to raise here the question of whether there were two masters of similar names—Roger de la Pasture, of Tournai and Bruges; and Rogier van der Weyden, the Brussels city painter. Such a discussion would transcend the framework of this study). Finally, the so-called Master of the *Virgo inter Virgines* and Geertgen tot Sint Jans chronologically bracket the artistic career of Hieronymus Bosch, the former in Delft and Antwerp, the latter in Haarlem.

It is probable that Hieronymus had occasion in his hometown to see original works from more than one of these masters, or at least from their workshops. It is also possible that he journeyed to several artistic centers in his neighborhood, such as Haarlem and Utrecht, or Antwerp, Brussels, and Bruges, to expand his horizons. A trip to Italy, however, proposed by some critics, seems improbable.

In the section "Oeuvre," we shall point to what appears to be specific borrowing of stylistic elements in the corresponding paintings by our artist. In any event, Bosch's manner, as we can see it in his traditional paintings, owes much to his contemporaries. He takes up the mannerism first intimated by the Master of the *Virgo inter Virgines*; in the *Ecce Homo* in Frankfurt (Cat. No. 4), he borrows from German prototypes; and *Christ on the Cross* (Cat. No. 7) in Brussels openly acknowledges debts from Rogier van der Weyden. A newly discovered *Madonna* (Cat. No. 3) in an American private collection clearly parallels an early Madonna with Child by the slightly younger Geertgen tot Sint Jans at the Ambrosiana, Milan.

Thus, far from being an island (Panofsky) that cannot be fitted into the pictorial language of his contemporaries, Bosch's first category shows him decidedly as an artist who was not enigmatic. Rather, we see a distinct personality in concept and expression, slightly archaic and provincial, but whose form language cannot be called intrinsically alien to the mainstream of painterly production of his time. What sets him apart is his technique. He eschews the delicacy of details and the plastic volume brought into painting by such artists as the Van Eycks, the Master of Flémalle, or Rogier van der Weyden. His execution is flat, bidimensional, and graphic rather than painterly. In this respect, he draws from the art of the book illuminators, one of whom Friedländer surmises to have been his teacher; Lyna, reinforces the proposition on the basis of the content of Bosch's devilries. Bosch approaches his mode of expression in the spirit of the great figures of the German schools, such as Schongauer, Cranach, and Dürer, who were all more skilled in handling the burin rather than the painter's brush. Hieronymus, too, devoted his main attention to the underlying preliminary drawing, placed on the white ground of his panel, over which he painted a transparent layer in a color or a shade more or less like flesh (*primuersel*). Frequently, he used the ground for part of the final effect of the painting (Van Mander). As a consequence of this technique, the drawing can clearly be seen in many of his works, through the transparency of the glazes in which he built up his colors. Thus, what comes clearly to the fore is that Bosch deals in lines like an engraver, and not in spatial blocks. Some see such a propensity as a trait of genius, and others might, to the contrary, ascribe the tendencies to provincial, and therefore

antiquated, professional training. It is not quite an *alla prima* or direct-painting manner, such as was developed in Italy in the seventeenth century and from there taken over by the Flemish and Dutch. The salient difference consists in the fact that the seventeenth-century method used one single covering layer of paint that, like the moderns, modeled everything shown on the painterly surface, whereas Bosch remained faithful to the Old Masters in superimposing numerous layers of pigments to obtain the desired tonalities.

While on the subject of technique, it behooves us to mention that a considerable number of works by Bosch were painted on canvas. Most of them perished, but documentary evidence exists. Such mainly larger compositions were executed in the technique of the *Waterscilders*, thus consisting of relatively less costly watercolors with gum added to the painting medium for better adherence and therefore extremely vulnerable to the ordinary cleaning by, for instance, the charwomen at the Escorial, where many such paintings fell victim to their moistened brooms (cf. Justi). An excellent example of this technique having fortunately survived in a very good state of preservation is the *Adoration of the Magi* by Joos van Gent, painted around 1467, at the Metropolitan Museum of Art, New York. However, even the panel paintings by Bosch have suffered more than usual compared with other works from the same period. One must therefore assume that what we consider his oils are not done purely in this more resistant process, but probably in a mixed technique (tempera and oil) that left their surfaces easily open to damage. The poor state of preservation of such major works as *The Hay Wain* and *The Garden of Delights* could hardly be explained otherwise.

To resume, the paintings of the first category consist primarily of devotional subjects. We might add that in later paintings of the kind, the satirical aspect of his figures comes more and more to the fore. "He shows the envy and the rage of the false doctrine, which does not desist until it has taken away the life and innocence, which is Christ, and here one does see the Pharisees and scribes with their furious, cruel, and snarling faces, who in their habits and actions convey the fury of these passions" (Sigüenza). A good example of this style which flows into the second category is *Christ Carrying the Cross* from the Ghent art museum (Cat. No. 30). All figures are shown in half-length, and their expressions are exaggerated, caricatural, and overdone. One can ascertain a distinct relationship with a series of cartoons by Leonardo da Vinci that feature similar hyperboles, and the question "who influenced whom?" has given rise to much scholarly discussion. Cuttler (1968) characterizes the Ghent painting as the peak of Bosch's emotional involvement in his didactic exhortation pointing to man's folly and its inevitable consequence of punishment in hell; he calls it "his supreme statement."

To the second category belong the temptations of Saint Anthony, as a subject with which the artist could reveal singular meanings. "In one place, one observes this saint, the prince of the hermits, with his serene, devout, contemplative face, his soul calm and full of peace; elsewhere, the endless fantasies and monsters that the arch fiend creates to confuse, worry, and disturb that pious soul and steadfast love; for this purpose, he conjures up animals, wild chimeras, monsters, conflagrations, images of death, screams, threats, vipers, lions, dragons, and horrible birds of so many kinds that one must admire him for his ability to give shape to so many ideas" (Sigüenza).

All this leads us to Bosch's third category, in which the monstrosities and devilries play the primary role. Significant examples of this branch of Bosch's creativity are the

Temptations of Saint Anthony altarpiece in Lisbon (Cat. No. 28); *The Altar of the Hermits*, Palazzo Ducale, Venice (Cat. No. 20); and *The Martyrdom of Saint Julia* in the same collection (Cat. No. 21). Finally, Bosch painted a number of works that are based on moralizing themes, for the figures of which he made use of imaginative creatures borrowed from many sources and changed according to his own fantasy (see, e.g., Cat. Nos. 31, 18, 51, 52, and 53).

To understand this category, which was and still is responsible for much of Bosch's fame, we must allow for the multiple explanations for the content of his works, as well as for the all-embracing source material that has been imputed to him.

Essentially, what distinguishes Hieronymus Bosch from other painters of the *Waning Middle Ages* is a luxuriant imagination, which led him to people a large number of his works with anthropomorphic and zoomorphic creatures, bizarre and frightful at the same time, and thus striking the imagination of the viewer. Older masters had represented hell and paradise, the Last Judgment, and similar scenes. But it was left to Bosch to conjure the devilish fiends and monstrosities that set his creations apart from all others. This aspect of his talent has been vividly discussed since its inception, and has provoked diverse reactions. Van Mander writes: "Who can relate all the wondrous and strange fantasies that Jheronimus Bosch conceived in his mind and expressed with his brush, of spooks and monsters of hell, often less pleasant than gruesome to look at?" The Italian authors of the sixteenth century classify him as appallingly unbalanced. In Spain, one approached the oeuvre of the artist principally in function of its theological orthodoxy. Attacked by some, he found a warm defender in the person of Philip II. It is therefore not astonishing that other learned writers provided arguments of a nature to please their sovereign. Among them, we encounter the above-mentioned Felipe de Guevara, humanist, numismatist, courtier, and himself an avid collector of Bosch's paintings. In his *Comentarios de la Pintura* (see above) he attributes the origin of the Boschian genre—which he calls *Grylli*—to an Egyptian painter by the name of Antiphilos, and comes vigorously to the defense of master Hieronymus against those who wanted to see in him a painter of monstrosities only.

Fray José de Sigüenza (1605) also espouses the predilection for Bosch's works by Philip II, and sustains him qua theologian: "Among those German and Flemish pictures, which as I said are numerous, there are distributed throughout the house [Escorial] many by a certain Geronimo Bosco. Of him I want to speak at somewhat greater length for various reasons: first, because his great inventiveness merits it; second, because they are commonly called the absurdities of Geronimo Bosco by people who observe little in what they look at; and third, because I think that these people consider them without reason as being tainted by heresy." A defense of Bosch's theological orthodoxy follows, and then, "The difference, which, to my mind, exists between the pictures of this man and those of all others is that the others try to paint man as he appears on the outside, while he alone had the audacity to paint him as he is on the inside." Of the third category of our artist's painting, Sigüenza continues: "I am convinced that it is with [the poet Merlino Cocajo] that Geronimo Bosco [would have] wanted to compare himself: not because he knew him—for I believe that painter did grotesque scenes earlier than the author—but because he was inspired by the very same thoughts and motives....Thus, he embarked upon a new road, on which he would leave the others (Dürer, Michelangelo, Raphael) behind while he was not behind anyone else, and on which he would turn eyes all toward himself; a kind of painting, comical and

macaronic (on the outside) yet mixing with such jests many things that are beautiful and extraordinary with regard to imagination as well as execution in painting, now and then revealing how skillful he was in that art—just as Cocajo did when he spoke seriously."

As we can see, the acceptance of Bosch in Spain did not come about without opposition. If some were ready to accept his monsters as symbolic representations of vices and mysteries, others discerned in them a basic irreverence, amenable to the tribunals of the Inquisition.

How were Bosch's works received in the Low Countries? To judge from the numerous copies and imitations, as well as engravings making use of his motifs, his works met with great favor. Many notables awarded him commissions, such as, as we have previously seen, Philip the Fair, duke of Burgundy; and Margaret of Austria, governess of the Low Countries. The elder Pieter Bruegel is unthinkable without Bosch. But with the exception of the latter artist, who borrowed the form language from his predecessor to imbue it with his own significance, most other Bosch followers degenerated into painters of more or less folkloristic diableries, whose aim was to frighten and terrify the spectator instead of inform and educate.

Closer to us, art criticism has sought to penetrate by all available means the essence and deeper meaning of his works—or at least, to impute to him such thoughts even if they existed in the mind of the interpreter only. Initially considered simply droll (Rénouvier), one subsequently took him to be a satirist (Maeterlinck), naturalist (Van Bastelaer), and finally, a mystic, full of hidden allegories, potential rebel and forerunner of the Reformation (Tolnay).

Some scholars put together elaborate systems, and made Bosch a member of obscure heretical sects—lacking any proof for these allegations—to explain the Boschian iconography according to their whims, and the artist as a covert opponent and derider of the teachings of the Established Church. It is true that religious heresies survived, albeit with the greatest difficulties, during the Middle Ages. However, to propose that Bosch—a solid citizen who depended upon the goodwill of a class of customers who were both socially prominent and closely linked to the Church—to earn his living would have hidden heretical propositions in his paintings, whose discovery could have led him straight to the stake, appears ludicrous. The more so, as the artist seemed, to the contrary, set to establish himself in the community where he lived as a patrician, having risen above his initial mediocre birth to the status of a citizen of quality. Witness his marriage with a lady of the nobility, who, though older than himself, brought wealth and standing to the union. Bosch had hardly enough of the psychological makeup of Till Eulenspiegel in this nature to thus risk life, fortune, and position for mere bravado. Quite to the contrary, his membership in the Brotherhood of Our Lady vouches for the orthodoxy of his faith.

One of the writers who attempted to involve our painter with a heretical group and earned some passing popularity in the sequel was Wilhelm Fraenger. He linked Bosch to the Brethren of the Free Spirits, who were vaguely known throughout Europe for their supposed sexual promiscuity, which they practiced during their religious rites. In this manner, they pretended to regain man's innocence prior to the original sin, and hence also called themselves Adamites. Bosch's triptych *Garden of Delights*, and especially its central panel, show, according to the German author, paradise as it was before the Fall, and as it was going to be again according to the law of the Brethren. It represents the Holy Prostitution according to the tenets of gnosticism (!). Furthermore, the work was commissioned by a certain Jakob

van Almaengien, whom Fraenger identified—again, without proof—as the grandmaster of the sect. By the same token, the writer connected other works by Bosch with the Adamites, and pretended to find sediments of their doctrines in them. The whole story was, of course, promptly disallowed by contemporary scholarship for complete lack of basis in historical fact, all of Fraenger's assumptions being no more than blatant inventions. Nevertheless, the general public and the popular media kept it alive for quite some time, because the theory agreed with our own modern approach to sexuality and eroticism, rather than the traditional interpretation of the love scene in the central panel as a didactic sermon against carnal lust. Gibson even quotes from an author who must be interested in the study of eroticism per se, who refers to the Bosch panel as "an illustration of his own theories put into practice"—namely, therapeutic sexuality (!).

A recently published book by Lynda Harris (1995) asserts that Bosch was a member or at least in contact with one of the surviving cells of Catharism and a secret believer. This heresy, based on early gnosticism, affirmed that the earth was literally hell, ruled over by Satan. Its adherents clung also to a transcendental vision of the divine realm of light. In short, Catharism was dualistic, while the Brethren of the Free Spirits, as much as one knew about them, were pantheists. The Cathar/Manichean heresy was wiped out from its strongholds in Lombardy and the Languedoc in the course of the thirteenth century. It was of Slavonic origin, especially well implanted in Bosnia, whence it spread throughout western Europe. In the south of France, the sect became especially threatening to the established Roman Catholic faith in the region of Albi. Pope Innocent III finally ordered a crusade against these infidels, and they were subsequently vanquished in the battles of Muret and Toulouse in 1213. Most of the Albigeois, as these Cathars were called, perished either by fire or by the sword, and it was only under the regency of Blanche de Castille (1229) that peace was reestablished in the south of France by the Treatise of Paris. Those of the Cathars who had settled in northern Europe, Flanders, Germany, and adjacent regions had also become victims of the Inquisition. From the end of the twelfth and the first half of the thirteenth century, practically no Cathars survived in western Europe, and the last mention of them dates from the early fifteenth century. There may have been clusters of believers still established in Bosnia in the times of Bosch, but as we do not accept the possibility of a voyage to Italy by the artist, there were no occasions for contact with them via Venice. In his hometown, the sect of the Cathars was certainly extinct by then. The thesis of Lynda Harris, interesting though it may be, founders, like that of Fraenger, on two rocks of unlikelihood. First, no cells of the particular heresy with which these authors want to associate Bosch are any more known during his lifetime, and there is neither an oral nor a written tradition to underpin the assumption. Second, their postulate of Bosch's inner conflict—good Catholic outside, detractor and opponent of the established religion inside—lacks all justification. Consequently, Lynda Harris's speculations turn out to be a mere chimera without any historical foundation. The symbols adduced by her are also current in Catholicism.

Lotte Brand-Philip fancies herself an art-historian detective who competes with Fraenger and others in the sophistry of her construction. In an extensive article (1958), she avers that the Rotterdam Prodigal Son, whom she calls a Wayfarer, represents the melancholic temperament and originally belonged to a triptych, together with three other panels, constituting a cycle of the Four Humors. The other panels were the original of the *Conjuror*, the *Stone of Folly*, and a lost composition reconstructed by her, the *Hog Hunt of the Blind*.

She considers them to be symbols for the four elements and signs of the zodiac, and that their combined significance was a warning against evil. D. Bax (1962) refuted the article in general, and Brand-Philip's assertion that the four pictures formed the outer wings of a triptych, in particular. The result is that her theories have now been abandoned. The same applies to her attempt at iconographic explanation of the Prado *Epiphany* (1955).

Other writers derived Bosch's sources of inspiration from literature, such as the works by Augustine, Albertus Magnus, Denis the Carthusian, and Gerson. Bosch was certainly acquainted with the *Legenda Aurea*, or Golden Legend, which was widely known. Written by Jacobus de Voragine before 1298 (year of his death), more than six hundred manuscripts in many languages have survived, of which about ninety date from the fifteenth century—a number of them in Dutch. Among the devotional literature, we mention the *Ars moriendi* books, whose origin points toward the Rhineland: *The Voyage of Saint Brendan*; and *The Vision of Tundale*. Bosch borrowed freely from the latter.

Both *The Vision of Tundale* and *The Voyage of Saint Brendan* were written by Irish monks, probably in the twelfth century. They depict scenes from hell or purgatory. More specifically, the *Vision* stands out by the description of a journey through hell, featuring all kinds of torments, demons, and bestial monsters—adapted by Bosch and translated into his own form language in several of his paintings. In the visit to paradise, the author speaks of walls made of silver, gold, and precious stones (Marijnissen, 1987). Finally—and this is only a succinct enumeration of the possible sources for the painter, literary or plastic—we must assume that the artist was well acquainted with Sebastian Brant's *Das Narrenschiff*, published in 1494 in Basel, in whose illustration Albrecht Dürer played a significant part.

A group of critics sought sources for Bosch's imagination in alchemy (Combe, 1946), medicine, and pharmacy (L. S. Dixon, 1984). Curiously enough, while Combe's conclusions led him to aver that Bosch employed the symbolism thus derived to condemn alchemy and link it to evil in general, J. van Lennep (1968), starting from the same premise, arrived at a completely opposite result. According to him, the *Garden of Delights*, for example, represents spiritual regeneration by dint of an alchemical allegory (!).

Another critical tendency, primarily originating with Dutch scholarship and represented by Roggen, Grauls, and chiefly by D. Bax (1949), interpreted Bosch in a fashion that was more terre à terre, describing him as the plastic artist bent on explaining to the commonfolk Dutch folklore as well as the main literary works then accessible—thus eschewing esoteric comments as we have encountered previously, or even adding to the obscure meanings by adducing astrology, other occult sciences, and gnostic doctrines.

One will remember that, for instance, Brand-Phillip, inspired by Pigler (1952), had proposed that the Prodigal Son in the Rotterdam picture was one of the children of Saturn, and that the Conjuror represented those under the power of Luna. She went on to relate the composition to astrological prints, the *Planetenkinderbilder*. Compared with this rather daring exegesis, that of the Dutch group stands out for its common sense, seeking the obvious and elucidating its symbolism through the richness and color of the Dutch language. In short, as stated excellently by Gibson (1983), Bax assumed that "the transformation of verbal images into visual ones underlies much of Bosch's symbolism."

Given the fantastic nature of many of Bosch's creatures, it will surprise no one that he has not escaped the attention of psychoanalysts, or that art critics, starting with Tolnay in his first monograph (1937), attempted to use the theories of Freud and Jung to explain the

artist's dreamworld. Examinations by authorities in the field have yielded conclusions that Bosch was a neurotic whose phantasmic works constituted, in essence, a cry for help to preserve his own sanity. Others diagnosed psychic disturbances such as: schizophrenia; an Oedipus complex; sadomasochism; oral, anal, and phallic tendencies; and homosexuality (Gibson, 1983). Add to it addiction to narcotics and certain intoxicants, and the enumeration becomes complete!

On this tenuous basis, critics proclaimed Bosch a forerunner of the Surrealists and Salvador Dali! Fortunately, the times of colorful explanations of the artist's hidden meaning in his compositions seem to have passed. Common sense suggests that Bosch, having lived centuries before Freud and Jung, could hardly have drawn upon their theories to apply them in his paintings. In addition, his contemporaries, steeped in late medieval lore, would have been unable to understand them.

The current tendency, represented by Gibson, Marijnissen, and others, marks a return to the views of the older generation of Friedländer, Baldass, and Van Puyvelde (1956). They saw in Bosch a late-medieval Christian in outlook, a moralizer, and his works a preaching in paint. We especially like Van Puyvelde's suggestion that every form that Bosch painted did not necessarily contain a specific meaning, but were freely imagined and thus invention for its own sake - *l'art pour l'art*. The scholar categorically dismisses borrowings from sorcery and other hermetic or esoteric beliefs, and insists upon Bosch's humorous side, which even pervades representations of hell, as well as moralizing subjects.

If we want to sum up the personality of Hieronymus Bosch, we come to a number of divergent conclusions. He was primarily known throughout the centuries as the *faiseur des diableries*. Even in our day, Gibson noted that at an important Bosch exhibition in the 1970s, the public thronged before the phantasmic paintings and virtually ignored all others, just as in the museums of Berlin or Vienna, people are attracted by Pieter Bruegel the Elder's Proverbs—trying to decipher them—rather than those whose subject is a symbolic narrative. In a review of Bosch's sources, one often forgets his debts to the Bestiaries, of Alexandrian origin, and going back to scrolls dating from the third or fourth century onward A.D., and the book illuminators who decorated the margins of their manuscripts in the thirteenth and fourteenth centuries with mischievous scenes that constitute extremely imaginative forerunners of Boschian lore. We have already alluded to the stonemasons who used to decorate the capitals of the church columns with grotesque faces or figures, often redolent of Asiatic influences. The salient point is, investigation into Bosch's debts to other sources brings forth that the subject matter of these fantastic monsters and their manner of representation was about a thousand years old by the time that the master of 's Hertogenbosch appropriated it for his own purposes. As Marijnissen appropriately states (1987), "Upon closer analysis, it cannot be denied that Bosch's work represents the powerful development of something that in its initial stage was very modest and marginal!....It is obviously unreasonable to expect that one could climb—manuscript by manuscript—a stairway toward Bosch." Lyna's view of the matter was as follows: "What began in the decorated margins as humor, satire, or a taste for the bizarre, later took on overpowering dimension in the work of Bosch." One must add to this evaluation that more forms of monsters than normally assumed, more fantasies invented as we see them in Bosch's pictures, preexisted as such in the above-mentioned sources. Contrary to the critics who maintain that Bosch assimilated and did not borrow, the opposite is true. We shall devote a few paragraphs to some bes-

tiaries where what we thought were Bosch's own creations floated in the air or impressed humans hundreds of years prior to having been reproduced by our artist. The way Bosch elaborated his compositions was indeed a powerful development over earlier representations. However, his great contribution consisted in the fact that he was first to lift these hellish scenes from the pages of manuscripts onto large paintings or canvas—and thus made them accessible to the mass of common people. They did not read and study this material in the libraries. Suddenly, they were confronted and tickled by these scenes in a familiar environment: the church, where they customarily congregated, and thus were for the first time exposed to all these delicious horrors. Hence, popular acclaim for Bosch and his widespread reputation. His customers were not the rabble that gaped at his works, but kings, nobles, and patricians, who actually bought them in quantity. He had filled a market gap, and the world was at his feet! Translated into modern terms, Bosch's bizarre creations were then the equivalent of a modern film like *Jurassic Park*, and obtained a similar success from a public carried away by the novelty.

The grotesque and the caricatural had been outstanding characteristics of Flemish art since its beginnings. Thus, the allegorical fauna of Bosch traces its roots and inspiration back to the bestiaries, which derive themselves from the *Physiologus*. The latter was a composition written in Greek in Alexandria during the second century, and its content—theological, scientific, and moral—dealt with a number of animals, plants, and stones, real or fabulous, whose properties and virtues were interpreted according to an allegorical approach.

The writing having achieved considerable success, numerous bestiaries were produced and illustrated during the Middle Ages. The animals there described found themselves transposed into the ornamentation of the curves of arches or vaults, portals, and gargoyles. Among such manuscripts, one of the most interesting for our purposes was written at the beginning of the twelfth century by Philippe de Thaon (or, de Thaum) in England, in French, and dedicated to Queen Aelis of Louvain. The text is complemented by explanatory miniatures. Hence, the work permits for the first time to determine exactly the significance of the various beasts or fantastic figures. A few examples follow, translated by this writer. For more details, see Larsen (1950).

A lion devouring an ass. According to de Thaon, the lion, with an enormous neck and a relatively small and weak body, represents Jesus, son of Mary.

The monosceros or the unicorn. She has the shape of a he-goat and bears a single horn on her forehead. To capture her, one proceeds in the following manner: *"La met une pucelle/Hors de sein sa mamele/Et par ordurement/Monosceros la sent"* (A virgin thrusts out of her bosom one breast. By her odor, monosceros smells her). The unicorn is God, the virgin is holy Mary, and the breast is the holy Church.

The Panther and the Dragon, as well as the Goat (*dorcon*) also represent Jesus Christ. The Antelope (*aptalon*), the monster half ass and half man (onoscentaurus), the Castor (*bièvre*), the Hyena, the Mouse (*mustele*), the Ostrich (*assida*), to cite only a few, are all symbols of the devil. His customary representation however, is the Crocodile, whose open mouth signifies the entry to hell: *"Cocodrille signefie/Diable en ceste vie/Quand busche uverte dort/Dunc mustre (montre) enfern e mort"* (Crocodile signifies the devil in this life. When it sleeps with the mouth open, it shows hell and death).

The *Liber Floridus* (library, Ghent, beginning of the twelfth century) contains among its miniatures a representation of the crocodile "of the Nile," adorned with the head of a lion. A

Seraine (Siren) is shown with the *faiture* (form) of a woman, the feet of a falcon, and the lower part of the body coming to an end in the form of a fishtail. This strange creature weeps during good weather, but sings when it storms.

A little-known bestiary was discovered by L. Maeterlinck in the archives of the bishopric of Ghent, dating from the fifteenth century, and comprising a multitude of strange beasts. We cite a few examples:

Polipo: composed of a female body of pale sea-green color and ending in an enormous tail of a speckled fish.

Corulco: features the face of a man shown with a frightful expression. The body is that of a porpoise with two articulated claws like a lobster.

Dracone maris: a creature with the head of a fish and the body of a lizard.

Piscis monachi: the flying monk astride a fish, described by all the naturalists of the time. Bosch made use of him in the left wing of the triptych of the Hermits (Venice).

It becomes therefore easy to establish that this kind of image formed the reserves from which the satirical and droll artists of the fifteenth and sixteenth centuries borrowed. Bosch was certainly no exception. Although the bestiaries are mentioned by most critics among his sources, much too little attention has been paid to them as to the details. Nevertheless, Bosch does not always seem to have followed the ancient interpretations. His interest was aroused by the strangest forms and their hermeneutical explanations. In this conjunction, the naturalists following the teachings of the Greek scholar Oppianus certainly exercised a distinct influence upon him. A few examples drawn from the Greek's work *Hunting and Fishing*: "Very often hymen brought together the wolves and the cruel panthers, and of their union was born the vigorous race of tunny-fish....The panthers used to be in bygone times charming women....The giraffe is the product of the union of the same panther and the camel....The ostrich is the product of the camel and the sparrow...etc." It is indisputable that the marvelous fictions of Oppianus must have contributed to stimulate the imagination of generation of artists.

Bestiaries thus constituted a very important source for Bosch's phantasmic paintings. Some among them must have been easily accessible in 's Hertogenbosch. Most biographers of the painter mention them duly in their enumeration as possible origins of his inspiration, without, however, examining them in depth as to apposite details.

The purpose of the above explanation does not constitute an attempt at debunking Bosch, but at freeing his image from the legends with which it has been veiled by most of his critics during the past century. Let us start with Friedländer, who avows that Bosch's brilliant originality places him completely outside the development of fifteenth-century Netherlandish painting. This is a complete misconception. It derives from the romantic notion of the artist as a divinely inspired entity, unique in time and spirit, interested in the remote and with a predilection for melancholy. However, what was acceptable and even admirable in the time of Victor Hugo did not fit into the intellectual web of the Middle Ages. There was no place for loners in a society that was strongly organized and stratified. Generally speaking, no genius ever evolves in any field, completely untouched by the wisdom of the past. Hence, Friedländer's emphasis upon content rather than form in the oeuvre of the artist. Panofsky calls Bosch an island in the stream of...tradition, and it is only with Tolnay and Baldass that common sense finally prevails. The former suggests that Bosch's father and grandfather were painters (we agree as far as the father was concerned; also, that

Bosch trained under him) and representative of the local school. Baldass recognized the parallels between Bosch and Geertgen tot Sint Jans as well as the Master of the *Virgo inter Virgines*. He also was aware of influences exercised by the international style from around 1400.

It must be stated here again that Bosch was a provincial painter, and that, as first suggested by Friedländer and later by Lyna, Hieronymus's second master was probably a manuscript illuminator, which explains his evident archaism. The research of Hammer-Tugendhat (diss.,1975) appears especially important in this respect, because she revives the recently contested separate identity of Hubert van Eyck as the Master of the Turin Hours (the so-called Hand G) and established Bosch's borrowings from him. Other masters from the southern Netherlands upon whom Bosch drew were Rogier van der Weyden and the Master of Flémalle. Hoogewerff (1936) must be praised for his insight in this respect. He sought Bosch's stylistic predecessors mainly in the southern Brabant and Cologne. We must add broader German regions to the painter's territory of appropriations. Martin Schongauer and the Master E. S. stand out among Bosch's quest for inspiration. This is true for his traditional as well as phantasmic works. We shall see such derivations subsequently, in the "Oeuvre" section, and observe the way in which the artist experimented with his stylistic allegiance, from one composition to another, without, strictly speaking, developing a proper manner of expression other than in a few externals. The rest belongs to the respective sources. If we add to the foregoing that the painter represented his subject matter by means of a bi-dimensional technique, ignoring the recent conquests of the Flemish school in the field of plasticity and mastering of the rendering of space, he indeed gives the impression of an archaizing artist, tucked away in his provincial township. The winds of progress touch his workshop, but cannot entirely blow away the cobwebs! Thus, Bosch was by no means a great craftsman. The technical innovations of his century passed him by, and what remains in this respect is an artist a level better than a folkloric painter of Madonnas for pious pilgrims visiting the cathedral of his hometown. There remains, of course, the appreciation of the content of his works, to which Bosch owes his reputation. This fame, as already mentioned, does not stem from traditional compositions, such as an *Adoration of the Magi* or an *Ecce Homo*. It entirely flows forth from the devilries for which he borrowed the building blocks as previously described. What remains—and it is enough to permit us to consider Bosch a great artist—is his power of invention in the combination of structure and assembly of these strange and bizarre elements. He made use of this infernal, and yet so believable rabble, as Lyna puts it, in large triptychs instead of simply confining it to manuscript illuminations where they eked out a marginal existence in the borders. The transposition of his monsters into the limelight, where they suddenly became accessible to the masses, was the equivalent for Bosch of building a better mousetrap; and the world beat a path to his door.

Bosch has not juxtaposed his fantasies in a haphazard mode. There was method in his madness, as opposed to his followers, who apparently were unable to decode his meaning. But as Panofsky succinctly put it, we do not seem to have discovered the key. We can definitively exclude all attempts to link him to one or the other heretic sect. The subsoil of popular art, with which Bax has connected him, furnishes some explanation. For the rest, he was, to quote Panofsky again, "one of those extreme moralists who, obsessed with what they fight, are haunted not unpleasurably, by vision of unheard-of obscenities, perversions, and tortures." It is true that certain allegories and certain symbols were understood by the

public of the period much more easily that in our day. The Church was during the Middle Ages very far from disregarding the educational possibilities of painting. The Synod of Arras had already decreed in 1025: "That which the illiterate were unable to learn by reading and which they cannot see in writing, it behooves that painting makes it manifest to them." Saint Augustine formulated his wishes on the subject in the following manner: "A thing notified by allegory is certainly more expressive, more agreeable, and more imposing than when one enunciates it in technical terms." However, from there to discover a hidden meaning in every detail, to want to interpret each attitude and each fantasy, puts a wrong construction upon everything, just like the unfortunate interpreters of Rabelais or the too-zealous commentators of the second part of *Faust* by Goethe.

Therefore, suffice it to admire the different facets of Bosch's art: in turn, realist, symbolic, and fantastic. For the amateur of verisimilitude, he magically produced shady landscapes that were the first to render nature truthfully. He was the father of this genre in the North, and Gerard David as well as Patinir must be ranked among his followers. The faithful were enlightened by the comprehension of the symbolic meaning of his works, which illustrate so magisterially the works of Saint Paul: "We do not have to strive against the enemies in flesh and blood, but against the princes of darkness, who, in the shade, command them" (Ephes. 6:10). And for the amateurs of the fantastic, how better to formulate the essence of Bosch's art but in the works of Viollet-le-Duc with respect to the gargoyles of Sainte Chapelle in Paris: "It is difficult to push further the study of nature, applied to a being that does not exist." (For much of the preceding, see Larsen, 1950.)

Oeuvre

We have already mentioned previously that we dispose there exist only twenty signed works, but that in only eight instances at the most can we accept these indications as apposed by the master himself. Our doubts are fortified by the writings of de Guevara, who, around 1560, warned in his *Comentarios de las Pintura*, "not only of false signatures [*falsamente inscripto*] but also of copies that were smoked in the fireplace to give them the appearance of age." We also owe to him the mention of a pupil among Bosch's followers, who, out of devotion to the master or with the intention of improving the likely acceptance of his own work, signed it with Bosch's name instead of his own (Marijnissen, 1987). We are therefore left with only five of the artist's paintings, which are attested to by sixteenth-century documentation—thus, not from his lifetime, but reasonably close so as to be regarded as strong possibilities (J. Folie, 1963). None of these, or any other paintings, are dated, the sole exception being a version of *The Cure of Folly* (original at the Prado, our Cat. No. 8), which appeared during World War II on the Brussels art market with the date 1516—the year of Bosch's death. I have since lost track of the painting. The date does not fit in with the artist's style in this painting—the original must stem from around 1475. Hence, it is quite possible that we are dealing with a later addition to the inscription, or a copy from the workshop.

The five paintings in question are:

1. *Christ Carrying the Cross* (our Cat. No. 11). Recorded in the inventory of paintings donated to the Escorial by Philip II in 1574.

2. *Adoration of the Magi* (*Epiphany*) (our Cat. No. 29). Listed in the same inventory as above as *Nascimiento de Christo*, and subsequently (1605) by de Sigüenza as *Adoración de los Reyes*. As stated in our apposite catalog entry, the triptych seems to be identified by a Brussels document from 1567 as the one initially belonging to the Bronchorst-Bosschuyse family, whose arms it bears. However, according to the document, the arms should appear on the outside and not on the inside of the wings, as is the case with the triptych now in Madrid. Marijnissen's explanation of the discrepancy is tenuous, and it may be possible that there existed two variants of the composition: one that found its way to Spain and became the property of Philip II; the other one, formerly in Brussels, having disappeared. Given the great productivity of the Bosch workshop, as well as the activities of his followers and imitators, this becomes another instance of the difficulties that confront the cataloger of his works.

3. *The Seven Deadly Sins*. Tabletop (our Cat. No. 5). First mentioned by Guevara (ca.1560), then in the 1574 inventory.

4. *Christ Crowned with Thorns* (our Cat. No. 13). There are different interpretations concerning the identification of the subject matter, and hence the question of whether they apply to this painting. At any rate, this work was included either in the inventory of 1574 or, at the latest, 1593. Unverfehrt traces its provenance back to 1526, via Lisbon, and opts for its acquisition by Philip II prior to 1593.

5. The Garden of Delights (our Cat. No. 31). First mentioned in the second inventory of paintings given by Philip II to the Escorial, thus in 1593. Its relatively elaborate description reads as follows: "A painting in oils, with two wings [thus, a triptych] depicting the variety of the world, illustrated with grotesqueries by Hieronymus Bosch, known as Del Madroño."

Aside from these five surviving works, there are a number about which we have knowledge from various documents, but that are presumably lost. All others are attributions. Their degree of authenticity depends entirely upon the credit that we allot to the possible author of a Bosch Catalogue Raisonné, whom we have consulted. Thus, for instance, we esteem the late Max Friedländer as the dean of studies in the field of the Flemish primitives. However, his major writings concerning Bosch date from the late 1920s, and his cataloging has therefore become subject to pruning. Art history, like any other academic discipline, changes now every five years, with new understandings coming to the fore, especially with respect to connoisseurship. The same restrictions apply to the catalogs of Tolnay and Baldass. Every author who now writes about Bosch is therefore on this own, concerning attributions and the sequence in which he ranges the oeuvre. Many compositions that we attribute to Bosch by common consensus exist in several variants. It again depends upon the individual scholar, whether he accepts one or the other version as the authentic work, or relegates all of them to copies or later workshop replicas. This becomes the more important, as we know that Bosch painted an almost abnormal number of his works on canvas. They were of the more decorative kind, and owing to the less onerous cost of production, the agglutinate being either water or gum or a mixture of both, and canvas being considerably cheaper than a good panel; such compositions were in great demand. Their technique was obviously that of the Flemish Waterscilders. The tempera was of a considerably different consistency than the Italian manner bearing a similar name, and their aspect could possibly lend itself to confusion with the soi-disant oil technique of the Flemish painters. One can reasonably suppose that all paintings identified in the Spanish catalogs, being the most

elaborate with respect to Bosch, were done on canvas. Justi (1889) cites altogether thirty-eight instances of works given to Bosch in the Spanish inventories. Of these, sixteen (!) were expressly designated as being on canvas (lienzo). Their number must have been greater still, because the indication of the support is lacking in numerous descriptions. Thus, when adding works described as on canvas, to those executed in tempera and the ones lacking a specific description of the support altogether, we conclude that the proportion of paintings, executed in the water/gum medium, must have exceeded more than 50 percent of the entire production. At present, all that has come down to us of such works consists of the ruin of a Christ Carrying the Cross formerly in the London trade, which we have mentioned in our catalog; and a Temptation of Saint Anthony, also badly damaged, formerly in the collection Czuczka in Geneva, which I have published some time ago (Larsen, 1950), and which I have omitted to catalog here, because the painting has disappeared from view and I would have liked to verify my judgment again. Justi (op. cit.) points out that by 1609, a number of Bosch paintings were replaced in the Spanish collections by copies in oil, which were probably more resistant to atmospheric changes and inclemencies of the weather. At the same time, one tried to save parts of damaged compositions by framing and hanging them on walls. The same author found that the 1772 inventory of the Castle of Buen Retiro speaks of a certain number of Bosch works among the Pinturas Maltratadas, or pinturas totalmente perdidas, arroladas, and declares them of no more value...inutiles.

The great loss and waste of Bosch's canvas paintings in the royal Spanish collections, previously alluded to, can probably be explained by the fact that when dust and dirt accumulated upon the surface of the paintings and tarnished their aspect, one more than likely washed them with water and alkaline products, such as was customary with oil paintings. What happened in Spain can reasonably be expected, having also occurred elsewhere. Even though we still possess an abundant surviving production of Boschian works, it is sad to imagine the number of treasures that fell victim to the cleaning broom of an army of overzealous housemaids all over Christendom.

In view of the absence of original dates on Bosch's paintings or documents to that effect, it fell to the various authors of Catalogues Raisonnés of the master's works to arrange them in a certain sequence. Most of the theses advanced up to the present in the pursuit of an acceptable chronology mutually exclude one another, though separately often being ingenious. In our opinion, Baldass's endeavors in this respect (1917, 1938, 1943) deserve our closest attention and are full of common sense. Our own proposition concerning this problem adopts some of the Austrian author's guidelines and leads to the following probable design in the master's artistic evolution: all paintings that remind us of the soft Gothic style, and by the faintly accentuated drawing of the folds of garments, and by the strongly raised line of the horizon, are to be placed at the beginning of Bosch's artistic career. In these works, the horizon draws very near the upper border of the painting and often even juts out beyond the composition.

Later paintings—and we have to consider a span of around forty-six years making up Bosch's career (about 1470–1516)—become more precise and drier in the drawing. The folds of the garments are crisper, the line of the horizon appears lower on the pictorial surface, and a cosmic landscape replaces the stretch of nature initially constituting the background of his first works.

This attempt at classification has the advantage of taking into account certain sources of inspiration, such as book illuminations harking back to the soft style around 1400, certainly pre-Eyckian. As far as Bosch's palette is concerned, the first comparisons between the soft style and our painter are due to a French critic, now almost completely neglected, by the name of Bertaux, who in 1908 had proposed theories for which modern scholarship generally credits Max Friedländer. *On ne prête qu'aux riches!* The Dutchman's evolving approach to landscape can be explained by his contact with the ideas of Renaissance theoreticians, such as L. B. Alberti. He therefore successively abandoned the archaizing patterns of expression of his early works, such as the several viewpoints of his perspective replaced by a single one, the landscape composed of building blocks in the style of Giotto, in favor of compositions in which the different strata flow one into the other, and in general, a structure that tends toward a realistic conception of nature.

It must be stressed that this process of change did not evolve on a curve. Paintings with new outlooks were certainly done at the same time as more archaizing ones. Borrowings from, for example, Rogier van der Weyden, were typical during Bosch's early years, such as in his *Christ on the Cross* at the Brussels Museum (our Cat. No. 7), which dates from about 1475. We encounter them again thirty-five years later in the Prado *Adoration of the Magi* (our Cat. No. 29), executed around 1510–15, this time in a work of ripe maturity. This intellectual Saint Vitus's Dance can be observed in the works of all great masters, with strides forward into the unknown, and then periods of standing still, reflection, and reaching backward toward the points of departure.

We can divide Bosch's evolution roughly into three periods: the early one, from about 1470 to 1480; the middle period, from about 1480 until 1500; and the last and mature one, from about 1500 to the master's death in 1516. There exists, of course, a certain amount of overlapping, but the indicated dates serve as approximate boundaries.

The ensuing catalog of the paintings deals with each entry separately. In the following pages, it is our intention to depict Bosch's artistic development in broad touches, thus designating characteristics as they come chronologically to the fore, technique and invention alike. Finally, we evaluate briefly the artist's position within his time.

The earliest known work by Bosch is the *Adoration of the Magi* at the Metropolitan Museum of Art, New York (our Cat. No. 1). Its composition is simple and naive, derivative, as we have repeatedly stated, from a Dutch conception. Geertgen tot Sint Jans appears to have been the particular source of inspiration for the patterns of the figures, while the landscape traces its origins to the Haarlem school. This is thus our first encounter with the master from 's Hertogenbosch, chronologically speaking. We see him as an artist seeking his path, not yet an independent personality, but possessing a level of very acceptable craftsmanship. His vision does not derive from a provincial school established in his hometown, as variously proposed by Tolnay and others, but from the form language of his great compatriots. There is also little influence of a putative master who is thought to have been a painter of manuscript illuminations. Such an influence could possibly be traced in the technique, which tends toward a flatter rendering than in the case of Flemish models, from which Bosch also drew inspiration during the same years, as we are going to learn from other works from the same period in his career. The *Adoration* does not seem to have been executed in the *alla prima* manner, but appears underpainted in tempera. Whether the finishing glazes were done with oil as a painting medium becomes very difficult to establish, in view

of the bad state of preservation of the work. It is precisely the more-than-average amount of damage sustained by most Bosch paintings—the Prado *Epiphany* being a laudable exception—that leads me to believe in the presence of a mixed technique (oil and tempera) for the execution of the upper layers of paint. Compared with the bodies of work by Bosch's contemporaries that have come down to us, no other artist's oeuvre has suffered so much from abrasion, fallout, and other injuries. Bosch's pictorial surfaces must therefore be particularly vulnerable, and the only common trait that comes to mind as a possible explanation is oversensitivity to moisture or humidity. Oil paintings done in the Flemish manner following the Van Eyck formula are generally well preserved. Bosch has obviously departed from the general norm in his specific application of paint. It sets him apart from his contemporaries, and it is in this modification that one possibly could acknowledge the influence of book illuminators, or better still, of the *Waterscilders*, who were numerous and influential not only at the time but until the late seventeenth century. One will recall that Jacob Jordaens made his debuts in this specialty and gained quite a reputation for himself before turning to oil painting. Basically, large paintings on canvas, done in the water/gum technique, were cheap replacements for the more costly tapestries. Such an artist could certainly have been active in 's Hertogenbosch toward the second half of the fifteenth century, and have taught the young Hieronymus the tricks of his craft and painting techniques. It would explain, perhaps more adequately than book illuminators, Bosch's predilection for paintings on canvas, and hence his very individual technique.

Aside from Dutch source material, German artists exercised considerable influence upon Bosch's compositions. In his panel representing *Christ Shown to the People* (*Ecce Homo*) at the Stäedelsches Kunstinstitut in Frankfurt am Main (our Cat. No. 4), the dependence upon the Schongauer engraving at the Brussels Print Cabinet dealing with the identical theme becomes evident. There is also an anonymous woodcut from the middle of the century representing the same subject, as well as a Dutch drawing from around 1480 at the Berlin Print Cabinet. We owe these latter references to Combe, and Tolnay points to connections with the work of the Master of Flémalle and concludes that Bosch's composition must be based upon a lost work by the Flemish painter. In any event, we see Bosch, like the young Rubens, borrowing from multiple sources in the quest for his own personality. Interestingly enough, this is the first instance in which contortions like the grimacing heads are coming to the fore, which express the anger and evilness of the mob. Are they paraphrases of Leonardo's caricatures, or copies from masks worn by participants of religious processions or connected with representations of Passion Plays? One does not know, but the fact that the young artist turned from his beginnings to such expressions of distortion and twisting is indicative of his later bent for devilries and phantasmic creatures.

The next step in these evocations of the irreal is to be encountered in the tabletop with the representations of *The Seven Deadly Sins* at the Prado, Madrid (our Cat. No. 5). Contrary to traditional representations of religious scenes during this part of his career, we encounter in these roundels a coarser and peasantlike manner, and in the rendering of the figures and in the scenery. Just as the composition of the tabletop is unusual for the period in painting—although previously known from prints and miniatures—so is the manner of execution. These figures are quite familiar from minor Gothic cathedral sculpture, as we encounter them in the capitals of the columns or, in Saint John at 's Hertogenbosch, sitting astride the buttresses supporting the roof. But they had never before found their place and appearance

in panel painting. Hence, Bosch's first attempt at such new visualization made great demands upon his craftsmanship, and the result is perhaps less than entirely satisfactory. Consequently, some critics were rebuffed by evident weaknesses in the draftsmanship and modeling, and either proposed that the artist followed archaic methods, or attributed the painting to the workshop. In fact, we must take into account that the artist created with this work a new genre for panel painting. He soon overcame the initial obstacles, and as we shall see in subsequent creations featuring a similar approach, soon became extremely proficient in expressing himself in this original manner.

Witness his *Extraction of the Stone of Madness* (*The Cure of Folly*), Prado, Madrid (our Cat. No. 8). As in *The Seven Deadly Sins*, the figures appear crude, boorish, and ungainly. However, when examined in the original, Bosch's technical execution has visibly improved, and the faces have become considerably more expressive. The artist has accustomed himself to his new manner, and relaxes in handling and fitting these forms into the visual conception. Some critics are still reluctant to accept this facet of Bosch's art (e.g., Gibson, 1973) but feel constrained to state that only Bosch could have been responsible for the landscape background whose delicately painted forms recall the vista in his early *Epiphany* (our Cat. No. 2). The reader may rest assured that a thorough visual interrogation of the original brought us to the conclusion that one and the same artist has painted this fine little picture. The high horizon of the landscape confirms our early dating. Finally, the figures, done in a translucent technique that permits the identification of the subjacent drawing in many parts, fit in with the peasant style, of which we must now recognize Bosch as the father and initiator, and which has become an archetype with Peter Bruegel the Elder. In the case of the latter, this style has been accepted without further protest, because it constitutes Bruegel's language of forms throughout, hardly any better or more refined in quality than his forerunner. Bosch had to grope and proceed tentatively in his first endeavors. They are nevertheless unequivocally his. He featured this mode of expression when it came to representations of proverbs, castigation of human folly, and the like, while maintaining a more idealistic and elegant manner of rendering mankind when depicting religious scenes. It is this dichotomy (absent or rare in the work of the Elder Bruegel) that has led many critics astray when trying their hand at Bosch connoisseurship.

The master of 's Hertogenbosch did not spare the religious orders when it came to castigating their sins of commission and omission. In *The Cure of Folly*, the sole presence of a monk and a nun in the composition constitutes an unfavorable allusion to a possible conspiracy with the quack operating on the stupid patient. In the middle years of his career, Bosch continued the satirical representation of a group of a monk and two nuns in the *Ship of Fools* (our Cat. No. 52), which survives in a copy at the Louvre only. Essentially, the painting's aim is to serve as an exposé of the excesses of the clergy, who are here depicted as carousing and otherwise giving themselves over to lust. The peasants seen in their company have obviously been suborned by the religious, who should know better, to participate in their transgressions. The fact that interests us here in connection with our preceding statements is that Bosch has again used the particular idiom of the peasant style to give vent to this anger. El Greco used elongation and normality to separate the celestial from the terrestrial. Bosch had invented the peasant style to serve as his medium for interpreting temporal affairs.

Aside from Dutch and German sources, Bosch borrowed frequently from the Flemish

masters to the south of his hometown. Tolnay had already pointed to the Master of Flémalle as a possible inspiration. In *Christ on the Cross* at the Brussels Musées Royaux des Beaux-Arts (our Cat. No. 7), Bosch closely followed in the tradition of Rogier van der Weyden, especially in the figure of Christ and those of the Virgin and Saint John, to the left of the cross. Unfortunately, the painting had to be extensively restored, which accounts for the so-called archaisms of certain parts. Otherwise, the Flemish filiation would appear still more evident. The exception is the landscape, which belongs to Bosch's own inventive aptitude. In its magnificent development and *sfumato*, we see the artist stepping outside the patterns of the Haarlem school. We can follow them, for example, in the backgrounds of Dierik Bouts; and witness Bosch's very own approach to the realistic rendering of nature.

We have thus seen from a few examples, that Bosch, during the first and earliest decade of his career, attempted to find his own style, and during this search, borrowed patterns and motives from various sources (German, Dutch, and Flemish): his Dutch almost-contemporary, Geertgen tot Sint Jans; the German engravers Schongauer and Master E. S.; and the Flemish Master of Flémalle and Rogier van der Weyden. All can be identified as principal influences. Bosch's painting technique, his contributions to landscape painting, and his adoption and development of a colorful and coarse peasant style can all be counted as major personal achievements of these early years.

Around 1480, we first encounter the phantasmic creatures that were responsible for our artist's international reputation. They had existed for many centuries in the illustrations of bestiaries, the margins of book illuminations, and narratives of travels—real and imaginary. In the Vienna *Last Judgment* (our Cat. No. 14), they appear for the first time on the panels of a large triptych. Henceforth, Bosch features these creatures on most of his works, on wood or on canvas; and thereby stresses the moralizing side of his painted sermons, and instills fear in the souls of the beholders. It was to his merit that he pictured these gruesome composites in a manner that rendered them accessible to the broad public, and by that means popularized the terrors and shudders inherent in their loathsome forms. Hell has never seemed so awful as translated into Boschian terms; and the spectators, be they prince or peasant, returned to their homes duly impressed by the preordained consequences of their sins. Even in our day, Bosch still exercises an attraction upon the masses, which can only be explained by the strange titillation of his inventiveness. As I have previously stated, Bosch's compositions were the equivalent of a *Jurassic Park* for believers in Roman Catholic doctrine.

The Vienna *Last Judgment* is composed of three parts, which have to be read from left to right. It begins on the left shutter with the Garden of Eden, leads to the center panel with the Last Judgment, and finishes on the right shutter with Hell. The work dates from about 1480–82, and differs considerably in style from what we have seen by the master during the preceding years. Let us first consider the figures in the Garden of Eden. Up to now, they were either done realistically, as in traditional religious scenes, in imitation of known conceptions—Dutch, Flemish, or German. Or they were executed in the peasant style, when the subject matter was linked to proverbs, parables, and the like. Here, the figures are small, elongated, and almost manneristic, harking back to the conceptions of the international style preceding the Van Eyck brothers, or even more to the manuscript illuminations of around 1400. Thus, there is none of the force and vigor that characterizes, for instance, *Christ Carrying the Cross* in the versions at Vienna and the Escorial (our Cat. Nos. 9 and 11),

or *Christ Mocked* at the London National Gallery (our Cat. No. 12). The figures are almost diaphanous, irreal, and incorporeal. One cannot escape the impression that Bosch used them not as human figures in their own right, but as a kind of abstract pictorial alphabet by which he merely indicates the presence of, say, Adam or Eve, or in hell, the damned souls being punished and shown in their nakedness. Mankind has become an array of dolls, deprived of actual existence and relegated to the supernatural, or simply used as generic signs, and only in special cases going so far as to proceed with a protracted identification. This is the case with Adam and Eve, or with the angel expulsing the pair from paradise. In the center panel and the right wing—hell—the representation of the figures shrinks to the general concept of sinner, without any further individualization. And this part of doomed mankind is shown to us in the form of nude mannequins. It is the tortures and torments to which they are exposed that are important to Bosch. For him, the humans are simply the victims of their sins, receiving just punishment. However, the manner in which they are being dealt with remains that of an irate Moloch rather than that of a compassionate higher being.

This is also the first time that we encounter Bosch's devilries. There exists a tondo with the representation of hell among the scenes of the tabletop of the *Seven Deadly Sins*. However, we assume that we have here a later addition, whose date cannot easily be ascertained. It might very well have been an addendum appended even later than the execution of the Vienna triptych. Bosch introduces us here to the part of his imagination that earned him the epithet *faizeur des diables*.

These phantasmic creatures are the most salient aspect of Bosch's dreamworld. We have already stated that they are not entirely products of the artist's own invention, but rather compilations of, and combinations of parts of models, that he had pirated from diverse sources previously alluded to. There existed, of course, no copyright at the time, and the painter was completely free to borrow and adapt to his heart's content. His subject matter was primarily demons or devils that are basically anthropomorphous. They are known to the spectator from earlier representations, and therefore familiar. Starting from traditional forms, the artist enhances them with attributes borrowed from elsewhere, or combinations with frightening beasts, to construe them into composites that inspire terror and constitute the logical antagonists of the humans delivered to their tortures. They are players in an infernal game. Bosch denies individualization to the sinners and endows their devilish counterparts with marked distinguishing features. One finds them again and again in all the painting that, starting around 1480, depict the horrors of the Inferno: in Venice, Vienna, Lisbon; and the various Temptations of Saint Anthony, Saint Christopher, and other saints. As Heidenreich (1970) stated appropriately, Bosch's demons appear in human shapes "and...form the pandemonium of human society." As for humans themselves, Bosch attains his most impressive effects by turning them into passive objects of actions otherwise performed by them upon others. Unverfehrt (1975) cites a number of examples, such as man as quarry; a woman becomes a mount; mortals are being carved up like venison. Thus, Bosch depicts a topsy-turvy world in which the relative values are reversed. Humans become things, objects to be used and abused. The devils and demons, often in conjunction with elements of the fauna and flora, go about their business and lustily torture the unfortunates that have fallen into their hands. What attracts the attention of the broad public still today is the verisimilitude of the happenings, the naturalness, and the fact that these creatures are only supernatural up to a point. One does not need a tremendous imagination to accept the

possibility of their actual existence. Bosch takes the real and manipulates it just enough to render it horrifying, but not beyond the point of instant recognition. In other words, he remains within the realm of a reality that by being only moderately pushed into surrealism still vaguely remains attainable or imaginable. Bosch admonishes the beholder, he sermonizes him, and instills sufficient fear so that eventual repentance might ensue. It is the mixture of all these reactions and sentiments aroused by the painter that explains his popular success.

Aside from the anthropomorphous creatures that fill his paintings, there are the zoomorphic ones: beings that are formed out of animal combinations, with some parts exaggerated in their proportions, so as to appear unnatural and weird. For instance, a rat becomes a mount; out of a fruit breaking open escapes a multitude of demons; living bodies, as well as inanimate objects, grow into gigantic shapes (for further examples, see Unverfehrt, 1975). Bosch fills his compositions with these devilries. Unlike his followers, he has no voids in his paintings. Everything is grouped together, in a colorful and lively pell-mell, until the relative calm of the landscape background is reached. The latter, in assimilation to the archaic mode of composition of the painting of this category, does not fit into the structural evolution of the genre, as sketched out by us previously. When we contemplate, for instance, the left panel of the Vienna *Last Judgment* triptych, Paradise, we observe that the landscape is composed of building blocks that are separate and individualized. Bosch has inserted them according to need, and constructed the scenery in the manner of a theater stage. He follows there the lessons of Giotto, and subordinates in the fashion of his great forerunner the realism of nature to the action. Bosch's new conceptions of landscape art come to the fore only in paintings, which themselves are conceived according to new artistic trends, such as the modern Renaissance style. It is in those paintings that he reveals himself as a definitive innovator.

As previously stated, the demoniac in Bosch's oeuvre constituted a subordinate motif only during his youthful years, gaining in importance afterward, until finally becoming the chief center of interest. His realistic manner of juxtaposing heterogeneous details that appear perfectly genuine, inventing beings that are horribly possible and repulsive at the same time, begs the question whence such an oddity that is so little Netherlandish has crept into the Dutchman's artistic vocabulary. We are aware of the sources, but until Bosch, no one else in the Low Countries had elected to attach any exaggerated importance to devilries and make them the subject matter of large paintings. One can presume that the adjacent German regions were more fertile sources for Bosch's fantastic and bizarre imagination. As I wrote almost fifty years ago, "Bosch is like a tree planted at the crossing of territories that are adjacent but dissimilar. His roots dip deeply into the humus to extract the most diverse essences. He is Flemish by the color scheme; Netherlandish because of the characterization of his models and love of nature. It seems to us that the satirical and extraordinary aspect of his personality could be traced back to his German ancestry." By satirical, we do not mean the Flemish humor and practical jokes of Till Eulenspiegel and the Elder Bruegel, but the deeply pessimistic aspect of Bosch's approach, where caricature and joke degenerate into malicious pleasure and gloating about the misfortunes of others.

Starting in the 1480s, Bosch's interest in the temptations of various saints began to crystallize. We shall lay specific stress on those of Saint Anthony, because they were the most numerous, and have been treated by the painter not only in small panels but also in

the format of important altarpieces, and because Bosch seems to have devoted a great deal of attention to this particular saint and his afflictions. The reasons for Bosch's particular devotion to the Saint Coenobite are not clear. Perhaps a House of the Order of the Hospitallers of Saint Anthony commissioned a first painting from him and the artist persevered, and perhaps because the genre was a success with the public. In any event, hereafter a few words concerning the life of the saint and the causes for the revival of his cult in the Occident toward the end of the Middle Ages.

According to Saint Athanasius the Great (ca. 293–373), a Syrian bishop and church father who was the author of *a Vita Antonii*, written a few generations after the saint's death, the subsequent Saint Anthony was born about A.D. 150 in Coma, a locality in Upper Egypt, into a family of well-to-do burghers. One day, he entered a church and heard there the words of the sermon: "If you desire to be perfect, go and sell your goods and give their proceeds to the poor; come follow me, and you will inherit the treasures of heaven" (Matt. 19:21). The *Vita Antonii* minutely relates the diverse stations of the monkish life led by Anthony, first in towns and villages, later in the solitude of the wilderness. In the end, hives of cells, formed by his disciples, were grouped around the saint's abode, who, because of his growing renown, had taken over the lead in his capacity of their natural chief. Athanasius devotes important passages of his narrative to the snares that the devil scattered on the path of the pious hermit to cause him to swerve from the right way that Anthony had marked out for himself. According to Satan, the desert was his incontestable domain, and he was not of a mind to tolerate the incursions of the saint. He therefore tried to gain him over by lust, lewdness, and the promise of powers never to be surpassed. Then, having exhausted all other means, he would use brute force and the instigation of fear. The adventures were the principal subject of Bosch's illustrations and depict the saint steadfastly repulsing all attacks of the evil one.

Saint Anthony retired toward the end of his life to a hermitage at the shore of the Red Sea, which was called the Inner Mountain, and died there at the approximate age of 150 (!) years. There are two traditional explanations about what happened with the remains of the saint. According to the Eastern one, his disciples shrouded his body and buried him in a secret vault. The remains were recovered in A.D. 561, transferred to Alexandria, and there deposited in the Church of Saint John the Baptist. Later, the bones were laid to rest in Constantinople.

A different tradition pretends that Geilin II, count of the Dauphiné, found in the eleventh century the bones of Saint Anthony in an abandoned church near Constantinople. Emperor Constantine VIII made the Frenchman a gift of the remains, and Geilin brought them back to his Castle of de la Motte-au-Bois in the Dauphiné. The parish church of de la Motte became the depository, and the locality was from then on known as Saint-Antoine. In 1083, the church of Saint-Antoine and four churches contiguous to it were given to the Benedictine monastery of Montmajour, near Arles. Their abbot forthwith dispatched a number of monks to found a priory of Saint-Antoine de Viennois. From this moment on, the locality became a center of pilgrimage. Those who were primarily seeking recovery were suffering from an illness called the fire of Saint Anthony during the Middle Ages. The contemporary medical explanation for the cause of the disease points to a fungus, *claviceps purpura*, that attacks and poisons grains of rye. These grains are then called "spurred." The pilgrims prayed to Saint Anthony to preserve them from cholera and plague, the two great

pestilences of the fifteenth century, and also from fire and conflagration, apparently under a misapprehension concerning the nature of the fire of Saint Anthony.

Gaston, lord of the Dauphiné, and his son Guerin took the initiative and founded an Order of Hospitallers of Saint Anthony. Their purpose was at first to lodge the pilgrims and maintain the hospital where the incurably ill were attended. During the twelfth and thirteenth centuries, the Order spread, and houses rose in the principal Christian parts of Europe, as far as Constantinople, Acre, and the island of Cyprus. The miraculous cures obtained by the Hospitallers and the importance assumed by the Order led to friction with the Benedictine monks of Montmajour, from whom the priory of Saint-Antoine de Viennois was still a dependency. Finally, the Hospitallers expulsed their rivals *manu militari*. Their coup-de-main was sanctioned in 1297 by Pope Boniface VIII, who also converted the Hospitallers into the Order of the Canons of Saint Augustine. They remained so until 1775, when they were in turn absorbed by the Knights Hospitallers of Saint John of Jerusalem, better known as the Knights of Malta. Apart from the *Vita Antonii*, there existed a number of other manuscripts and writings devoted to the life and adventures of Saint Anthony.

Among them, the *Legenda Aurea* counts as the most important, to the point that we still possess around five hundred manuscripts of this work that were written prior to the invention of printing. Emile Mâle has written that "it suffices having read the *Legenda Aurea* to explain all the bas-reliefs and almost all legendary stained-glass windows that ornament our cathedrals." We may add that other subject matter is also expounded in the work, such as legends of the saints.

Considered from the iconographic standpoint, the physiognomy of the saint varies considerably, according to the institution that sheltered his cult. There are Occidental and Oriental interpretations, which differ basically from each other. The Occidental image, which is the only one that interests us in this context, bestows the following familiar attributes upon the saint: the big staff upon which he used to lean; the pig—which is explained as derivative from a police privilege in favor of the Order of Saint Anthony; and the cross in *tau* form. When the urban circulation was reformed in the locality of Saint-Antoine, the pigs of the hospitals belonging to the Order were the only ones exempted from restrictions and were allowed to roam freely, wearing as a distinctive sign a small bell hanging from a ribbon around the neck. Later, the saint and the Order became associated in the popular imagination, and the former's image was adorned and enriched by two iconographic attributes: the familiar animal and the small bell, which he henceforth holds in the hand.

Finally, the cross in *tau* form has been the object of several attempts at explanation. The most likely is, in my opinion, the one that identifies it with the crutch of the infirm patients, stylized for heraldic usage in the coat of arms of the Order. It appears as such in an illumination in *Le Livre d'images de la Vie de Saint Antoine*; in the armorial bearings above the portal of the monastery of Saint Anthony, which read *d'or a la croix en tau de sable*; and also upon the panel of the Museum of Valenciennes (our Cat. No. 36, verso). The ardent fire—a derivative of the bodily ailment—becomes, through transposition of its primitive meaning, the attribute designating the saint as recognized protector against conflagration and fire.

The abundance and reputation of Bosch's representations of Saint Anthony make us often forget that other artists of the fifteenth century, prior to the master of 's Hertogenbosch, had shown an interest in the miraculous life of the hermit. Van Eyck painted him in

the guise of a penitent in a monk's dress of baize. Hugo van der Goes represented him on the Portinari altarpiece, the little bell in hand. Memlinc showed him on the Chatsworth altarpiece, with all his attributes, including the pig. We find him also in book-illuminations, such as *the Breviary of Philip the Good*; and the illuminated manuscript *Le Livre d'images de la Vie de Saint Antoine*, which exists in two versions (Florence and La Valette) and dates from 1426. Finally, we know from diverse archival documents that various Houses of the Order of Saint Anthony customarily commissioned large paintings on canvas with representations from the life of the saint. Thus, the London House of the Order (at Threadneedle Street) owned, according to an inventory from 1499, two such painted canvases ("II stenyd [stained] clothys to hange above the churche, one of the lyffe of Seynt Anthonye. And another of the Invencion").

It is therefore not to be forgotten that Bosch himself also received such commissions, which, because of the fragility of both the support and the painting technique (gum/watercolor), have not survived. We are familiar with such losses from the Spanish royal inventories, but given the relatively great number of Saint Anthony temptations that have come down to us from the master's hand and the workshop, commissions from the House of the Order appear plausible in the context.

As we have enumerated whatever compositions seem close to the artist in our catalog, it would be redundant to examine them again in this part of our study. Suffice it to state that Bosch seemed to deal with the subject in different approaches during most of his career—starting with the earliest known versions at the end of his first period (ca. 1480) and continuing until his last years. The most important treatment remains the altarpiece at Lisbon (our Cat. No. 28), which, as I write there, can be considered "the synthesis of the artist's numerous attempts at interpretation."

There are two other Bosch compositions that stand out by their originality. The first is *The Hay Wain*, stemming from the artist's middle period (our Cat. No. 18, ca. 1485–90) and portrayed on the center panel of a large triptych. These were the years, as well as the first decade of the sixteenth century, when Bosch's imagination reached its peak of fertility. It does not necessarily mean that the artist produced renditions that were previously entirely unknown as to form or content. Bosch's genius manifested itself in his facility for adaptation in a manner that had not formerly been applied to painting on panel or canvas, but can possibly be traced back to other classes of the fine arts. Thus, ideas current in the intellectual sphere were made use of by Bosch in fresh and different garb. He also did not disdain archaic forms to enshroud such venerable thoughts or proverbs, so as to lift them out of the present into a generally valid conception.

The main theme of *The Hay Wain* is based on an old Netherlandish proverb: *"De Werelt is een hoilberg; elk plukt ervan wat hij kan krijgen"* (The world is a hay pile; everyone plucks from it what he can get). Some authors quote from diverse passages of the Bible. There is, however, a consensus that the hay signifies an allusion to the transitoriness of all things temporal. For the realization of the concept, Bosch has reached backward. He executed the work in an unusual proportion—great height against narrow wings, which thereby seems merely to serve as framework. The center looks, as Tolnay remarked, like a miniature between its ornamental borders. The composition features numerous small figures, customary during the first half of the fifteenth century, and having disappeared since. We find them among others in the *Carrying of the Cross* by Jan van Eyck (copy at the museum of Bu-

dapest), the two wings with representations of Golgotha and the *Last Judgment* by Hubert van Eyck at the Metropolitan Museum, New York; and the Turin miniatures, by the same artist, at the Palazzo Madama. The shape of the nudes (see especially the inner side of the left wing) also conforms in conception with the international style around the turn of the century; they are slim and elongated, forerunners of the sixteenth-century mannerism. Bosch made use of this archaizing approach in several other works of smaller size from the same period. But it is their employ in this important triptych that characterized a new tendency linking progressive ideas with old-fashioned manners and ways of execution.

The second work that stands out, dating from the end of Bosch's career, is the triptych *The Garden of Delights* (our Cat. No. 31). Here, too, the imagination of the artist stands out in a representation that varies from the usual choice of subject matter in the program of his contemporaries. Love gardens were not unknown in medieval literature or painting. However, at the time of Bosch's activity, such scenes were scarce on large-scale paintings, although occurring with a certain frequency in engravings and book illuminations. Exceptionally, we encounter an erotic bathing scene in the oeuvre of both Jan van Eyck and Han Memlinc. Bosch's composition is without rival as to the extensiveness of the treatment, the number of independent scenes of which the collective whole is made up, and the variety of small figures that the artist has used to describe the substance of the dream depicted here. The two shutters with the Garden of Eden (left) and Hell (right) complete the inherent sermon. Reading from left to right, we are confronted with the beginning and the end of original sin. Bosch has given full scope to his fertile imagination in this painting. There is no known literary source for the composition, and we must thus infer that we have here an outcome of the painter's erotic fantasy—a free play of this creative sexual imagination. Again, the forms of execution hark back to the earlier traditions of the beginning of the century, and the content has evolved with an almost Surrealist freedom.

During the last thirty years of his career (ca. 1485–1516), Bosch created a number of compositions, mainly of smaller size, that are new in the same sense as these two large altarpieces. We find them enumerated in our catalog, which follows, where their respective claim to originality in the conception is each time stressed.

It is now time to sum up Bosch's personality and place among the great ones of Netherlandish painting during its first heyday period —about 1400–1550. We would do best by first saying what he was not. He was not a loner, and he was not an island among his contemporaries. On the contrary, he drank from all possible sources in his hometown, which was at the crossing of the German, Dutch, and Flemish zones of influence. He was most probably taught his craft first by his father, a painter like himself, and perhaps the descendant of a whole family of painters hailing from Aix-la-Chapelle, if we are to believe Tolnay. Further training was probably provided either by a book illuminator, a *Waterscilder*, or both. Bosch's technique, such as we can determine it from his successive paintings, was not an invention worthy of a genius, as often asserted, but simply crude and simplified. His draftsmanship was more than adequate, but his painting technique remained elemental and bi-dimensional all his life. He never succeeded in mastering the plasticity in execution of his great contemporaries, such as the Van Eyck brothers, Rogier van der Weyden, or the Master of Flémalle. One could assert that he did not wish to emulate them in their delicacy and conquest of the third dimension. But it would seem to us that, not having been trained in the famous Flemish manner—much admired in Italy by the school of Naples (Colantonio)

and by Antonello da Messina, who journeyed to Flanders to learn this art in the studio of Rogier van der Weyden—Hieronymus Bosch adapted the content of his works to the execution with which he grew up. Hence, his bent for rusticity and droll figures, for whose rendition a roughhewn painting style was appropriate, and which made him the forerunner of Pieter Bruegel the Elder.

We have already set forth Bosch's various styles: from his traditional manner to the phantasmic creations to which he owed the attention of collectors and the general public, and finally his reputation. He was never a great innovator. For the first category of his works, he heavily leaned upon the great Flemish, and occasionally upon Dutch, contemporaries. As for his devilries, they are no more than large-scale borrowings from medieval intellectual property, transcribed and transformed according to his own imagination, the novelty being the transfer of such forms and symbols out of book illuminations and engravings onto paintings on canvas and panels of considerable size. Thus, what was hitherto reserved for the study of scholars or basically literate people became suddenly available to the public of the faithful, who thronged to the churches to be instructed, filled with fear and titillated by untold horrors that were in store for those who persisted in a life of sin. It was Bosch's basic idea of making all these weird forms and their significance available to all and sundry that became his great contribution; or, as already stated, his better mousetrap. As an artist, he was aware of a wealth of forms from which he could choose, and which he could also revise, retouch, and put together like a puzzle in a variety of patterns. His prototypes were as old as the bestiaries following Alexandrian inventions of the second century, book illuminations, illustrated travel accounts, and Chinese influences in the sculptures adorning the capitals of Gothic churches, such as Saint John in his hometown. Bosch was talented enough to become an excellent compiler. He also imbued his works with ultimate meaning, drawn from the Bible or the Apocrypha. This was in opposition to his followers, whose paintings featuring the kinds of creatures brought into fashion by Bosch did not further infuse them with any kind of spirituality. One has to wait until Pieter Bruegel the Elder to find a new purport in the great successors' drolleries. Aside from Bosch's familiarity with theological writings, he also seems to have been acquainted with the literature of antiquity, especially books interpreting dreams, which were then widely available. Bax proposes that he was even a member of the local Rederijker Society, which seems more probable than Unverfehrt's thesis, that he had first obtained the degree of Magister at a university before starting a painting studio on his own, as late as in the beginning of the 1480s! A similar proposition, that Rogier van der Weyden, alias Rogelet de la Pasture, was by 1426 invested with a master's degree because he was by then mentioned as Maistre in an official document of the city of Tournai, has also become bereft of all credence.

Hieronymus Bosch appears different from his contemporaries in that he was not a towering figure of overpowering genius. We are attracted to him because his style was archaic and provincial compared with, say, a Gerard David, a Quentin Massys, or a Geertgen tot Sint Jans. He aroused curiosity and drew the attention of large strata of the public as well as of more sophisticated connoisseurs, then and now, on account of his choice of subject matter in a great part of his oeuvre. We can compare him, in this respect, with the Dutch seventeenth-century landscape artist Frans Post, who would never have been but an honest painter of the Haarlem school, far beneath a Jan Van Goyen, for example, if he had not obtained the chance to accompany Maurice of Nassau to Brazil. Henceforth the recognized in-

terpreter of this exotic land, he enjoys a reputation that far exceeds his purely artistic quali-
ties. The same holds true of Bosch. Had he only painted in the traditional manner, he would
today rank only as one of the numerous good artists of his period—certainly talented, but not
of major importance. It is said that a man needs only one outstanding idea during his life-
time. Bosch brought devils, demons, and fantastic creatures to the broad attention of
mankind—and no one will ever forget him for this stroke of insight into the public's wishes.
Were he still alive, Hollywood would be on its knees before this marketer of genius!

Color Plates

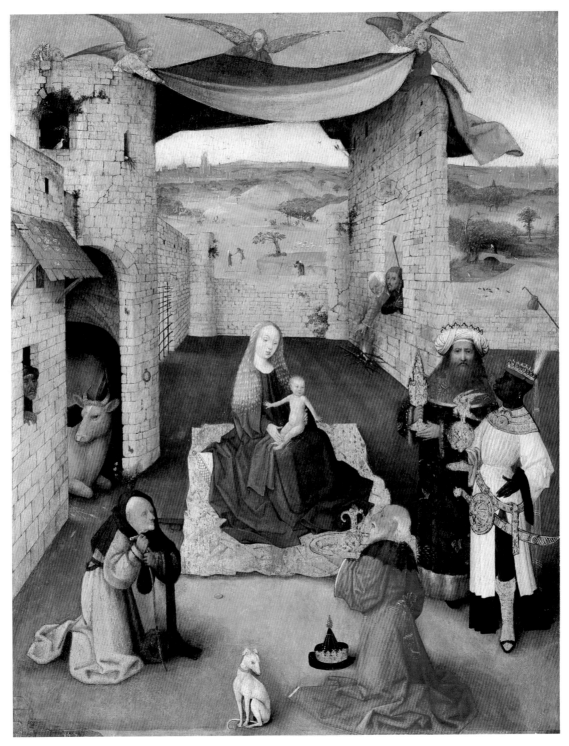

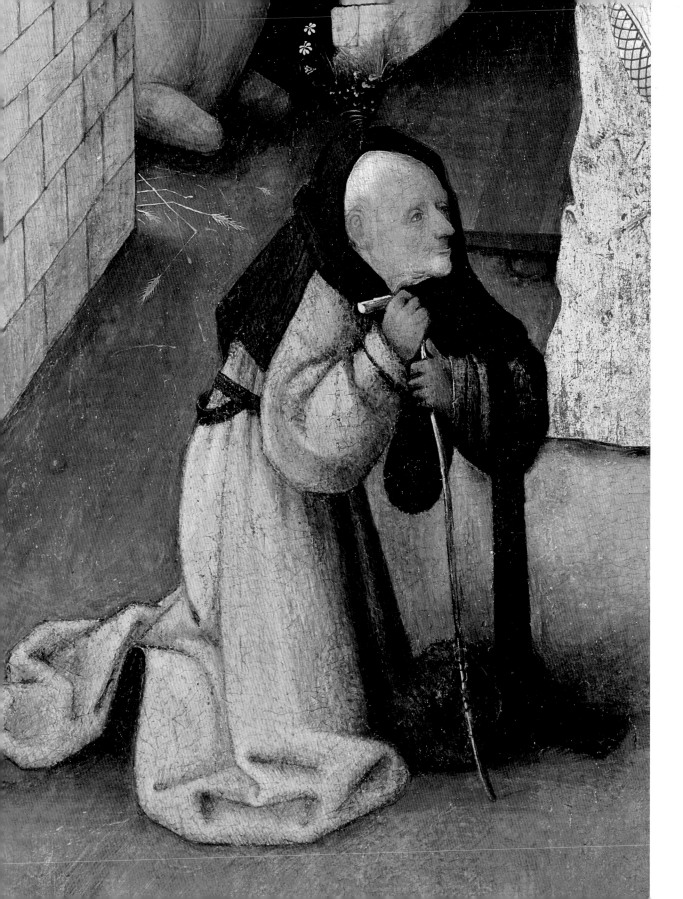

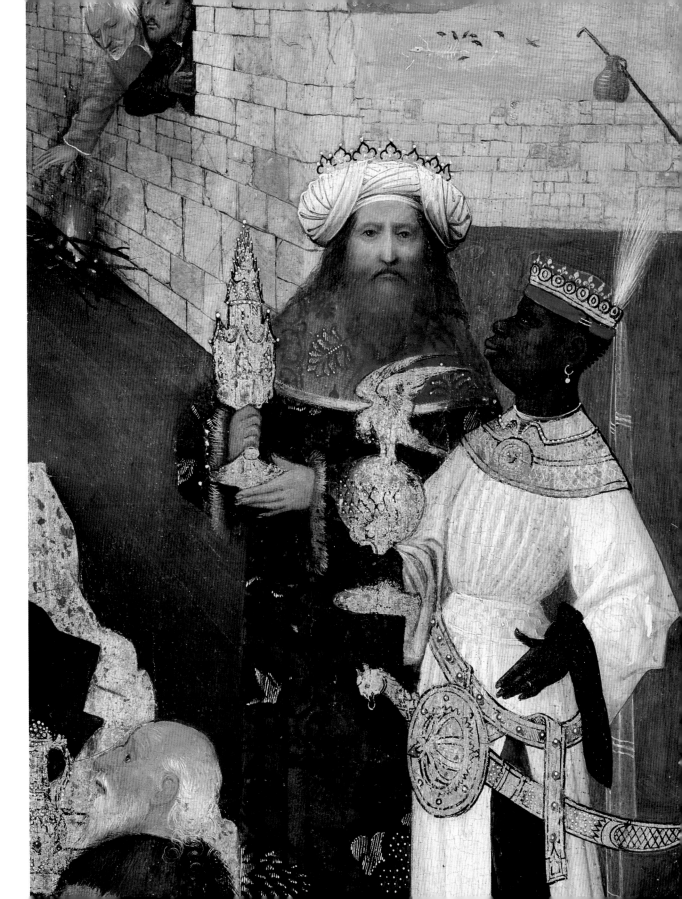

The Epiphany (Adoration of the Magi)
Philadelphia Museum of Art
[cat. 2]

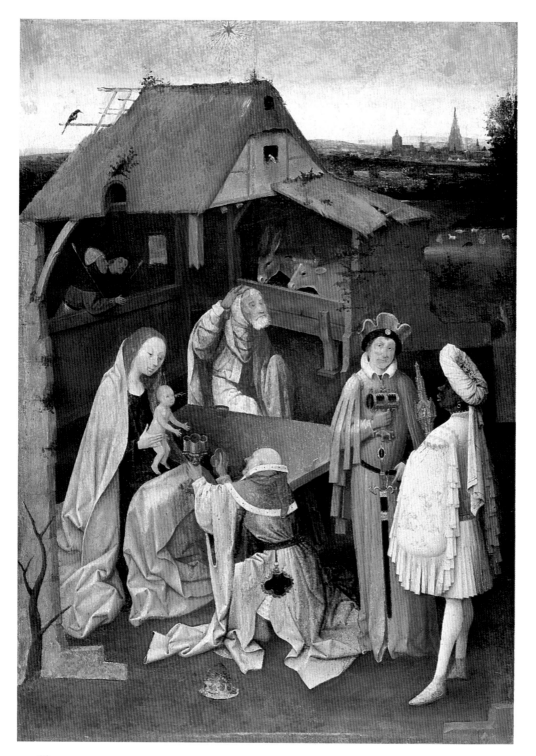

Madonna
Private Collection, United States
[cat. 3]

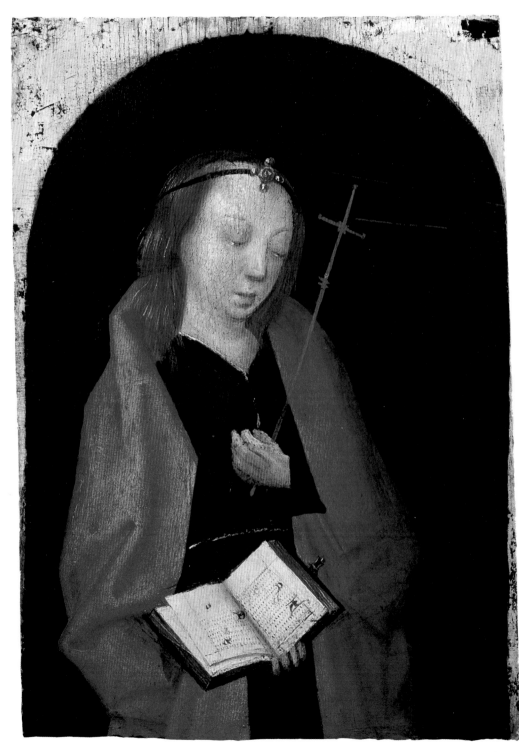

The Seven Deadly Sins
Museo del Prado, Madrid
[cat. 5]

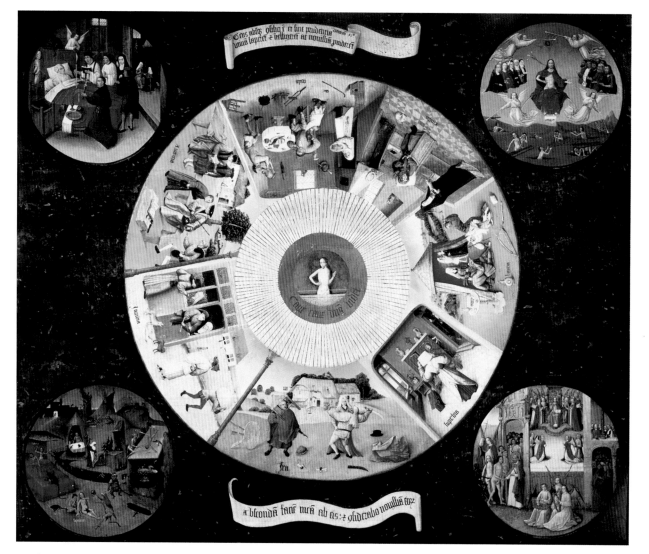

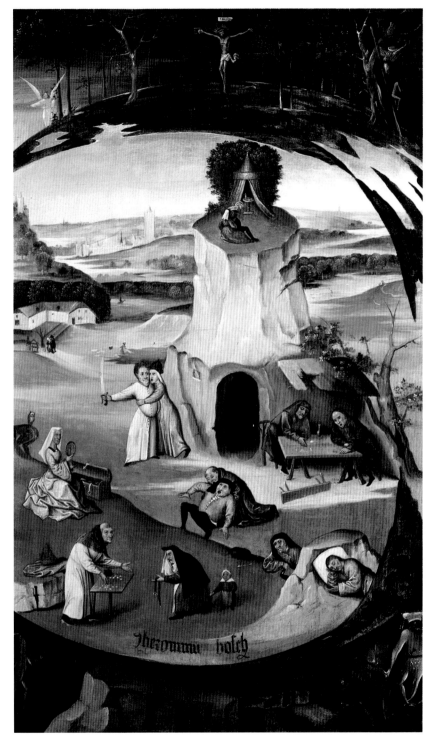

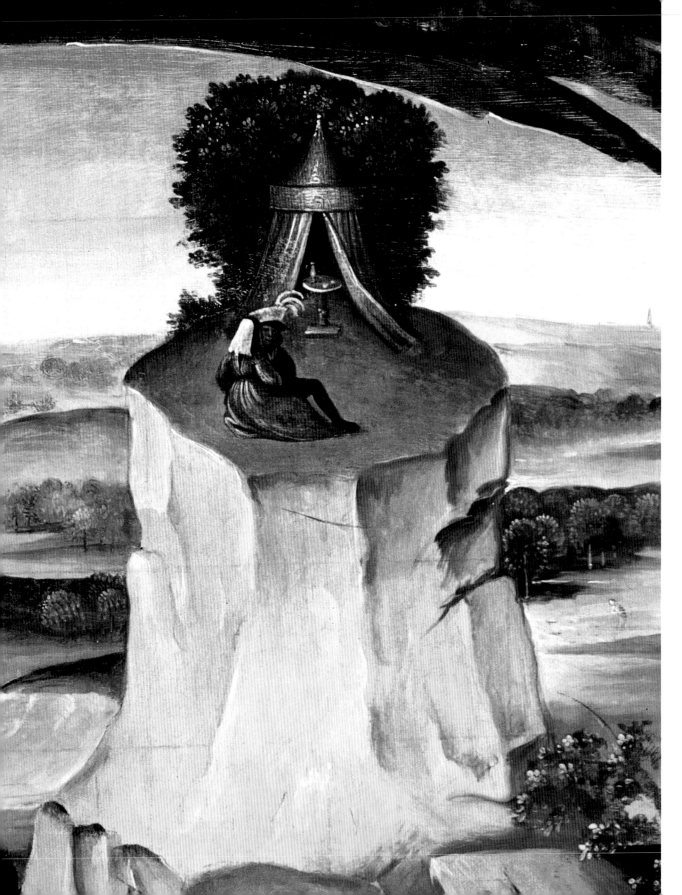

Christ on the Cross, with the Virgin,
Saint John, Saint Peter, and a Youthful Donor
Musées Royaux des Beaux-Arts, Brussels
[cat. 7]

on the following page: [cat. 7] *detail*

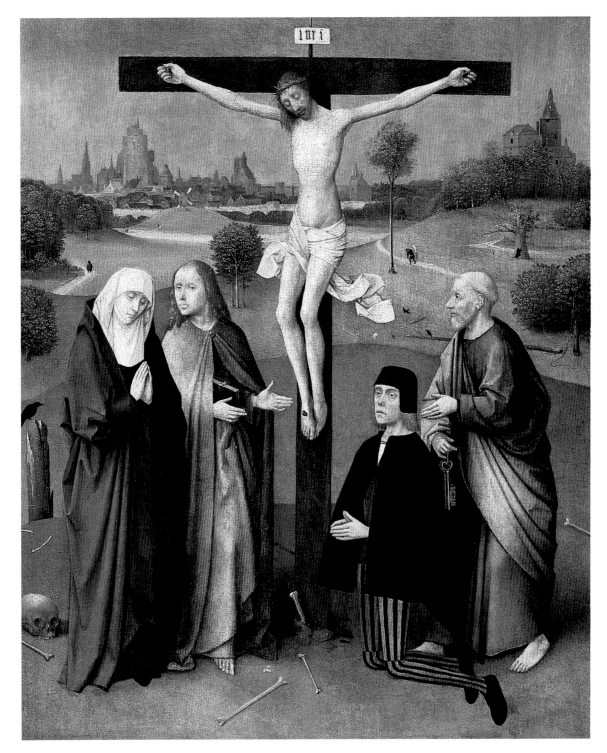

The Extraction of the Stone of Madness (The Cure of Folly)
Museo del Prado, Madrid
[cat. 8]

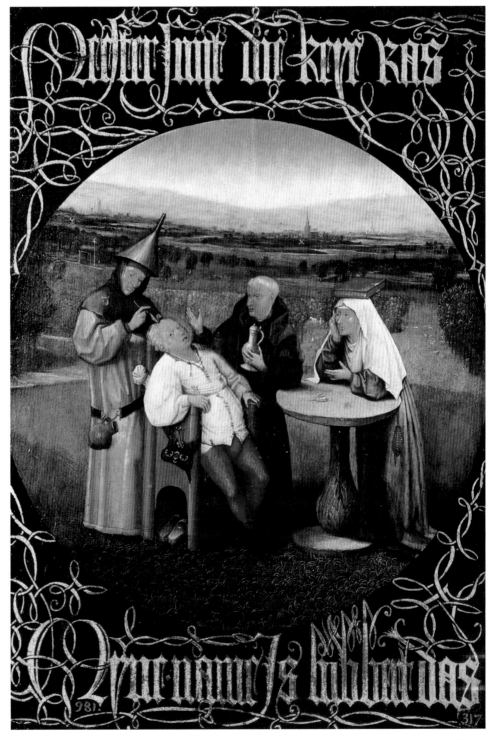

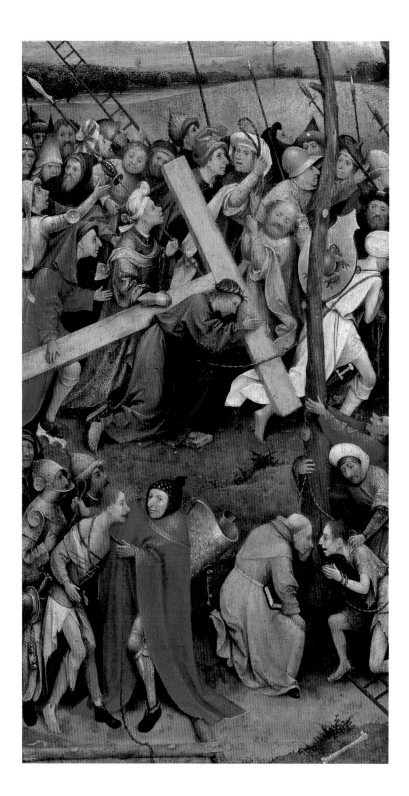

on the following page: [cat. 9] *detail*

[cat. 9] verso

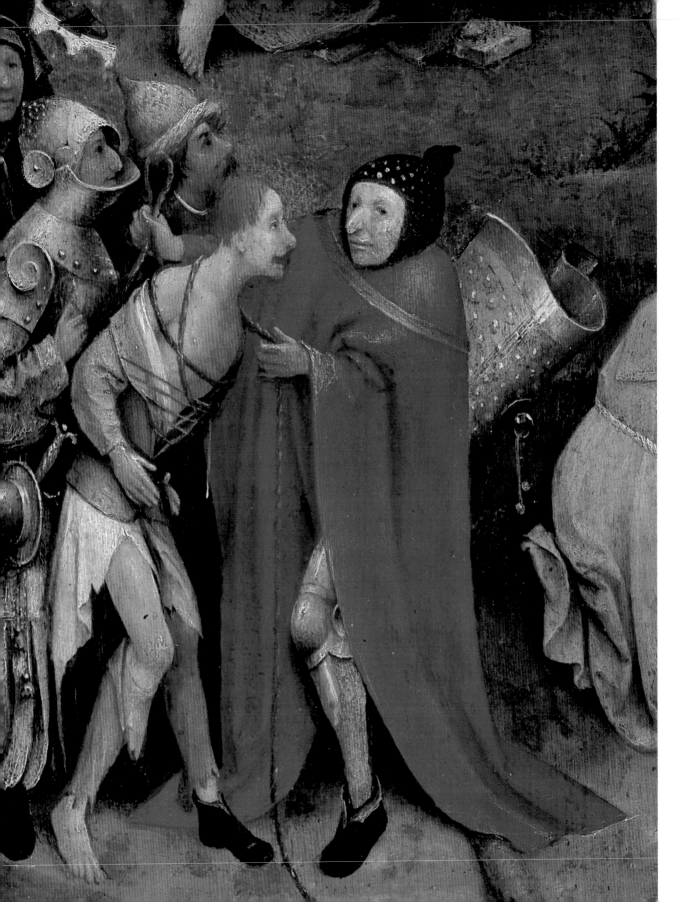

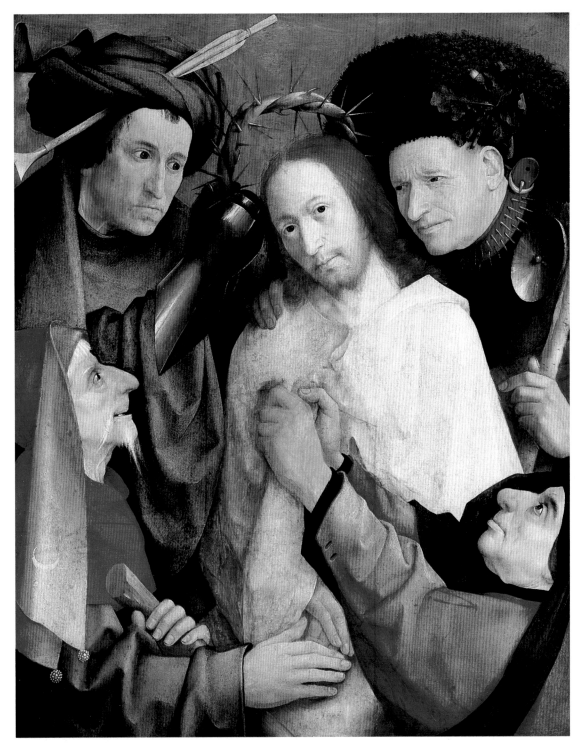

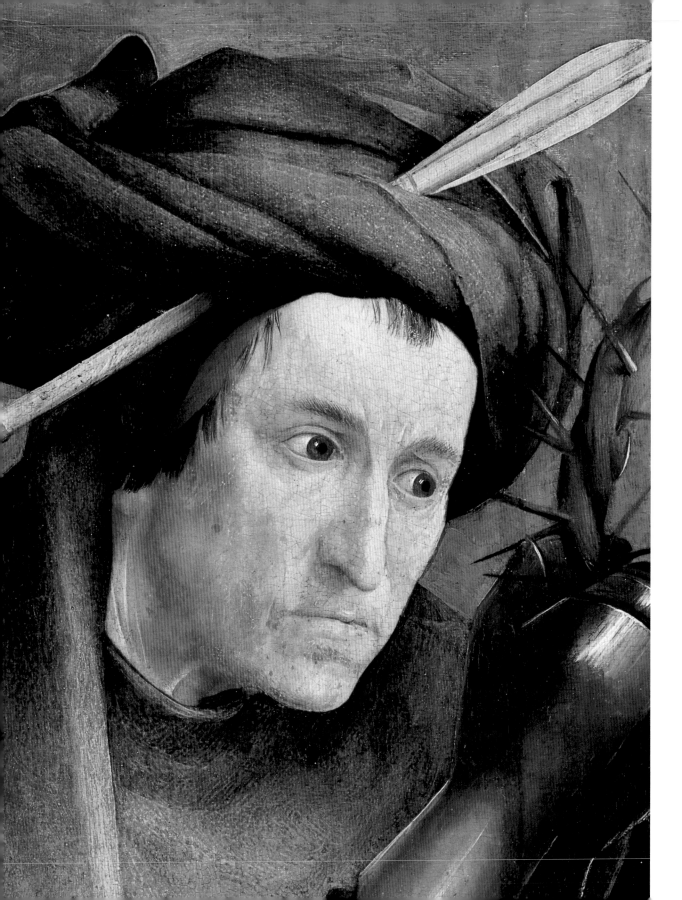

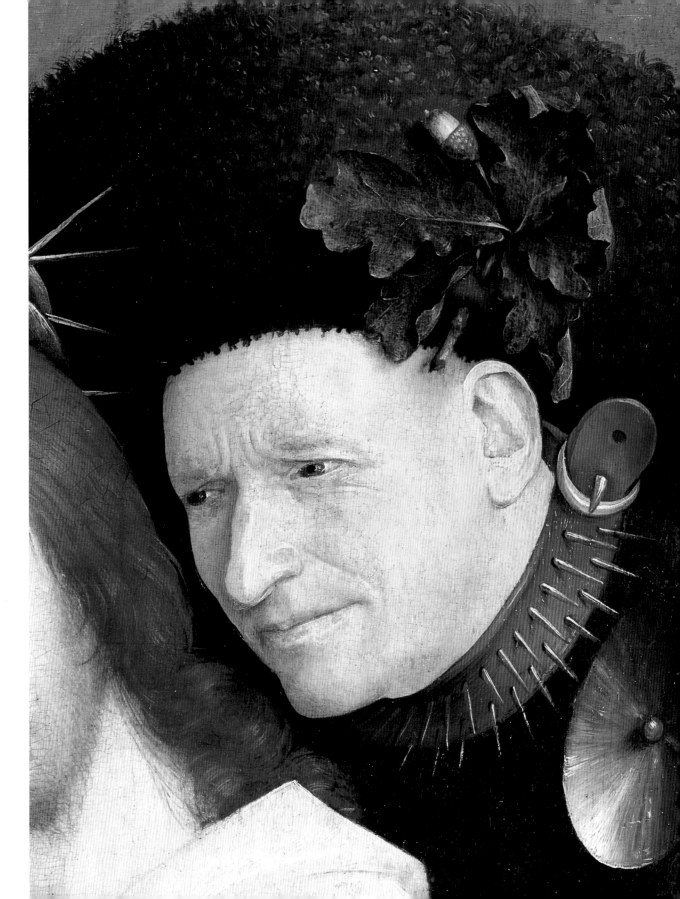

The Last Judgment
Gemäldegalerie der Akademie der bildenden Künste, Vienna.
[cat. 14]

facing page: [cat. 14]
center panel

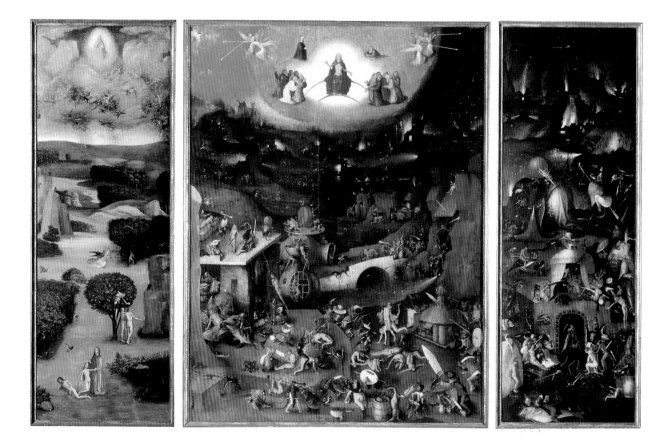

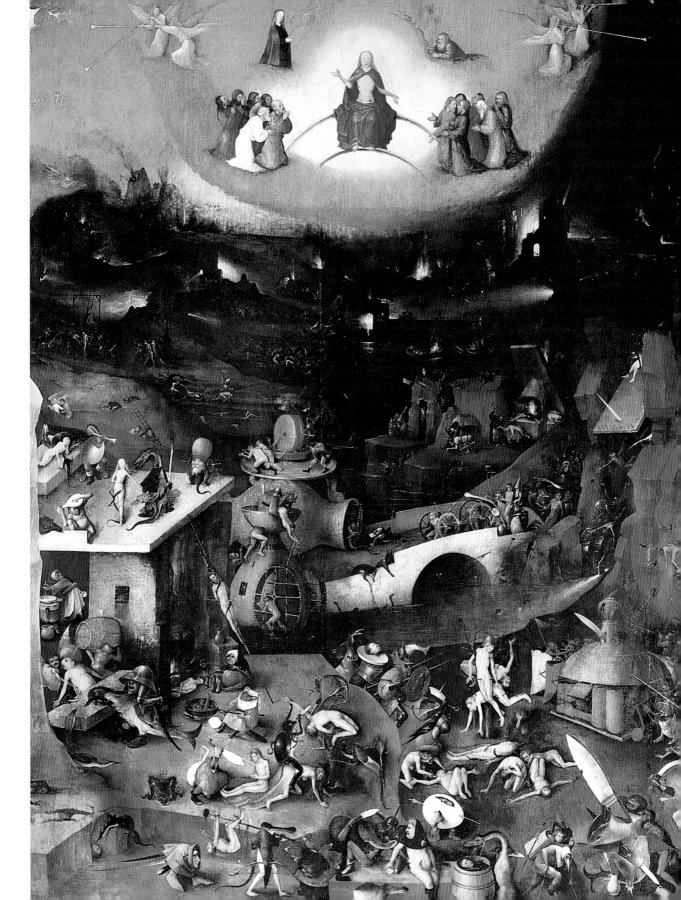

Hell
*Rotterdam, Boymans-Van
Beuningen Museum*
[cat. 15a]

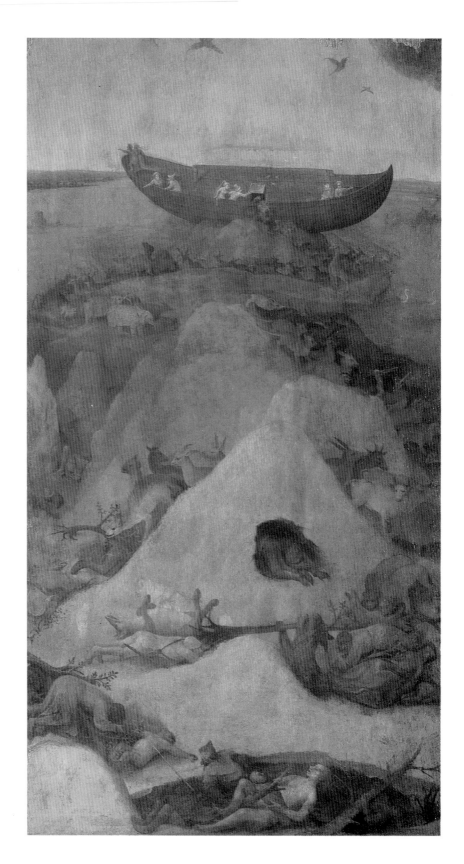

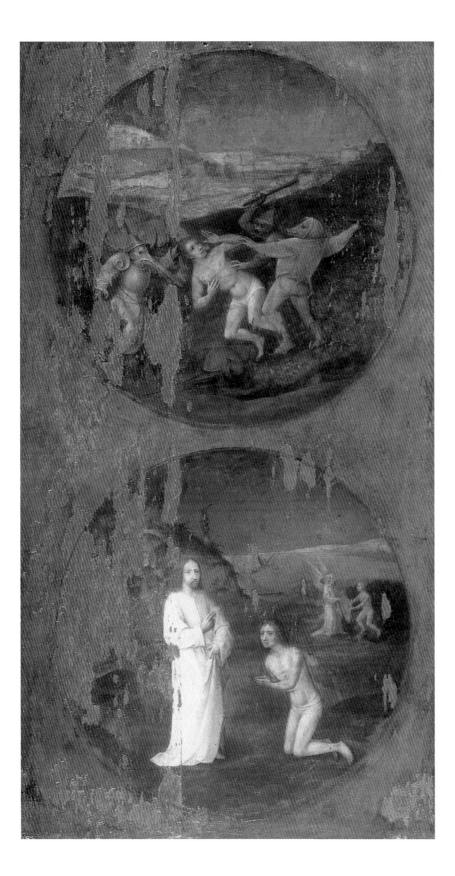

The Deluge
Rotterdam, Museo Boymans-Van Beuningen
[cat. 15b]

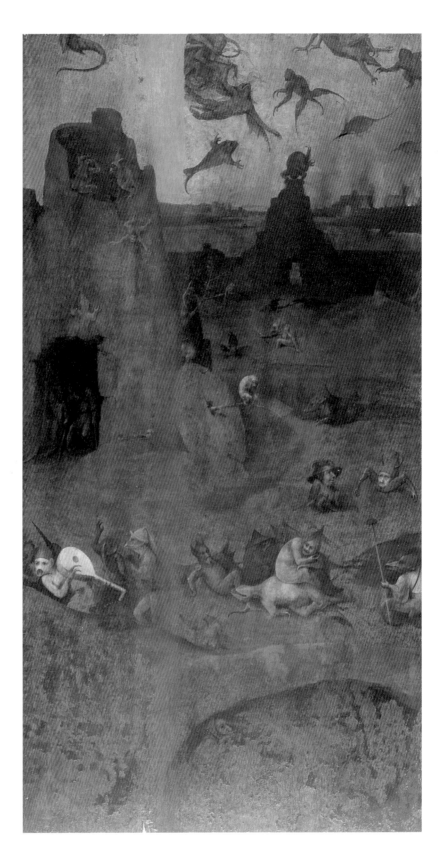

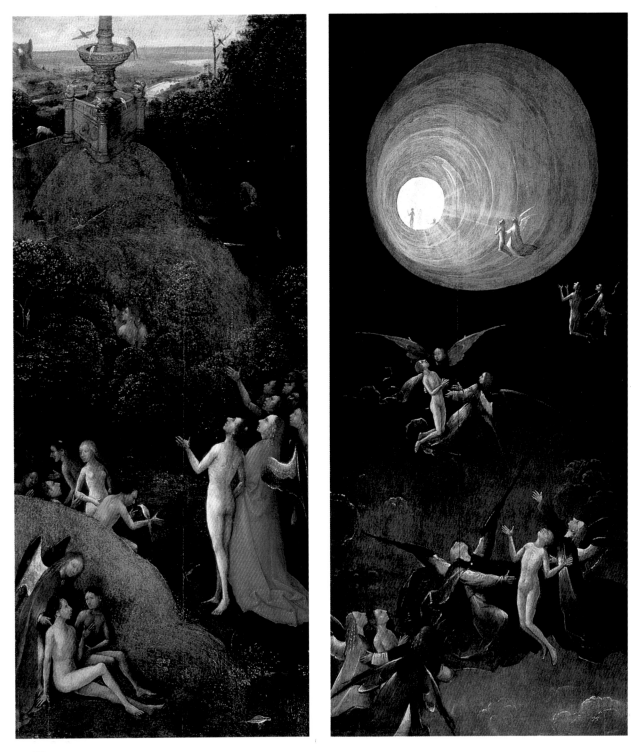

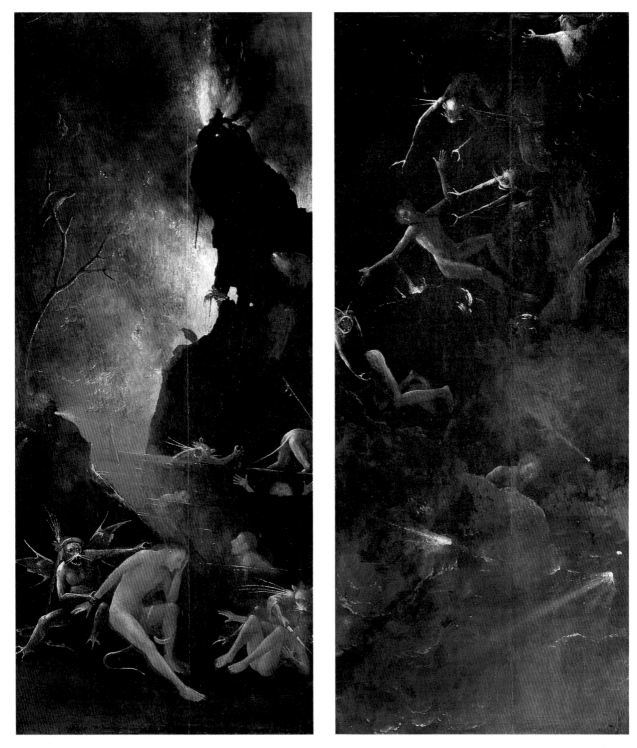

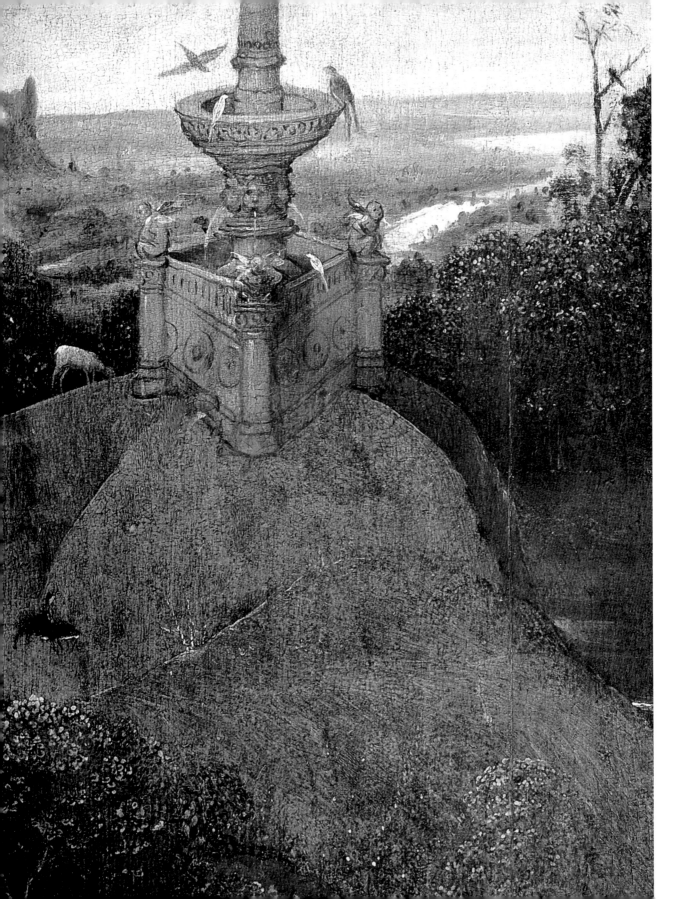

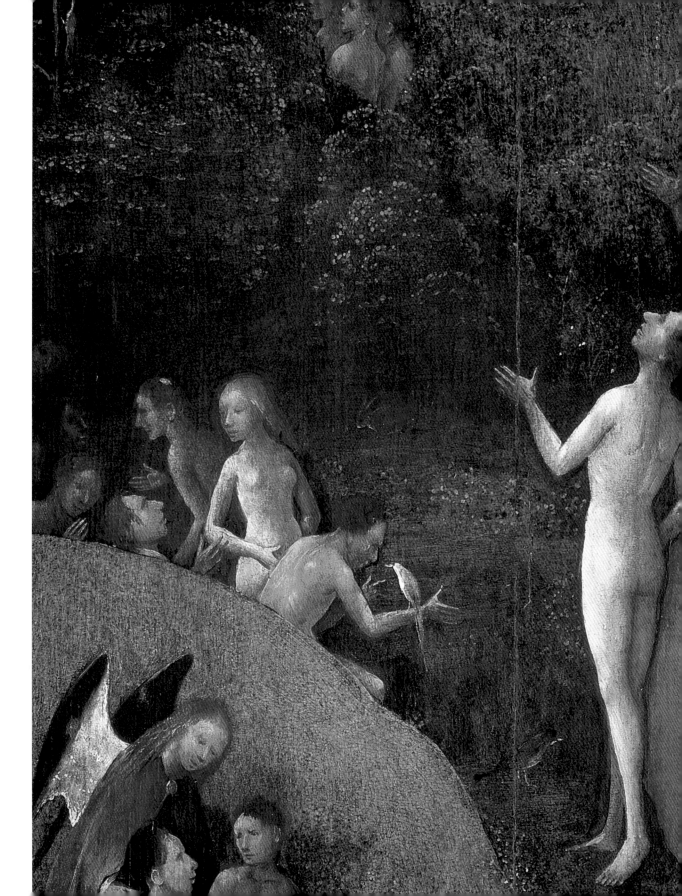

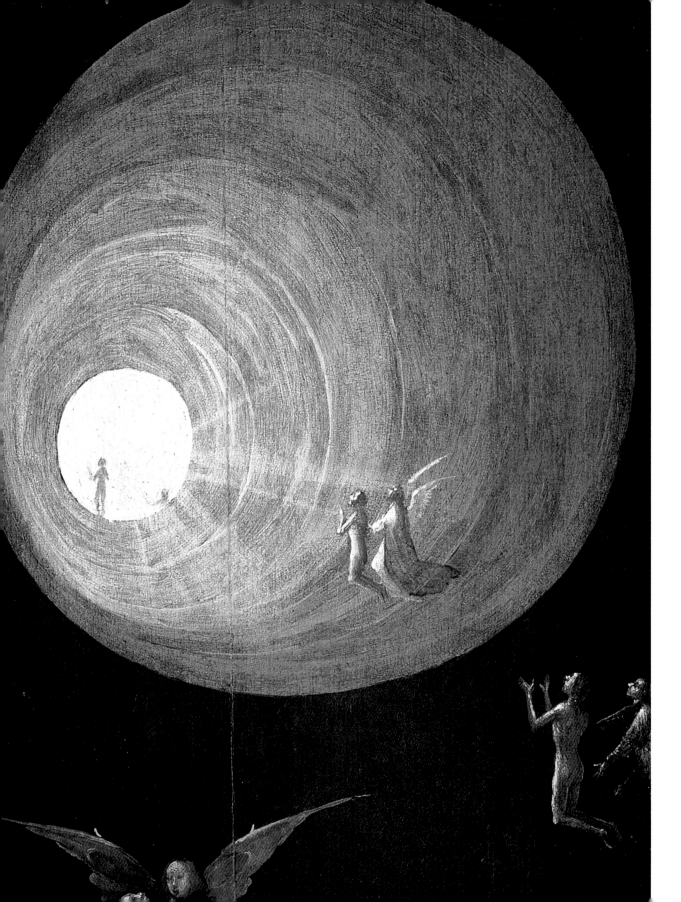

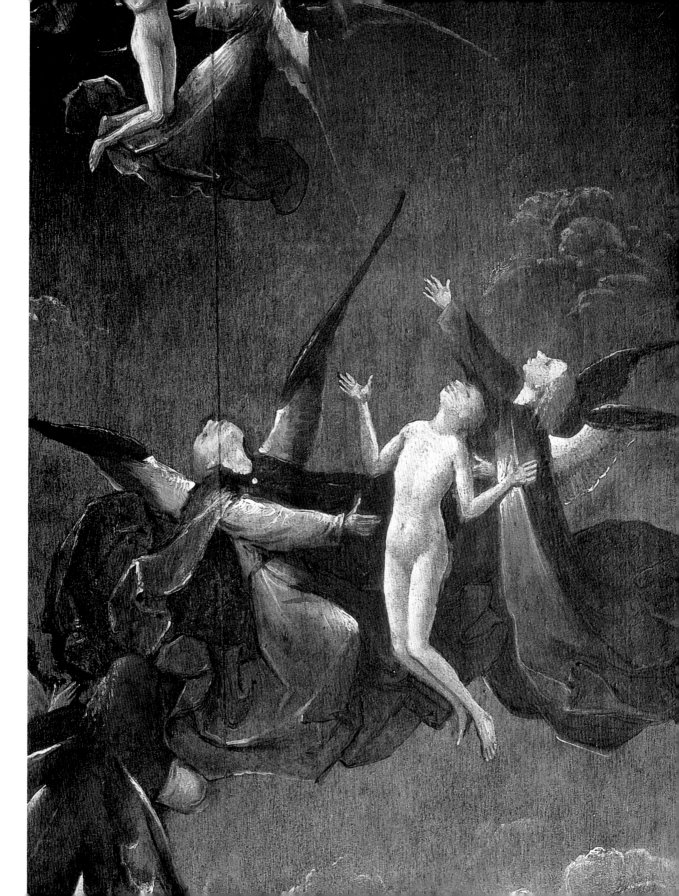

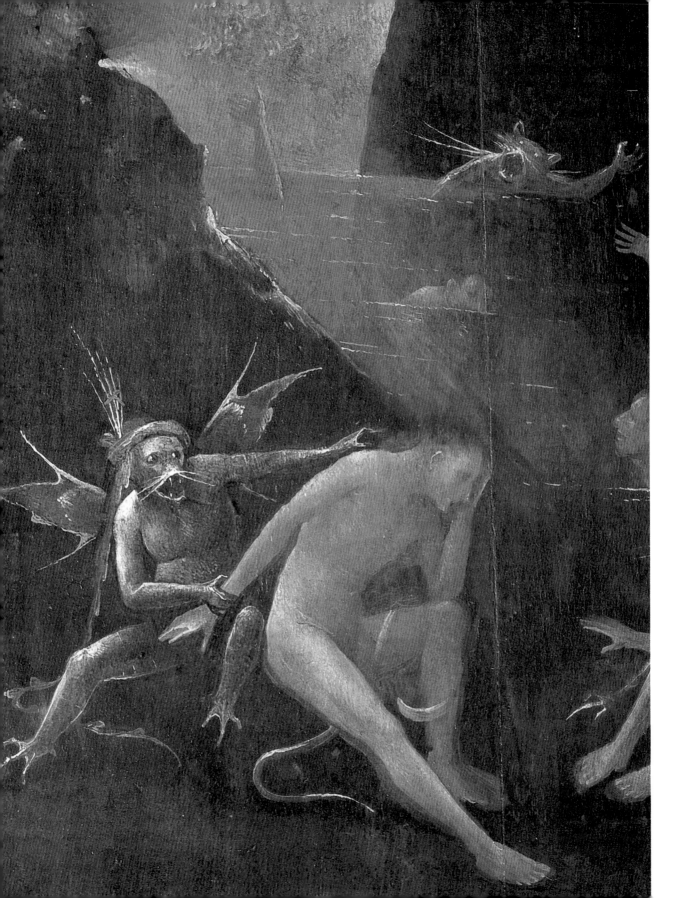

The Hay Wain
Madrid, Museo del Prado
[cat. 18]

on the facing page: [cat. 18] *center panel*
on pag. 76: *side panels*

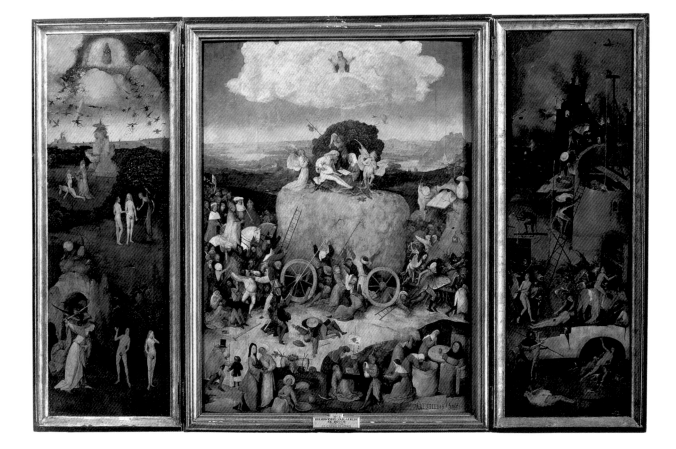

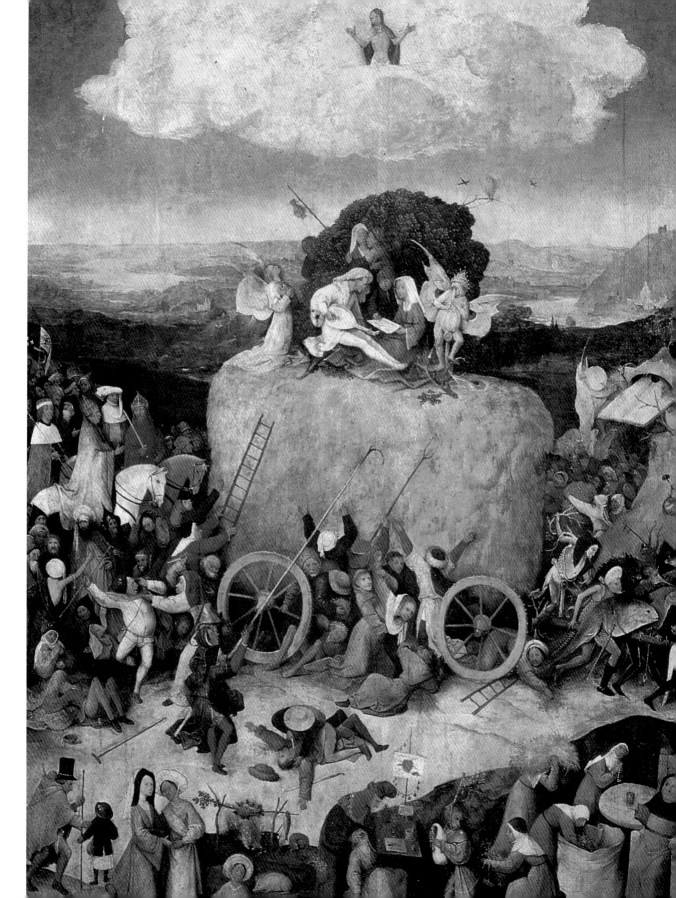

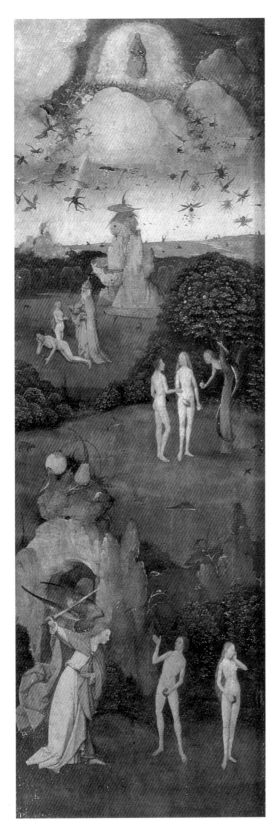
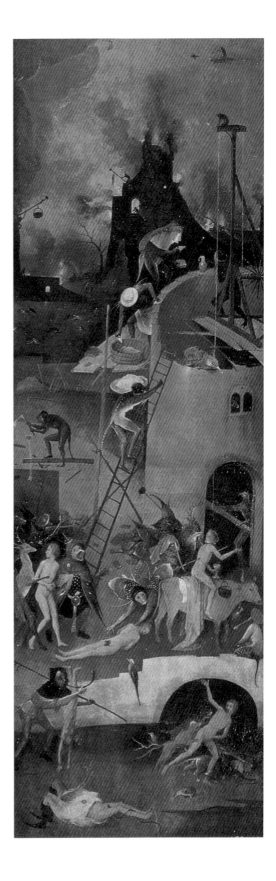

The Altar of the Hermits.
Saints Jerome, Anthony, and Giles.
Venice, Palazzo Ducale
[cat. 20]

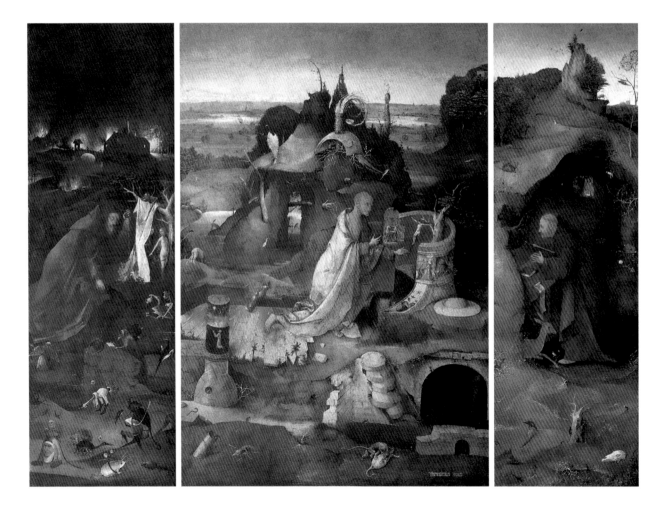

[cat. 20] *center panel*; pages 79-82: *details*

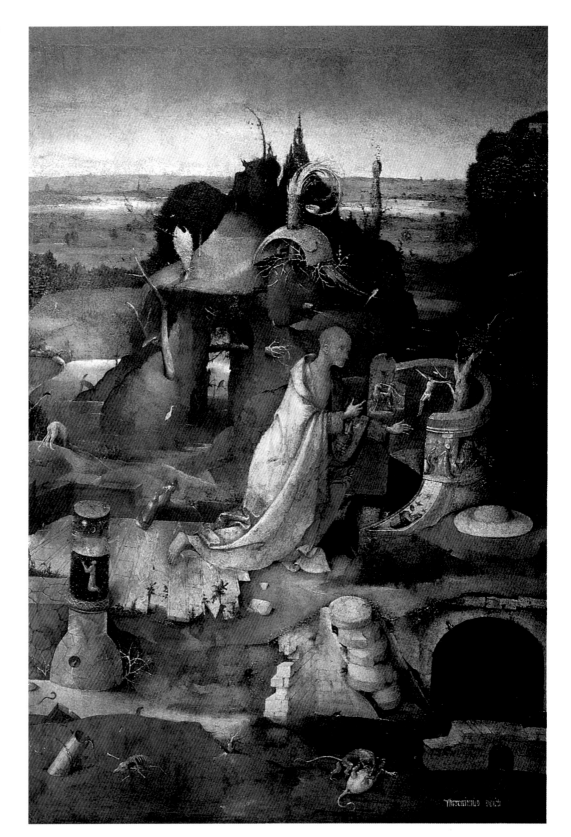

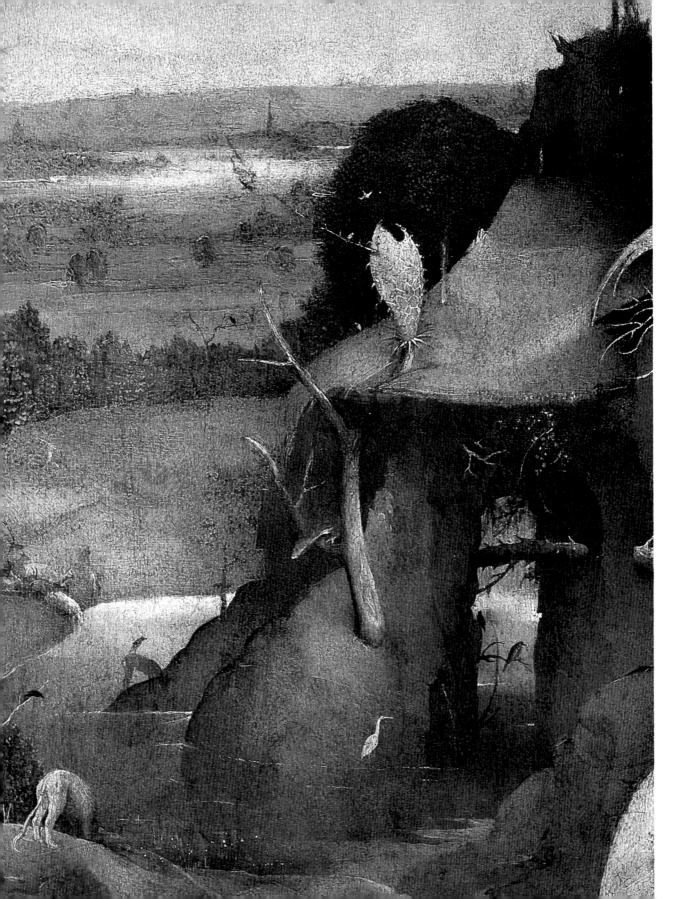

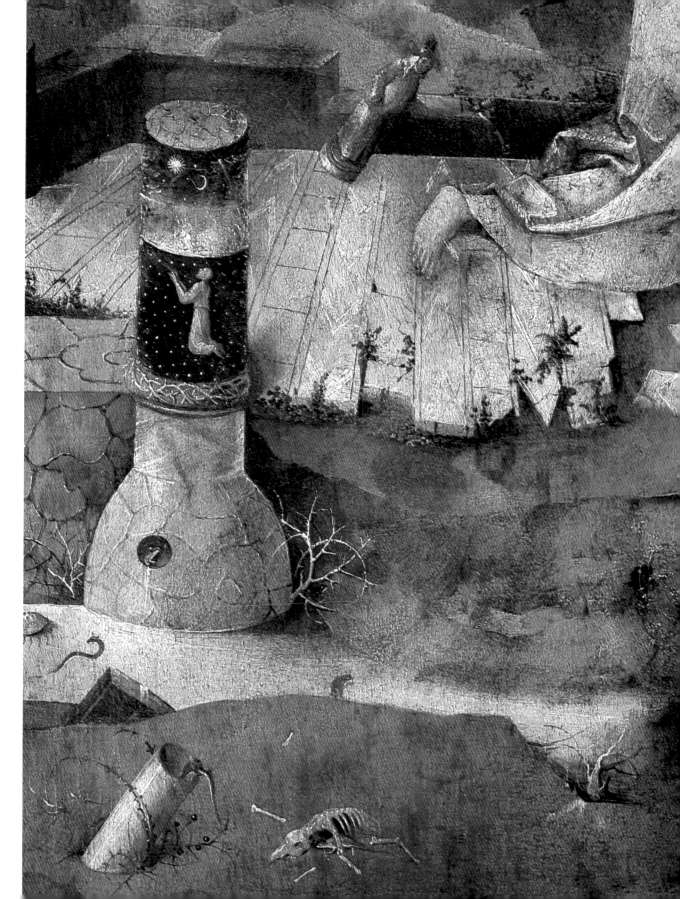

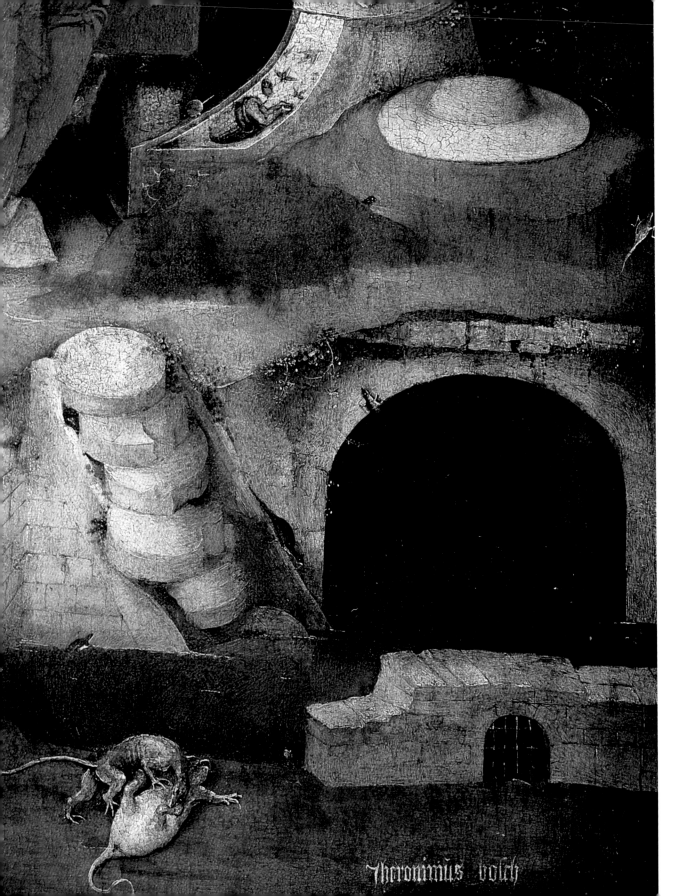

Jheronimus bosch

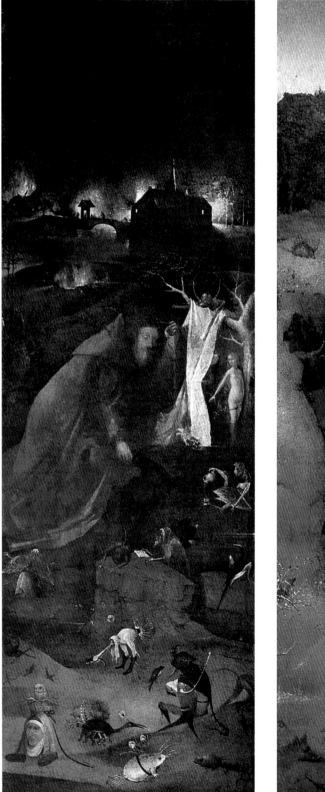

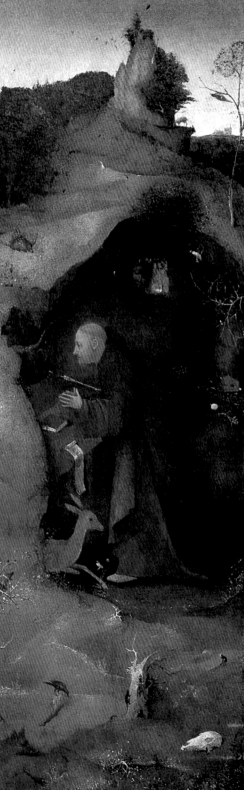

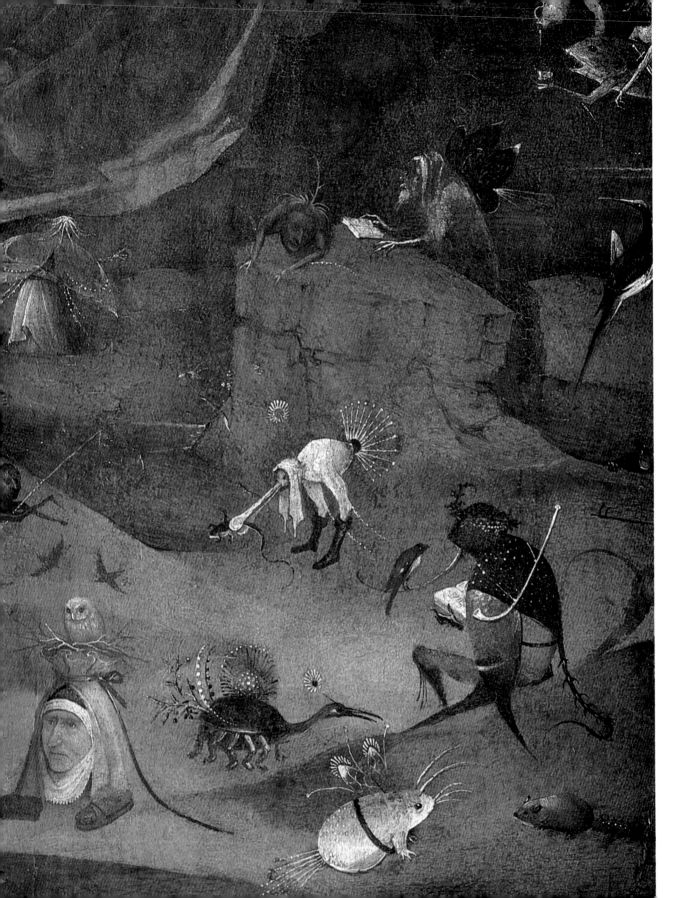

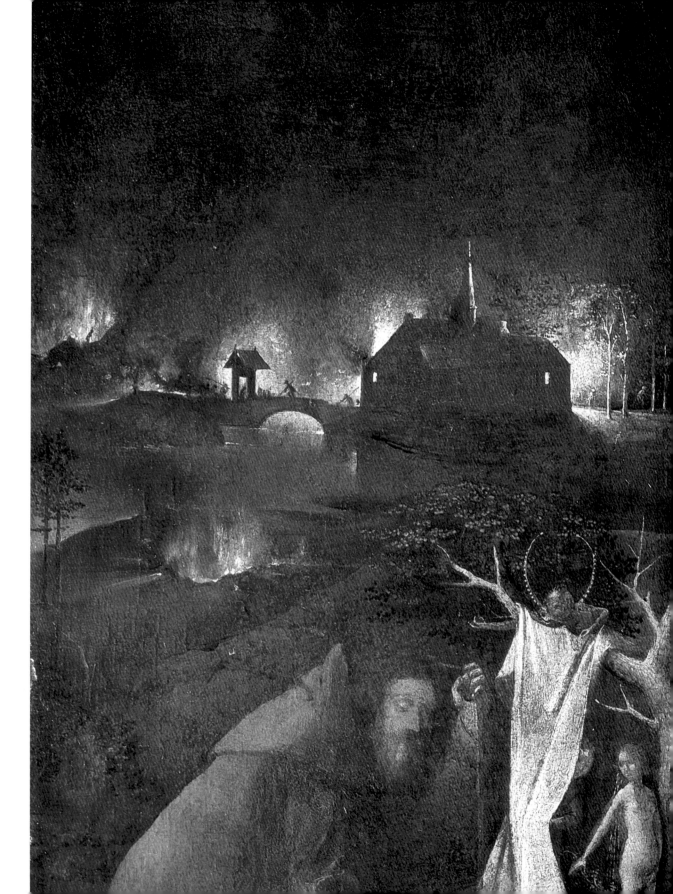

pages 89-93: *details*

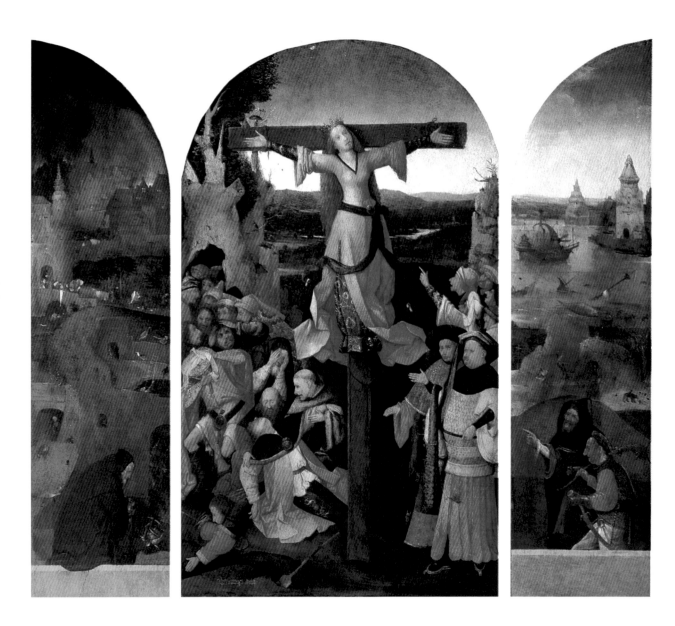

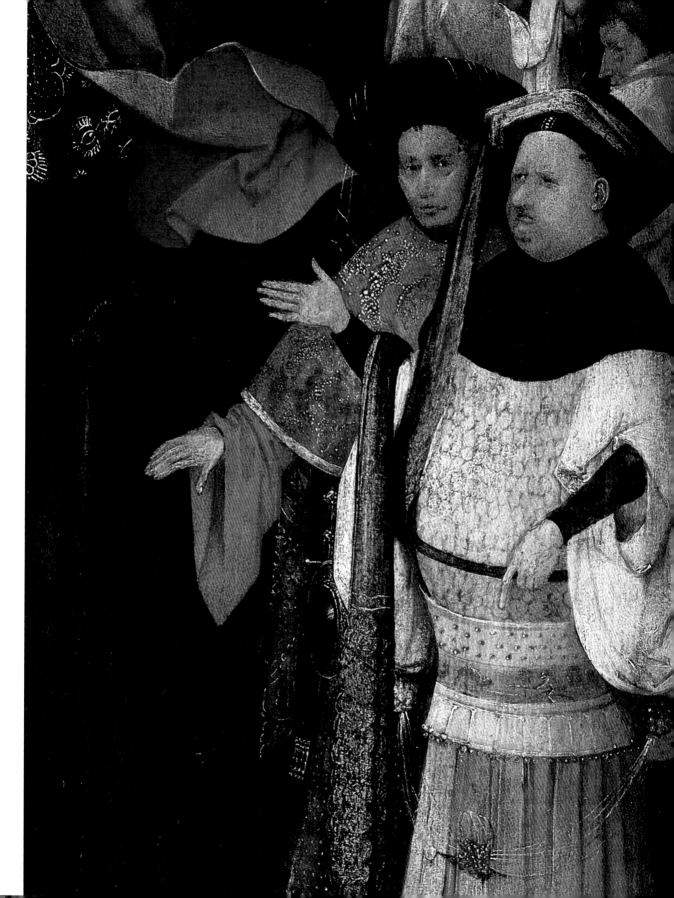

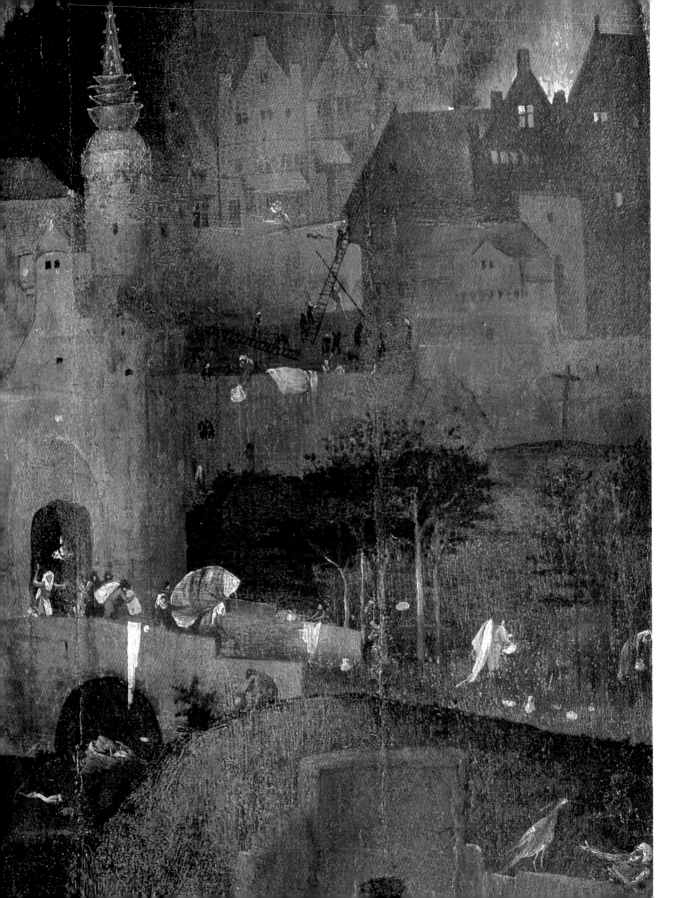

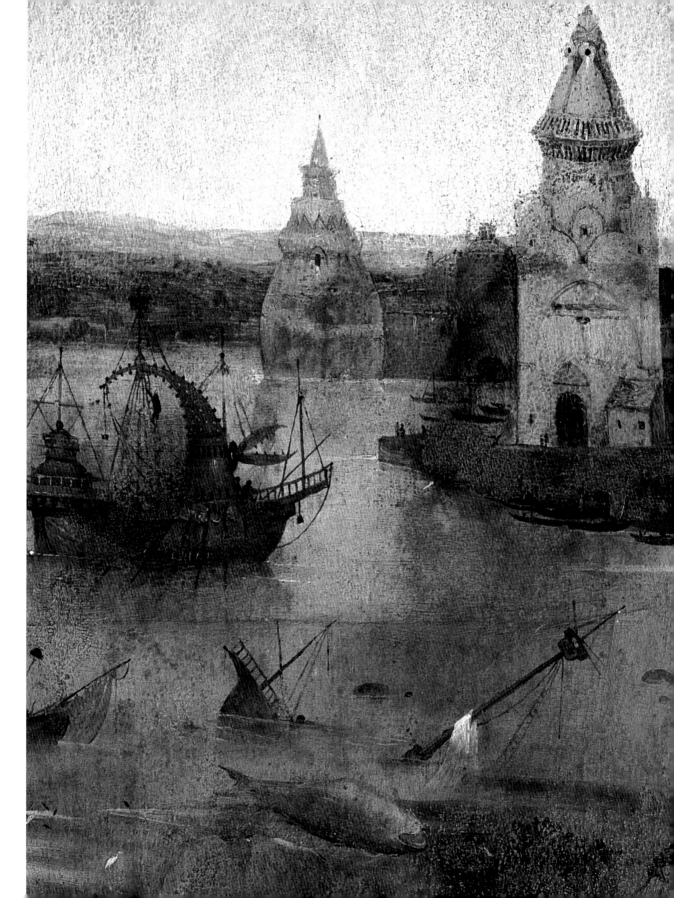

Saint Jerome at Prayer
Ghent, Musée des Beaux-Arts
[cat. 22]

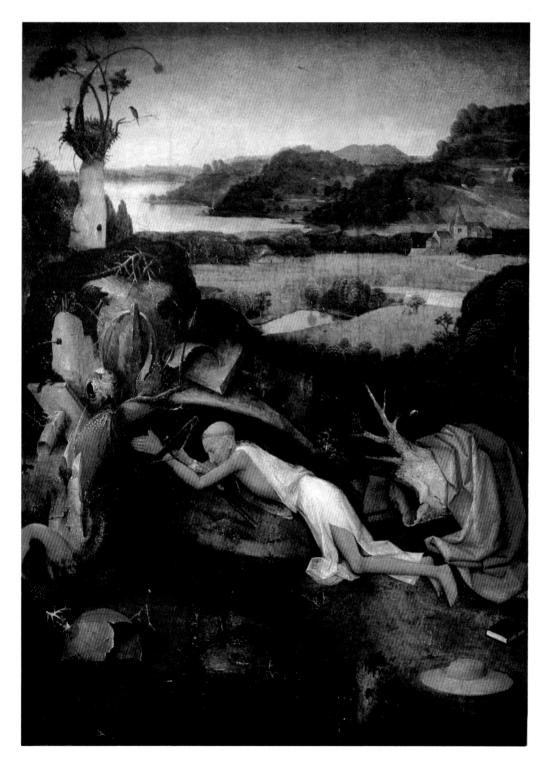

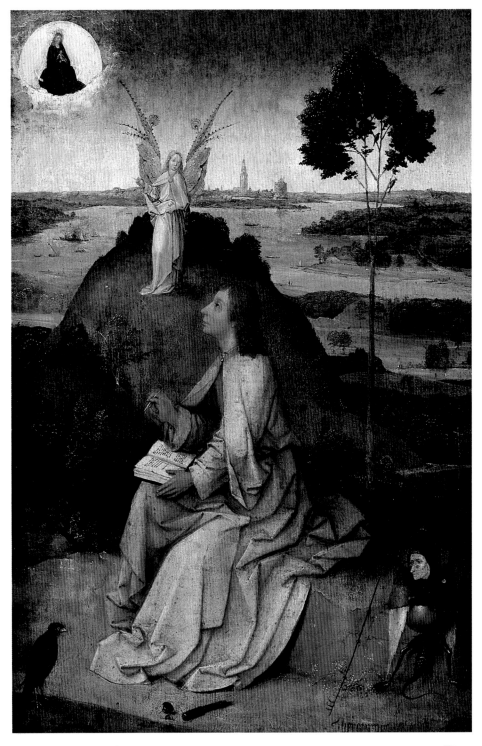

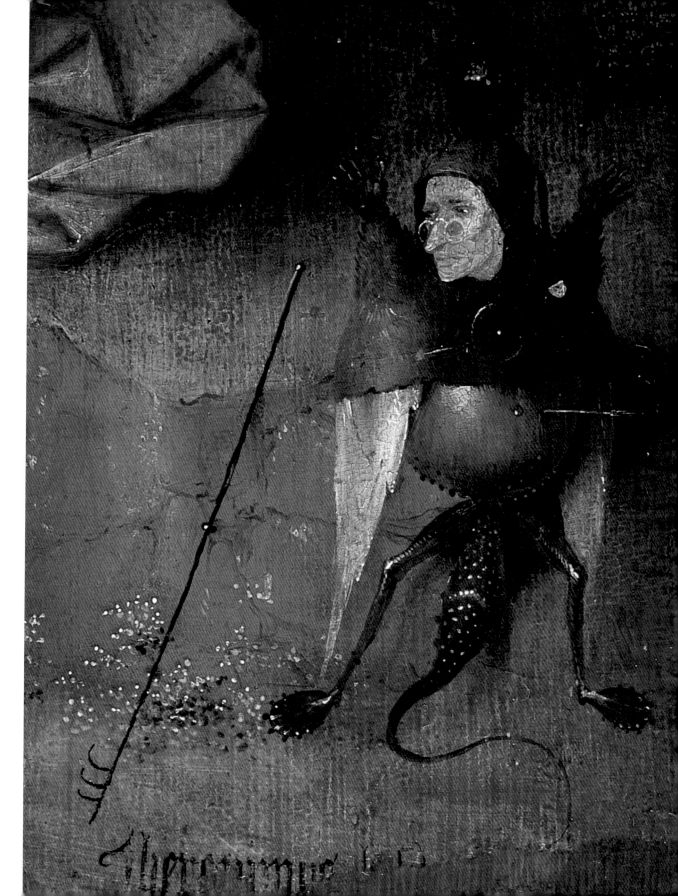

pages 99-100: *details*

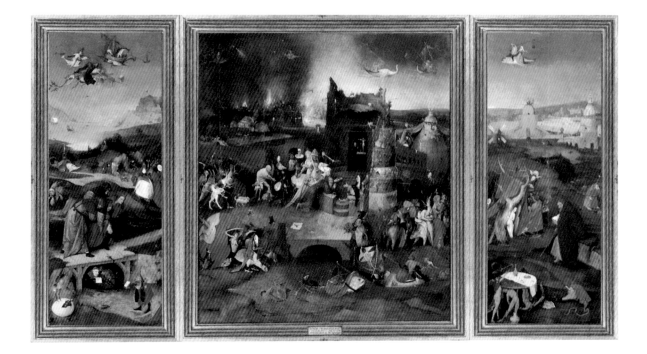

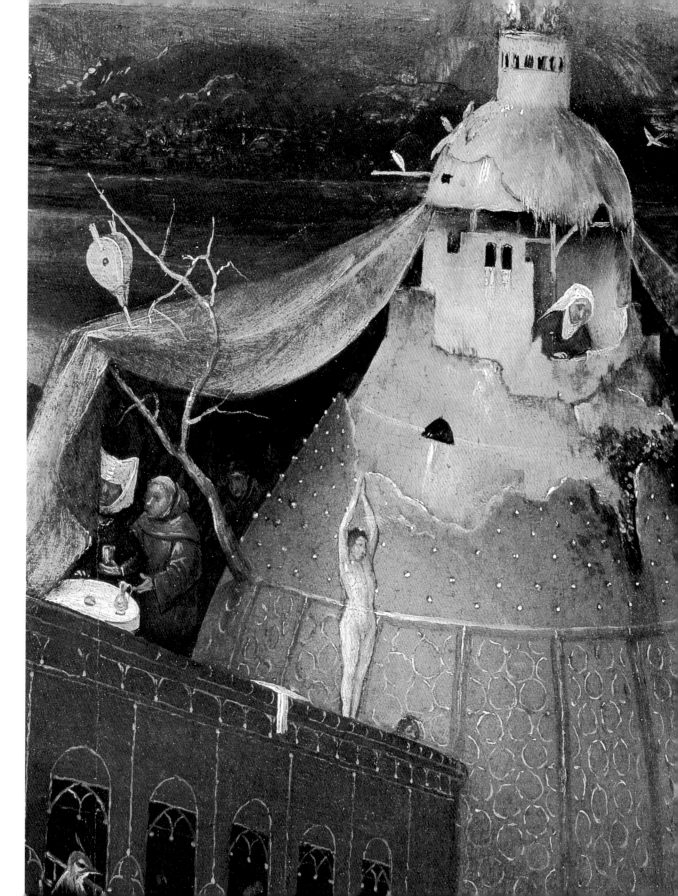

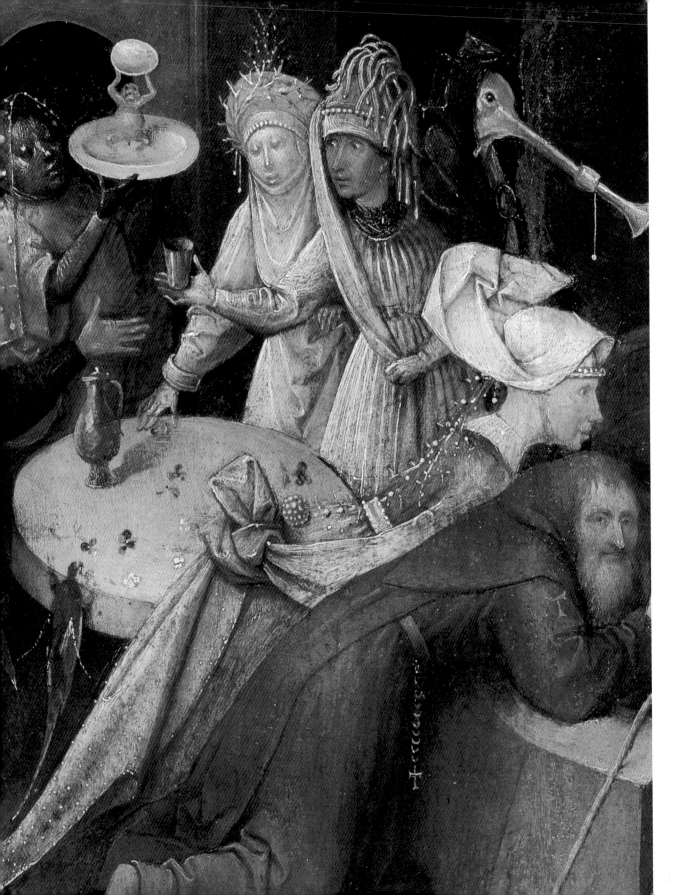

The Adoration of the Magi (Epiphany)
Madrid, Museo del Prado
[cat. 29]

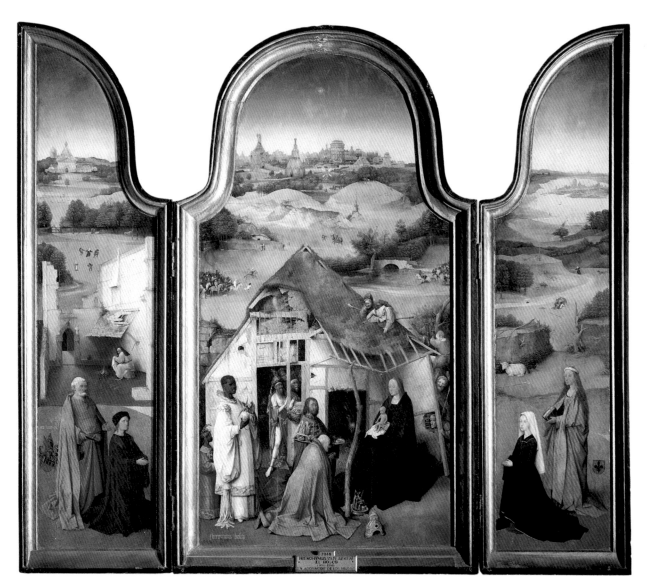

Christ Carrying the Cross
Ghent, Musée des Beaux-Arts
[cat. 30]

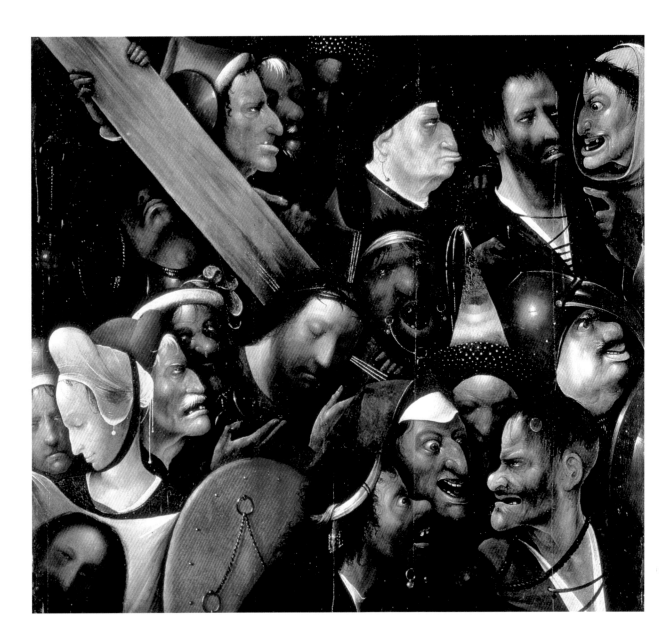

The Garden of Delights
Madrid, Museo del Prado
[cat. 31]

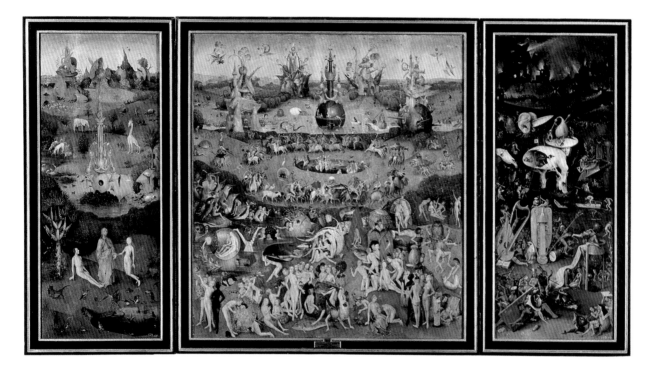

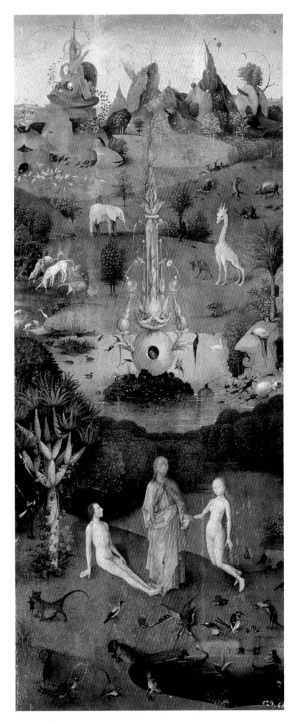

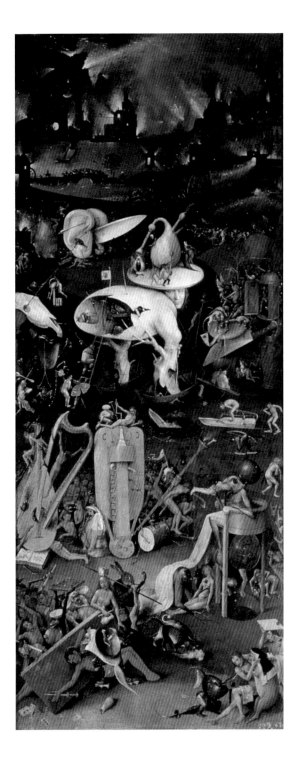

pages 106-108: [cat. 31] *details*

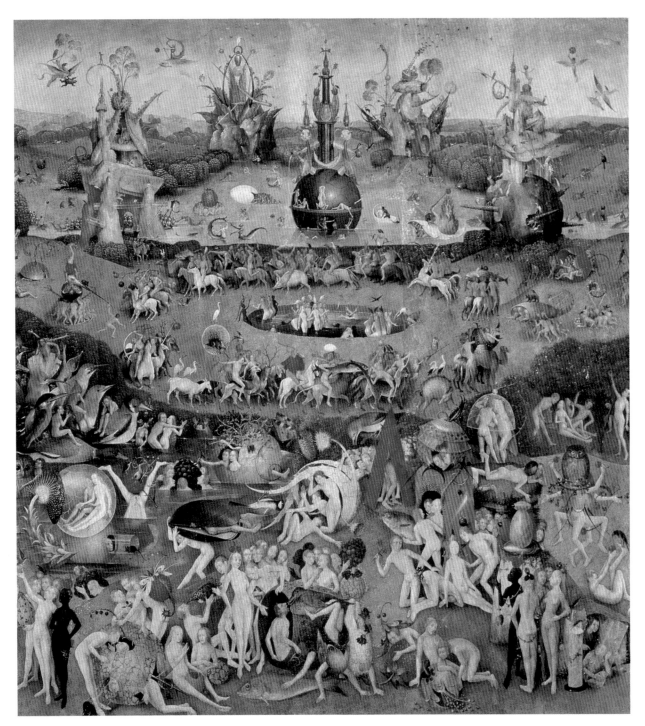

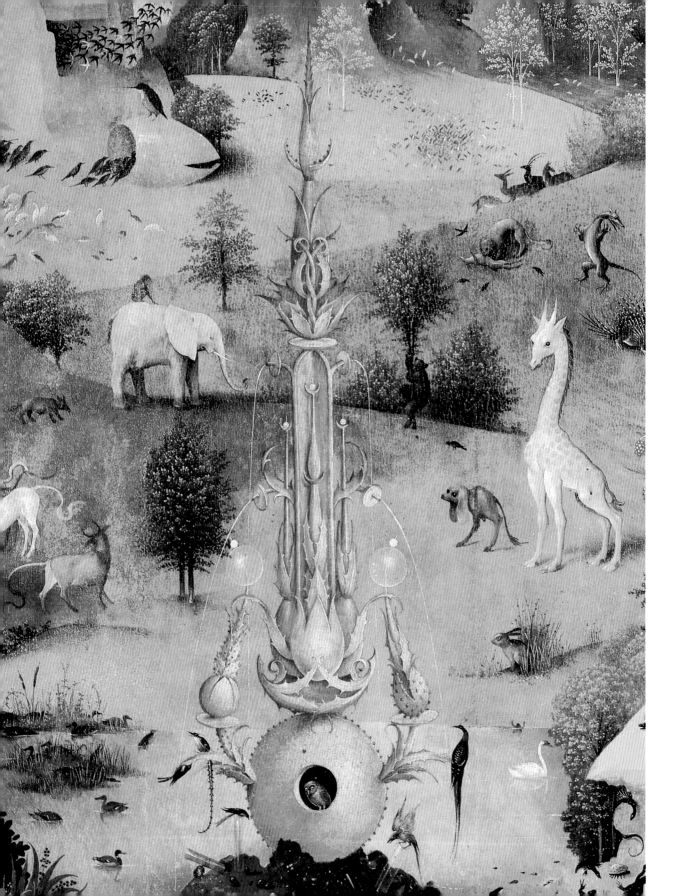

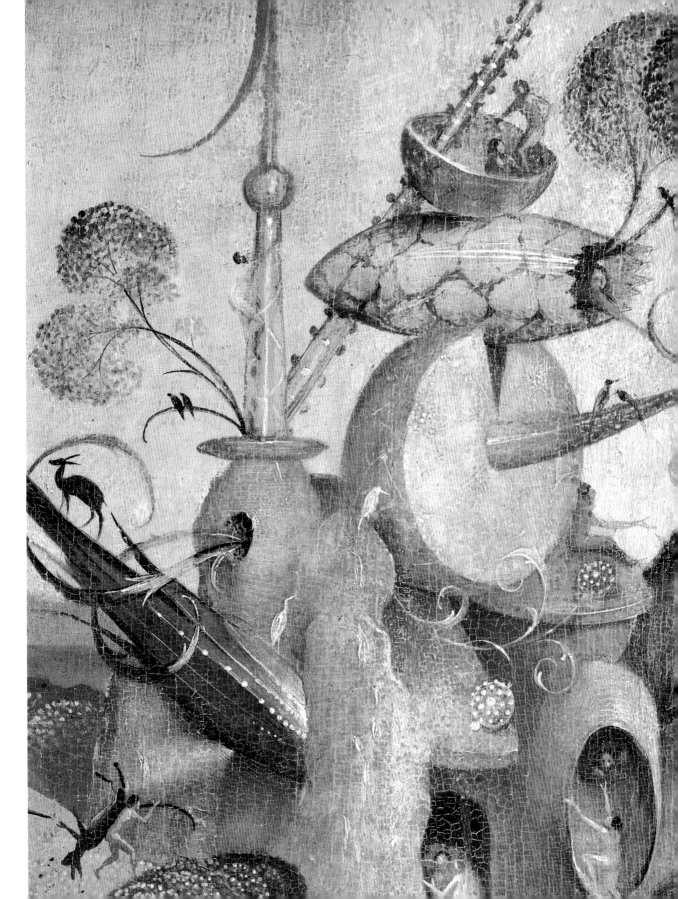

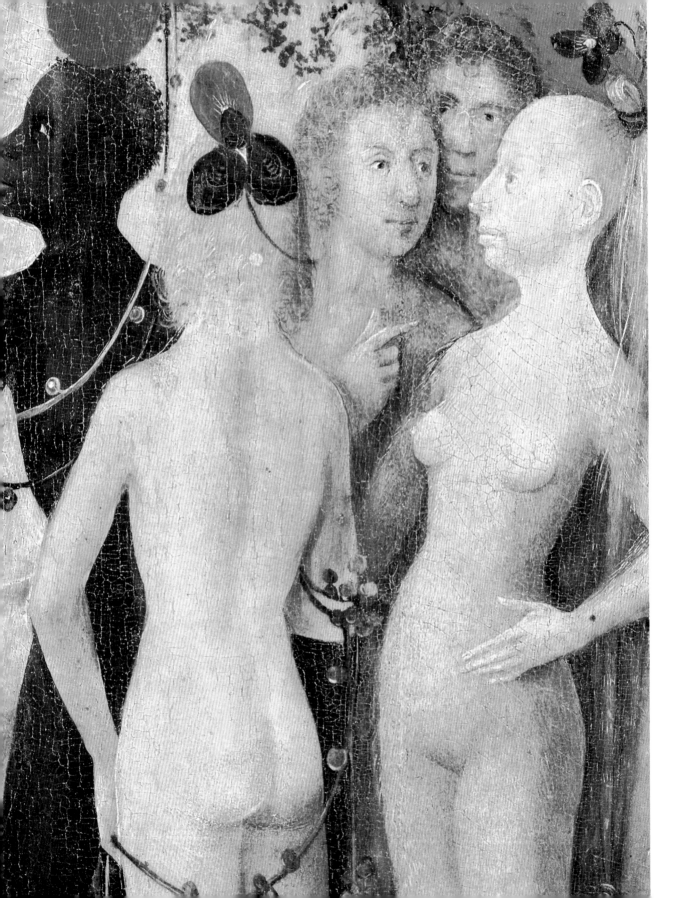

Catalog of the Paintings

As mentioned in our "Oeuvre" section, no painting by Hieronymus Bosch bears a date, nor can it be identified with a contemporary document permitting us to range it within the artist's career. Consequently, every biographer is forced to establish his own chronology, and there is considerable discordance among the numerous critics. A version of *The Extraction of the Stone of Madness* at the Prado Museum in Madrid, which appeared on the Brussels art market during World War II, was dated 1516 (the year of Bosch's death), and was accepted as the original of the composition by the late Hulin de Loo, and has passed from sight since. As the majority of connoisseurs consider the Prado painting an early work by the master, at least as far as its invention is concerned, the Brussels replica has only added to the imbroglio.

Bosch certainly presided over a large workshop and was freely copied and imitated, perhaps even during his lifetime, and certainly very shortly after his demise. This makes the pruning of his oeuvre more difficult, especially when we are dealing with large altarpieces for which studio assistance must be accepted as normal. The artist's painting technique, hailed as unique by some, was basically, as mentioned, gross and provincial, his draftsmanship clumsy. He stands out by his inventiveness rather than by the quality of execution. Illustrations after Bosch, in books or posters, usually look much better than the originals, where the lack of sophistication of his manner comes most strikingly to the fore.

We have attempted to group Bosch's paintings according to two viewpoints: 1) the evolution of his very personal landscape style, as first proposed by Ludwig von Baldass (in 1917); 2) the increasing maturity in his conception, and the stance and facial expression of his figures. As for the latter, one must, of course, take into consideration a bent for satire that apparently went back to cross-influences with Italy, and, more specifically, Leonardesque prototypes. Our chronology, like that of all critics, has found its basis in subjective considerations. It could not be otherwise, because of the complete lack of factual contemporaneous documentation. We do not share the inclinations of most German-trained scholars, who tend to propose artistic development on an evolutionary curve. This error, first castigated by the late Leo van Puyvelde almost fifty years ago, leads to fundamentally erroneous construction. Some of the greatest artists stop after having attained a certain level of achievement, take a breath, and return to perceptions that characterized their earlier years, only to reach new insights later on.

Inasmuch as Bosch produced traditional paintings side by side with phantasmic ones, commonly called diableries, we range them in order of their probable genesis. Many of his most incisive inventions have come down to us only in our section B, following the works that we assign to the master himself or consider to be mostly by his own hand. In section B, only the most important material is cataloged. For a complete list, see G. Unverferht, 1980, pp. 15–64.

A) Paintings mostly by Bosch's own hand

1

The Adoration of the Magi
The Metropolitan Museum of Art,
New York. Panel, 71.1 x 56.5 cm.
From the Lippmann Collection, Berlin.
No. 38 at the Berlin auction of 1912.
No.13.26 (Kennedy fund, 1912).

The Madonna, with long blond hair and clad in a blue robe with ample folds, is shown seated upon a bench that reposes upon a gold-colored rug. The Christ child sits in her lap, both arms extended. At the foot of the rug, to the left, is a kneeling shepherd; to the right is a king, also kneeling and carrying numerous gifts. Next to him is a little dog whose head is turned toward the spectator. Two other Magi, their robes gleaming with gold, are standing at the extreme right of the inferior picture plane. The barn is an open building, adorned with towers and loopholes. Its roof is formed by a cloth, held by angels. The background consists of a clear landscape that extends in the direction of a high and unencumbered horizon.

The composition is simple and derivative in its naive charm, from a Dutch rather than a Flemish conception. In the selection of types, such as the Madonna, Bosch approaches the form language of Geertgen tot Sint Jans, while the landscape appears strongly influenced from what we know of the early Haarlem school. In the latter respect, Bosch evolved in a manner parallel to, but independent from, the development of Dierik Bouts and Gerard David. Joachim Patenier borrowed from both branches for his own vision of the rendering of nature. As Max Friedländer first stated, followed by Paul Fierens, G. Glück, and this writer, "this is an especially early work" by H. Bosch. In our opinion, it is to be dated around 1470–75. Tolnay and others disagree, ascribing it to the workshop with a date of execution around 1510–15. We do not accept their arguments, which we consider tenuous. Any borrowings are from this prototype, and not the other way around. The state of preservation of the painting is unfortunately very unsatisfactory, and so is its restoration. A copy

belongs to the Museum Boymans-Van Beuningen, Rotterdam.

2

The Epiphany
(Adoration of the Magi)
Philadelphia Museum of Art.
Panel, 74 x 54 cm. John G. Johnson
collection, No. 1321. From the collection
of the Earl of Ellenborough. No. 97 in the
auction of 1814.

The composition follows closely, in its type of simplicity, the style of representation in the preceding entry. In this period, there were two ways of composing the scene. Either the Virgin was shown sitting frontally, as in our No. 1, or, as here, she was represented in a corner, with the action proceeding from her as the point of departure, stretching out over the remaining part of the picture. The first mode of composing was preferred by the Flemish, such as Rogier van der Weyden and Hans Memlinc. The second harked back to Dutch prototypes, more specifically, to Dierik Bouts, Gerard David, and Geertgen tot sint Jans, whose influence upon the artist from 's Hertogenbosch we have stressed in the preceding catalog entry. Tolnay links the composition to a Dutch miniature from 1438, thus attempting to explain archaisms in the iconography. One will remember that, as mentioned, Max Friedländer connected Bosch's style with that of book-illuminators, with whom the German scholar thought that Bosch must have trained. The hypothesis avers itself quite seductive, and would help explain the dependence of Hieronymus upon this source not only in the painting technique but also in the formulating of the content in his early works. Even the color scheme continues the palette of the international style, with the preeminent pink tonalities dominating in the main parts of the painting, set off by the light-green costume of the kneeling king and the white costume of the black magus. Panofsky has also directed our attention to the soft international style as one of the possible points of origin for Boschian inspiration. We will further confront and discuss such correlations when examining the triptych *The Garden of Delights*.

The type of the Virgin closely resembles that of the preceding entry and agrees with Bosch's ideal of femininity during these early years.

Friedländer call this "a rather early work," followed by Tolnay and most other critics. It should be dated around 1470–75.

3

Madonna
Private Collection, United States. Panel,
22.9 x 15.9 cm. From the estate of
Walter Langer, New York.

The Madonna is seen three-quarter-length, *de face*. She wears a red mantle over a dark dress. Her long blond-brown hair falls over her shoulder. Her left hand, placed over her bosom, holds the cross, while her right hand carries an open book with ornamental initials. This Madonna-type is again archaic, and the influence of book illumination from the soft international style is undeniable. In principle, the representation derives from much earlier examples current in eastern Europe, especially Serbia, where that Madonna holds a parchment roll instead of the bound book. Such icons were called *Paraklesis* and were usually accompanied by another one of Christ as a pendant. Although the Madonna is not placed in an architectonic niche here, the painted background finishes in a Romanesque arch—terminated by a make-believe gilt structure on top and on the sides. According to Panofsky, this signifies the Old Covenant and the timeless paradise. Finally, it behooves us to mention Lynda Harris's (1995) assertion, that Bosch was a member of a surviving Cathar cell. In spite of our skepticism in this respect, both the Cathars and the present Paraklesis avow common Serbian origins, which seems troubling. Almost all examples of representations of the Holy Virgin in Flemish art of the fifteenth century are of small size: house altars, small triptychs, and devotional paintings. Thus, this work fits in very well with what was in demand from contemporaneous artists. Geertgen tot Sint Jans again comes to mind with respect to similarity of form and design of the Madonna

type. The Dutchman was a contemporary of Bosch and seven years younger than he, at most. As this is the first Madonna painting ever identified as an early work by Hieronymus Bosch, we wish to cite in this respect yet another intuition by the greatest of all connoisseurs in the field of the Netherlandish primitives, Max Friedländer. He prophetically wrote more than seventy years ago (1927): "If we lack Madonna paintings [in the case of Bosch—this writer], we must not conclude from this that he has not painted any Madonna paintings. Although this theme may not have suited his manner of imagination, he has most probably painted Madonnas, especially in his early years, which may be lost, or also, lacking the distinct *signum* of his individuality, have remained unrecognized."

We hope that, proceeding in his spirit, we have been able to provide a significant addition to our knowledge of Bosch's early years. To be dated ca. 1470–73.

4

Christ Shown to the People
(Ecce Homo)

Städelsches. Kunstinstitut, Frankfurt am Main. Panel, 75 x 61 cm. From the Kaufmann collection, No. 108 in the Berlin auction of 1917. No. 1577. Exhibited, Bruges 1902 (L. Maeterlinck collection, No. 53).

The preceding three entries were all in a narrative mode, borrowing from the art of the miniaturist, archaic in the compositional types while tentative in the technique and the grasp of perspective. But they convey a certain degree of intimacy, kindly interest, and goodwill that is completely lacking in the *Ecce Homo*. Bosch switches here to a scene told with utmost brutality. The composition is divided by a diagonal line into two groups. The one to the left shows Christ, beaten and scourged, standing with Pilate and his companions upon an elevated platform. An owl is hidden in the small window recess above the head of Pilate and contemplates the scene without apparent emo-

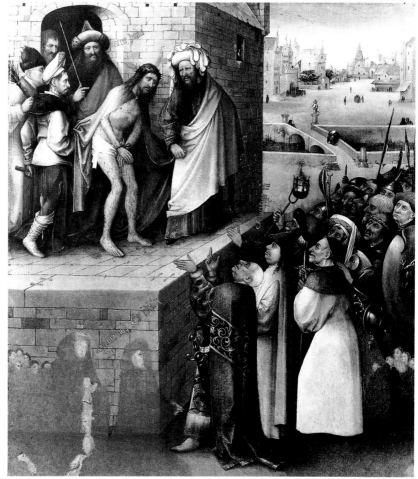

Cat 4 Christ Shown to the People (Ecce Homo)

tion. To the right and at a lower level, the mob howls for blood. The occurrence is being interpreted by inscriptions apposed upon the painted surface and which seemingly issue from the mouth of the speakers. Thus, Pilate says, "Ecce Homo" (Behold the Man), while the people below answer, "crucifige eu(m)." In fact, it was originally not the mob alone that thus cried out, but the two donors, who originally appeared in the lower-left corner of the painting, and who have since disappeared. Their outlines can still be clearly recognized from x-rays done for the purpose of scientific examination and restoration. From the same part of the painting emanates a third inscription: *Salve nos Christe redemptor* (Save us, Christ Redeemer) without any certitude as to who uttered it.

This is Bosch's first painting in which we encounter caricatural and grotesque faces, which are going to become frequent in his future production. Were they due to Leonardesque influences, as often proposed, or do they stem from autochthonous provenances? Tolnay alludes to the Master of Flémalle and, more specifically, to his *Marriage of the Virgin* at the Prado, Madrid, where similar spiteful and malicious faces can be found, as well as the gesture of a spectator placing his hand upon the back of a neighbor. He concludes that Bosch might have made use of a lost work by Flémalle. Others, like Combe, point to an anonymous woodcut of the middle of the century, representing the same subject; a Dutch drawing from around 1480 at the Berlin Print Cabinet, and, of course, the

Schongauer engraving at the Brussels Print Cabinet dealing with the identical theme. D. Roggen explains that the grimacing heads are simply based on the masks worn by the participants in the religious processions at 's Hertogenbosch; Leo van Puyvelde had long ago established a correlation between such masks and the Passion Plays commonly produced in Flanders at the appropriate time of year. In any event, here these contorted caricatures serve to express the mob's anger, while the Oriental headdresses of the men surrounding Christ stress the essential evilness of the scene. From one of the towers in the city in the background flutters the crescent. Islam was in Bosch's times thought to be the primary enemy of Christendom, whose holy places were then controlled by its warriors. Consequently, anything connected with the creed of Allah and its prophet had to be the work of the devil.

The multiplicity of possible sources for this composition establishes that Bosch was far from being buried in a provincial town, without frequent connections with the rest of the cultured world, and that he was not thrown upon his sole inventiveness. Stimuli reached him from the entire Netherlands and adjacent German regions, and far from being a loner, such as he has often been depicted, he fully participated in the intellectual streams of his time. To be dated ca. 1473–75. A derivative of Cat. No. 4 belongs to the Boston Museum of Fine Arts. See our Cat. No. 33.

5

The Seven Deadly Sins

Tabletop. Museo del Prado, Madrid (previously, Escorial). Panel, 120 x 150 cm.
Inscribed on top:
GENS ABSQUE CONSILIO EST ET SINE PRUDENTIA
UTINAM SAPERENT ET INTELLIGERENT AC NOVISSIMA PROVIDERENT.
(Deut. 32:28, 29).
Inscribed in the center below Christ:
CAVE, CAVE DOMINUS VIDET.
Inscription in the bottom part:
ANSCONDAM FACIEM MEAM AB EIS ET CONSIDERABO NOVISSIMA EORUM.
(Deut. 32:20).

This painting was first mentioned by Guevara (ca. 1560) as an original. In the inventory of the paintings that Philip II ordered to be sent to the Escorial (1574), the painting is described under No. 8 as *de mano de Gerónimo Bosco.* Referred to by Sigüenza (1605) together with other works by Bosch as "hanging in the bedchamber of his majesty," with description. The author also asserts that there existed a pendant with the Seven Sacraments.

The theme of this composition is unique in paintings of the period, although well known from miniatures and prints, from which Bosch may well have derived his inspiration. Combe mentions in this respect an Augsburg woodcut from 1477, and Tolnay refers to another one in P. de Crescences, *Le Livre de prouffits champestres,* 1486. Structurally, the composition reminds one of images of the universe, with astronomical spheres, which were here adapted to the specific representation. The eye of the Almighty is shown in three concentric circles, with the figure of Christ risen from the tomb in the center. The others convey his glory shining from the iris, and the world, a witness to the folly of man. The corner roundels, possibly late additions, preoccupy themselves with the last stages of human life: the Death of the Sinner, Resurrection, and Heaven and Hell. In the latter, we encounter the chronologically first, if still timid, evocations of the phantasmic creatures—anthropomorphous devils, curiously shaped reptiles, a peculiar bird—that are going to people Bosch's creations from now on and be responsible for his international fame. Considering that these scenes may stem from another hand, conclusions based on their style must be subject to extreme prudence. Are these phantasmic allusions present in our artist's imaginative vocabulary at this early date, or have they been introduced after his death by some helper in the workshop, to round out the late master's conception according to the helper's comprehension? We do not know.

Greater certitude prevails concerning the seven representations of the Dead-

ly Sins, which certainly mirror Bosch's own invention and style. The execution has often been criticized, and has given rise to the supposition that we are dealing with a later production, primarily done by the workshop. Combe therefore proposes that Bosch followed here archaic methods, and based himself for this work on Dutch provincial paintings of the beginning of the century. He cites as a pertinent example the *Roermond Retable* of around 1420, preserved in the Museum of Amsterdam; there is much to be said for his theory. Furthermore, it must not be forgotten that most artists reserve specific painting and drawing styles for the thematic individuality of their works. In these roundels, Bosch painted the world as it is—quite a different proposition from traditional religious scenes. Therefore, it becomes easily understandable that instead of the elongation and elegance set aside for the supernatural, he drew and painted his subject cruder, more peasantlike—a forerunner of a similar tendency brilliantly traduced by the Elder Bruegel. Another argument, that of a later date for some of the costumes to be seen in these scenes, can be easily disproven. The dating of costumes still remains far from precise, with the appearance of new fashions first coming to the fore in the more fashion-conscious capitals. Even there, new modes first appeared in the politically and militarily more powerful countries, and then trickled down to secondary cities and towns. A garment that was à la mode in Paris, or at the court of Burgundy, at a given date (and these are always approximations), could have been seen there by Bosch during one of his trips to Brussels, Mechlin, or Antwerp. It would take years before the good ladies of 's Hertogenbosch would set eyes on this latest fashion!

These seven scenes, whose titles we mention hereafter, thus constitute an extremely interesting aspect of Bosch's early style, executed in lively colors and with great vivacity. Envy (*invidia*) stands at the beginning of the circle. A toll collector or a shopkeeper scowls at a young nobleman, who

saunters down the road, a falcon on his wrist, while a dog barks at a bone negligently held in the envious one's hand. Anger (*ira*) is a brawl between two topers in front of a country house (a tavern) placed amid a peaceful landscape. A woman, obviously the lady of the house, is trying to soothe one of the adversaries, probably her husband. She is a husky person and physically an easy match for her pugnacious spouse.

In Pride (*superbia*), Bosch seems once again to have borrowed from the Master of Flémalle. He shows us a comfortable burgher's interior with a woman seen *de dos*, trying on a new hat. The spectator, looking over her shoulder, is able to judge the effect in a convex mirror held up by Lucifer himself. The room is luxuriously furnished. On the floor, to the left, is a jewel box; and on the window bench a pomegranate. Lust (*luxuria*) follows Pride and has been represented as the natural attributes of the well-to-do. Elegantly clad couples feast under a tent of precious cloth erected in the open and seem to exchange love potions. Sloth (*accidia*) takes us back into the house and is conveyed through allegory. A man sitting in the center of the composition by the fire is fast asleep. Next to him is a closed Bible. Faith comes to wake him, holding out a rosary and attempting to remind him of his duties. In Gluttony (*gula*), two peasants, one sitting, one standing, are eating and drinking to excess, setting a bad example for a child, who is already overly plump. Over the door is a staring owl, and nailed to the wall a hat pierced by an arrow. Both are symbols of sin and heresy. Finally, Avarice (*avaritia*), personified as the legend of the dishonest judge, is holding out his hands for bribes to both parties.

Gibson (1972) suggests that one of the uses of this tabletop was as an aid to meditation and intensive examination of one's conscience, which every good Christian was urged to undertake before going to confession. This seems to be a very good point, and goes a long way to explain Philip II's predilection for this particular work by the master from 's Hertogenbosch.

To be dated ca. 1470–75. Tolnay, Baldass, and Combe also accept the insertion of the painting into Bosch's early period.

6

The Seven Deadly Sins
Fine Arts Foundation, Switzerland.
Panel, 86.5 x 56 cm.
Signed. Art market, London
(Harris, 1935).
Art market, New York (Spencer Samuels Corp.). Stephen Bangerth, Ingersoll, Canada, ca. 1963. MS Statement by Max Friedländer, dated Berlin, March 17, 1930. The entry in M. Friedländer, Suppl. No. 137, 1969, vol. 14, gives the measurements in inches and not, as erroneously noted there, in cm.

The success of the preceding entry, the Prado tabletop, may have encouraged Bosch to paint a new version of the subject, different in composition. Here, he inscribes the entire theme into an immense sphere, signifying the earth, and includes the Seven Deadly Sins as groups distributed throughout a fantastic landscape, which is still rather archaic in conception. In fact, it strongly resembles older book illuminations, with a medieval city, castle, and wooded hills recalling the art of the Limbourg brothers. The interpretations of the Deadly Sins closely follow those of the Prado tabletop, but in a much simplified manner. It is therefore possible that we have here a preliminary version, afterward expanded in our Cat. No. 5. On top, the crucified Christ dominates the scene, and the bottom indicates a contracted representation of hell. According to a document of 1574, Margarethe Boge of Antwerp owned at that time "*een tafereel van Jeronimus Bosch wesende van de VII dootsonden*" (Moes, 1901, Denucé, 1932, pp. 5ff.). The Escorial-Prado painting was by then already in Spain and the property of Philip II. One can therefore assume that we have here a reference to our painting, which seemingly reached Spain at a later date, conceivably as part of the war booty of the duke of Alba.

Several pigment, dendrochronological, and radiocarbon examinations have been performed, which confirm *grosso modo* a date of execution corresponding to the years of Bosch's career. According to our style-critical analysis, we date the painting from around 1470–75.

7

Christ on the Cross, with the Virgin, Saint John, Saint Peter, and a Youthful Donor
Musées Royaux des Beaux-Arts, Brussels.
Panel, 70.5 x 59 cm.
From the collection of P. Franchomme, Brussels.
Prior owner: the Fétis collection, Brussels.

We have previously seen Bosch basing himself in these early years upon Dutch traditions. With this painting, Flemish style and conceptions come to the fore. Rogier van der Weyden is an obvious source for the figure of Christ, although some archaisms prevail, especially the united legs of the Savior, with his feet nailed together one over the other, instead of his legs astride and crossed feet, normally found in Rogier's representations. However, Christ's body, as well as the figures of the Virgin and Saint John to the left of the Cross, distinctly hark back to Rogerian tradition. One could therefore presume that they were executed shortly after a trip by Bosch to the southern parts of the Netherlands. Some scholars, among them Tolnay and Combe, point to the dependence of this painting upon the 1444 fresco in the 's Hertogenbosch cathedral, which Tolnay ascribes to the grandfather of Hieronymus Bosch. However, the connection does not seem close enough to us to go beyond normal similarities of an identical subject. Furthermore, it must be taken into consideration that the Brussels panel has greatly suffered from erasure and wholesale restoration. Much that looks primitive and awkward, both in the gestures of the figures as in the lacking glazing, must be credited to the hand of the conservator. One of the best surviving parts is the landscape, whose

magnificent development and *sfumato* seem to have been inspired by the environs of Bosch's hometown. The big city on the horizon remains that of 's Hertogenbosch, and it appears very possible that this was how the setting looked in our painter's day. To be dated ca. 1475–77.

8

The Extraction
of the Stone of Madness
(The Cure of Folly)

Museo del Prado, Madrid. No. 2056.
Panel, 48 x 35 cm.
Tondo on rectangular support.
Inscription, partly on top, and on the
bottom in florid Gothic script:
MEESTER SNYT DIE KEYE RAS/ MYNE NAME
IS LUBBERT DAS.

"*Lubbert das*" means, according to Vermeylen, cheated or duped badger. Other literary sources of the period designate Lubbert as a rather simple or downright stupid person—in this context, someone foolish enough to pay a quack good money to extract a stone from his head, thereby curing him of his lack of wisdom. In the picture, it is not a stone that crowns the result of the operation, but a flower, identified by Bax as a tulip (stupidity). Lotte Brand-Philip thinks that the flower signified money. The theme was a current conceit at the period—the assimilation of the sinner to a lunatic—but here represented in paint for the first time. No explanation is available for the funnel on the head of the quack, or for the presence of the monk and the nun, the latter carrying a book on her head. The seeming acquiescence of the two members of religious order in what apparently constitutes an unsavory transaction can only be explained by the painter's occasionally satirical attitude toward certain clerics. A very beautiful flat landscape that comes to an end at a range of medium-high mountains completes the composition, and fits in with the structural approach to the rendering of nature that we have already seen in our Cat. No. 7.

Scholarly opinions vary widely concerning the painting's provenance. According to Tolnay, it is identical with a roundel formerly the property of the bishop of Utrecht, Philip of Burgundy, and mentioned in an inventory of 1524 as hanging in the dining room of his castle of Duurstede, and later, belonging to Don Felipe de Guevara and sold by him to Philip II of Spain in 1570, then sent by Philip II in 1574 to the Escorial, No. 18. However, the latter painting is described as being done in tempera and on canvas. Therefore, Unverfehrt (1972) thinks that these documents refer to another version, since lost. What is certain is that the painting now at the Prado arrived at the Escorial in 1794, coming from the collection of the Duke d'Arco. As to its dating, most critics consider it an early work by Bosch; Friedländer places it around 1490; but more recently, Baldass (1959), Brand-Philip (1958), and Boon (1960) doubt the attribution to Bosch altogether. We do not accept the arguments of these last scholars, and are convinced that our Cat. No. 8 is an authentic work dating from the same time as, and very close in style to, the Prado tabletop *The Seven Deadly Sins*—hence, from around 1475. See our Cat. No. 5. The group of figures of *The Cure of Folly* exists in six other versions, which are all later imitations. They show variations in the structural form, which diverge considerably from the original Boschian thought. The most important such version belongs to the Rijksmuseum, Amsterdam, panel, 41.5 x 32 cm, No. A 1601, where the group is enhanced with supplementary personages, and the scene divided from the background by a wall. Max Friedländer ascribes this painting to Marcellus Coffermans, around 1560. Neither this work nor the variants are directly related to Bosch. They are far from matching the original in conception and execution.

9

Christ Carrying the Cross

Gallery, Kunsthistorisches Museum,
Vienna. No. 651a.
Panel, 57.2 x 32 cm.
Acquired in 1923 from Goudstikker
(dealer), Amsterdam.

Cleaned in the mid-1930s. One found thereby under the repaints, which were eliminated, that the cross of the Good Thief originally extended to the border of the painting, and that a third cross was lying on the ground. A distant landscape emerged from its concealment under the sky. The upper part of the painting ended formerly in a quarter-circle and has since been shortened by about 20 cm. The lower border was cut off by about 2.5 cm. According to Baldass, who was at the time curator at the Vienna Museum, the initial measurements of the panel were 97 x 31 cm. We have here the left wing of a small triptych, whose centerpiece represented, according to Tolnay, a Calvary, and the right wing the entombment of Christ. At the verso, the Christ child is represented in *grisaille* within a circle, in the guise of a child with a scooter and a whirligig.

Bosch's conception of the scene is unusual for Netherlandish painting of the period. The movement imparted to the representation basically differs from the static image of Christ carrying a small cross over his shoulder, which thereby became his attribute. We know this interpretation, showing Christ erect and full of dignity, from Giotto and the subsequent Sienna painters. The conception was then taken up by Franco-Flemish art and in the fifteenth century by Jan van Eyck and his followers. As Tolnay correctly pointed out, Bosch was much closer to the German way of seeing the happening, such as Meister Franke's panel of the same subject in Hamburg, and Multscher's in Berlin (dating from 1437). Even the grotesque and ugly heads of the populace can be found there. One of the bystanders seems to be an autoportrait of Bosch. The artist apparently wanted to convey by this composition that humanity, symbolized through the Christ child on the verso, had to complete its path through life by passing through various way stations, finishing with the sacrifice of our Savior. By linking one of the thieves with a Father Confessor, Bosch placed the biblical scene within his own time.

A *Christ Carrying the Cross*, tempera on canvas, connected in the composition

to our Cat. No. 9, was in the London art trade in the 1930s. Owing to its very bad state of conservation, an ascription to Bosch encountered much opposition. A further version, panel width, 56 x 86.5 cm, formerly in the collection Weinberger in Vienna, and then on the New York art market (before 1956), has been relegated to the status of a copy (Friedländer, 1969, No. 83a). There is a general consensus that our Cat. No. 9 is a youthful work by the artist, with Baldass the only critic to place it as late as 1480. Our proposed date: 1475–80.

10

Ecce Homo
Philadelphia Museum of Art.
John G. Johnson Collection.
Panel, 50 x 52 cm.

The painting is a fragment, probably the upper-left part of a panel, which represented the Stations of the Cross. A drawing at the Crocker Art Gallery in Sacramento, California, which seems to be a weak copy after the lost Bosch composition, shows Christ Bearing the Cross in the foreground and a scene, roughly similar to the one in this painting, in the left background. The copyist borrowed the figures of Christ, Pilate, and the soldiers almost literally. Similar representations of the Passion with small scenes in the background grouped around a large one in the foreground are customary in Netherlandish painting of the period. In the conception, this *Ecce Homo* presents itself quite differently from the Frankfurt interpretation of the theme (see Cat. No. 4). There, the eye of the beholder was led into space by a diagonal, dividing the principal actors standing on an elevated platform to the left, from the populace on the right. In Philadelphia, we are confronted by a friezelike arrangement before a gilt background, separated by a large horizontal balcony, with Christ and Pilate occupying the upper, and the populace the lower part of the pictorial surface. Left of Christ, who stands behind the lowest part of the irregular parapet and appears thereby bodily open to the scorn of the pack below,

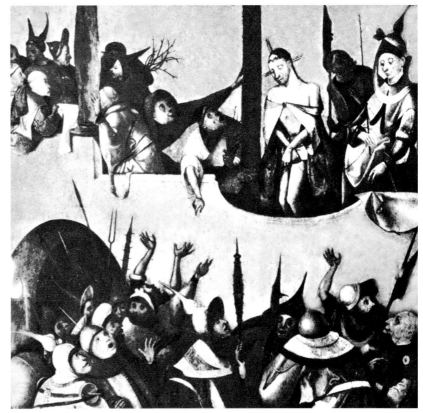

Cat. 10 Ecce Homo

are soldiers, or possibly the myrmidons of the law having previously scourged him. In the lower part, agitated priests and soldiers seem to gather in unending waves. This manner of tapestry-like composition strikes us as primitive, and we therefore agree with those critics who place the panel at an early date in Bosch's evolution, such as Baldass (before our Cat. No. 4) and Benesch (same period as Cat. No. 9). We follow the latter in dating the painting from about 1475–80.
The Clowes Fund Collection, Indianapolis, Indiana, owns an almost identical version on panel, 66.2 x 48.7 cm, which we consider to be a workshop copy.
Another *Ecce Homo* in a Swiss private collection, panel, 62.5 x 53 cm, is known to us from a reproduction only. On this basis, we think that the positive opinions of Tolnay and Benesch are by now antiquated, and that we are dealing in this instance with a later fragmentary copy after Dürer's wood-

cut from the Great Passion, painted toward the middle of the sixteenth century.

11

Christ Carrying the Cross
Madrid, Escorial.
Panel, 150 x 94 cm.

Mentioned among the paintings that Philip II sent in 1574 to the Escorial; for a time at the Palacio Real at Madrid, currently returned to the Escorial.
This large panel must date from the same period as our Cat. No. 9, inasmuch as Bosch repeated here almost literally the figures of Simon of Cyrene and the man holding a flagellum. In his spatial treatment, he has become more plastic, and less vivid in the color scheme.
The two paintings in Vienna and the Escorial convey the artist's conception at the same time as the two following

paintings dealing with Christ crowned with thorns.

We have a group featuring identical preoccupations with monumental rendering of the figures and a discreet as well as cool palette. Done around 1475–80.

12

Christ Mocked

National Gallery, London.
Panel, 72.5 x 58.5 cm. No. 4744.
Formerly in the Magniac collection,
subsequently in a private collection in
Rome.

Monumentality in the rendering has become the principal preoccupation of Bosch in this panel. Christ, a three-quarter-length figure, occupies the center, surrounded by four figures placed almost symmetrically into the corner space. A Roman soldier in armor pushes from the upper left the crown of thorns upon Christ's head. His fellow tormentor, opposite, seems to show more compassion as he soothingly rests his hand upon Je-

Cat. 11 Christ Carrying the Cross

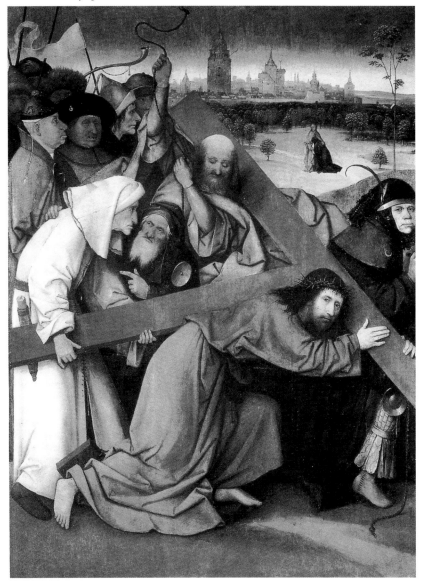

sus' shoulder. In fact, Tolnay believes that we have here the Good Thief. As for the nasty faces right and left at the bottom, we recognize the man with the big hat and the one with the snub nose from our Cat. No. 11, *Christ Carrying the Cross* at the Escorial. Both these figures display hate, envy, and aversion at the highest diapason, the one to the right attempting to claw at Christ's white mantle. Although conceived in the traditional manner, without diableries, this is the first time that we see Bosch adopting the compositional conceit of the close-up vision, dear to his Flemish colleagues Hugo van der Goes and Hans Memlinc. Our artist made further use of it later in his career, and we shall encounter an especially incisive example of this manner in the much later Ghent *Christ Carrying the Cross*. However, before attaining the mastery of depicting all things evil shown in the latter picture, Bosch had to struggle with his own creative imagination on various levels. Here, stillness in the deportment reigns in the upper part of the composition. Jesus looks out at the beholder with a sorrowful and gentle gaze, while the figures at the top are serious, unmoved, and free of emotion. Christ's figure, standing out against the gray-blue background, presents itself modeled with the utmost simplicity but unaccustomed plasticity when compared with the usual flat style of Bosch during his early period. This part of the sacred scene eschews the quality of actuality and stresses other aspects: timelessness and the conveying of Christian virtues, such as the overcoming of adversity through patience and faith. The lower part only given over to the jeering crowd, in this instance personified by the two figures of mocking detractors. Because of the focus on the heads and faces that flows forth from the compactness of the design, each head becomes a psychological study in its own right, used by Bosch to convey his proper variety of reactions.

The painting is not in a very good state of preservation, but where the original paint has been preserved, we can observe the preliminary drawing through the glazes. The date remains the same for the genesis of the whole group: 1475–80.

13

Christ Crowned with Thorns

Escorial, Spain.
Panel, 165 x 195 cm.

Tondo on a square panel. The corners in *grisaille* show Saint Michael and the Fall of the Angels. Sent by Philip II in 1574 to the Escorial (wrongly identified in the apposite document as *The Taking of Christ*). See Justi, 1889.

This imposing panel shows us a radically different conception of the theme. Whereas the London version stands out by its static approach, Bosch's new conception conveys movement, vio-

lence, and turmoil. Christ is again the center of the action, but in a different representation of the Redeemer: he is here enclosed by the group of tormentors, appearing physically diminished yet spiritually overpowering. His gaze, again seeking contact with the beholder, clearly expresses suffering and, at the same time, disdain, for those who cannot see and hear. Hulin de Loo was the first to observe that the physiognomy of Christ in this painting closely resembles that of *Christ in the Entombment* by Quentin Massys at the Antwerp Royal Museum, which dates from 1511. His conclusion that Quentin must have influenced the master of 's

Hertogenbosch needs to be reversed, however, and Bosch credited with the paternity of the artistic invention. The principal action remains confined to the right half of the composition: a rat-like man at the bottom trying to rip off Christ's robe with his mauled left arm and fist; above him, the usually debonair man with a large hat pierced by an arrow, whom we know well from other Bosch panels; and a third one with a hunting horn, watching from behind with an air of concentration.

The two figures at the left seem more detached while observing the goings-on. The second has placed one foot on

Cat. 13 Christ Crowned with Thorns

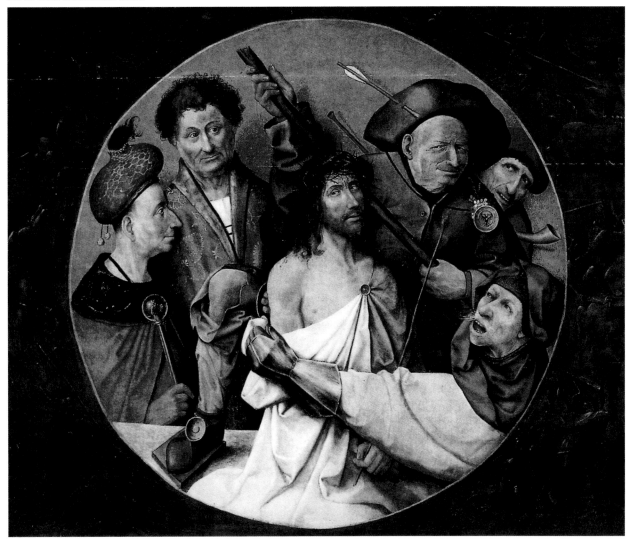

the ledge on which Christ sits—an unusual gesture—and pushes, sarcastically smiling, the crown of thorns more firmly onto Christ's head, while the first one contents himself with aloof observation. A gold background rounds out the scene, instead of the by-now customary landscape. Bosch must have reintroduced this archaism to stress the distance in time that separated his viewers from the actuality of the happening, and thus transform what could have been taken for a simple narrative into an icon permeated with transcendental meaning. To be dated 1475–80.

The composition was copied several times during the sixteenth century. See Friedländer, No. 79 a–c.

Another version, reversed and with variations, must have been in great popular demand at the time. The best-known specimen, with a donor, belongs to the Royal Museum of Fine Arts, Antwerp (83 x 68 cm panel, No. 840). Friedländer lists seven copies (No. 80 a–g) and Unfervehrt several more, some of which may, however, be repetitive with the Friedländer catalog.

The basis for the composition seems to have been a cartoon from the Bosch workshop. The latter probably turned out copies upon demand. Seeing that the dependence of the composition upon our Cat. No. 13 appears to be very close, and that it exists only in reversion, the supposition might also be hazarded that the original was known only from an engraving after a lost work by Hieronymus Bosch.

14

The Last Judgment
Altarpiece - Triptych.
Panel. Centerpiece 164 x 127 cm.
Shutters: 164 x 60 cm each.
Gemäldegalerie der Akademie
der bildenden Künste, Vienna.
Nos. 579–81.

The center represents the Last Judgment, the left shutter the Garden of Eden, the right one Hell. Verso, in *grisaille*, the Apostle James the Elder and Saint Bavo. Blank armorial bearings.

The triptych stems from the collection of Archduke Leopold William (seventeenth century) in which it was cataloged as an original by Hieronimo Bosz. Bought by Count Lamberg toward the end of the eighteenth century.

It is only after much discussion that his work has now finally been accepted as an original by the master, the main reason for the dissension being large areas of overpaint stemming from the seventeenth and eighteenth centuries, which have been removed; and fallout inpainted during two extensive restorations:

Cat. 14 Apostle James the Elder

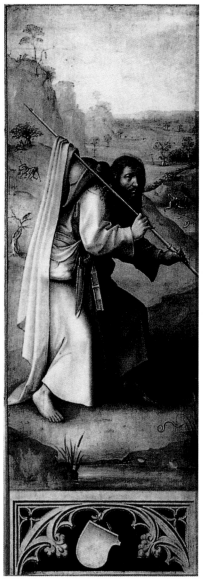

one in the late 1920s (see Eigenberger, Kat. 1927) and the other in 1960 (see Kat. 1961, catalog entry by M. Poch-Kalous). The cleaning revealed the fine pictorial quality of the triptych as well as numerous corrections (*pedimenti*), which completely exclude the former theory of a copy. An engraving of the centerpiece was published by H. Cock, thus in the sixteenth century.

We stated above that in 1504, Philip the Fair commissioned Bosch to paint a Last Judgment whose dimensions were 11 x 9 feet. H. Hymans, an otherwise merito-

Cat. 14 Saint Bava

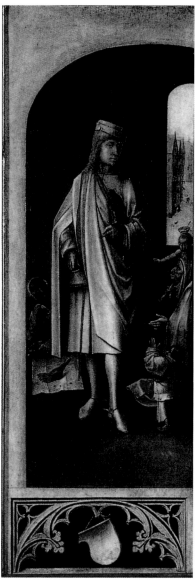

rious Belgian scholar, proposed in 1884–85, without rhyme or reason, that the Vienna triptych was nothing but a reduced copy of this Last Judgment. His contention was accepted by a number of serious art historians, without any of them questioning the obvious, namely, that no one knows what this monumental lost work by Bosch looked like. One Last Judgment is not necessarily identical with another one, even if they are by the same artist. Aside from this very questionable ascription, Glück and another Austrian by the name of Dollmayr discovered in the Vienna work a letter *M* appearing on a knifeblade. Such letters, especially when they are not written in Gothic script, as customary with Bosch but in *antiqua*, are generally simple decorations. One can find them not only on a knifeblade like here, but on jewels and ornaments, even on badges on hats. Nevertheless, Glück (1896) attributed on this tenuous base the Vienna triptych to Jan Mandyn, and Dollmayr (1898) to Jan Mostaert. By now, "all doubts seem...to have been silenced," as Friedländer stated in 1969 (No. 85). With the exception of Tolnay, who remained unconvinced until the end, our Cat. No. 14 is finally accepted as authentic by the general consensus.

This is the first work in the artist's phantasmic manner linked to religious subjects—a combination to which he owed his widespread reputation. As in most of his large triptychs, the content has to be read from left to right. In this instance, the story begins with paradise, namely, the creation of Adam and Eve, above, i.e., farther back in the composition, the temptation and finally the expulsion of the guilty pair (from the heavenly abode of which they had shown themselves unworthy) by an angel wielding a naked sword. These three scenes are set into a luscious landscape, still primitive in the structure and put together with separate units of lawn, trees, rocks, and water. The archaic character of the composition stresses the irreality of the happening - far removed from earthly comprehension and belonging to the realm of the supernatural. On top, our Lord is shown throning amid clouds, while Lucifer and his fallen angels are being de-

prived of His presence and banished to earth. There turned into demons, their activities become part of the subject matter of the central panel. It is here, and in the side panel to the right, Hell, that Bosch allows his imagination complete freedom. Aside from God and some angels at the top as well as the twelve Apostles kneeling right and left of Him, almost the entirety of the Last Judgment is given over to the punishment of the damned. Vice is being chastised everywhere with demons and odd creatures going lustily about their business. Quite obviously, the artist had no intention to show the Apocalypse as something other than a stern reckoning with the sinners, and there is an almost complete disregard of those who were saved. Accordingly, Bosch must have been convinced that the overwhelming majority of mankind deserved to be doomed, and his paintings are essentially a last-minute warning and representation of what was to be expected in the next world.

Hell is therefore an extension of the Day of Judgment. The prince of darkness, to whom homage is being paid by his followers and servitors, occupies the forefront of the scene, while the damned human souls, shown in their nakedness, are exposed to the most unbelievable tortures and torments. Bosch did not preach a sermon in this altarpiece. God and His son are not the embodiment of love in his understanding, but the executors of a stern, almost Mosaic justice. Therefore, he neither dwells upon hope nor redemption. Doubts are permitted, whether or not the painter truly believed in salvation.

The outside representations of the altarpiece are the Apostle Saint James the Elder, whose grave is revered in Compostela (Spain), and Saint Bavo of Ghent, who was in his lifetime a count, who repented his former excessive lifestyle and ended up by giving his wealth to the poor. There is no reason to believe that the two saints are in any way connected with the initial owner of the altarpiece—the more so, as the blank armorial bearings indicate that Bosch did the work without having a specific purchaser in mind. A close copy of the triptych, without the versos of the

shutters, was done by the hand of Lucs Cranach the Elder and belongs to the Berlin Museum, No. 563. Panel, 163 x 125 - 58 cm.

Our Cat. No. 14 should be dated ca. 1480–82.

15

The Deluge. Hell
Two shutters,
on the back in grisaille
four medallions with tondo pictures of
allegorical religious scenes.
Panel, 69 x 35 cm and 69.5 x 38 cm.
From the collection of Count Chiloedes,
Madrid, and Koenigs, Haarlem.
Museum Boymans-Van Beuningen,
Rotterdam,
Nos. St. 27, 28.

The paintings were most probably originally wings of a triptych, whose centerpiece is missing.

Because both sides of these shutters are painted in *grisaille*, the central part may very well not have been a painting, but a relief or scene sculpted in wood. It is known that Bosch completed another such altarpiece for the Brotherhood of Our Lady in his hometown.

He also was asked to furnish only the wings. Hell seems here to have been the left wing and the Deluge the right one. Scholars do differ as to the interpretations of these paintings, but one is reasonably sure that the right wing shows the landing of Noah's ark on Mount Ararat, with all the animals, as well as the human beings, landing in pairs—male and female. This seems to be an allusion to the fertility of the new life on earth.

As for the tondos on the verso, readings of their meaning remain variegated without arriving at a consensus.

The two paintings are originals, although imperfectly preserved, and belong, with the preceding catalog entry and the following, to a group that illustrates Bosch's preoccupation with the mysteries of the end of the human race and the coming of the inevitable Day of Judgment, at this precise point in his career.

To be dated ca. 1480–82.

16

Four Panels

*Two of them show the damned,
the other two the ascent of the blessed.
Panel, 87 x 39 cm each. Currently at the
Palazzo Ducale, Venice. Formerly at the
Accademia, same city, Nos. 182, 184.*

Marcantonio Michiel mentions in his *Notizia d'opere del disegno*, 1521, three paintings by Bosch that he had seen in the house of Cardinal Grimani in Venice. Among them, *La tela del inferno con la gran diuersità de monstri fo de mano de Hieronimo Bosch* and *La tela delli sogni fo de mano de linstesso*. It is probable that these paintings are identical with those now in Venice. No others have been found that tally with the description, and art historians have accepted provenances with much less serious foundation than the one that can be traced back to the generally reliable Michiel. The support of the paintings being wood and not canvas as mentioned by our chronicler, behooves us to clarify what appears to be a recurrent misunderstanding. In the Romance languages, the term *tela* or *toile* can signify in everyday usage simply a painting, without specifically meaning that it was done on canvas. Thus, even in inventories, the description of the support must not always be accepted as final. It all depends upon the whims of the scribe, who, as is generally known, often varied the spelling of the name of the author of the work according to his fancy. This custom lasted well into the eighteenth century, and frequent examples can be cited from official and notarized documents, until the oral tradition was finally replaced by the written one.

The panels, which one supposes to have been originally wider, seem to belong to a triptych whose centerpiece has been lost. According to Tolnay, whose order of grouping has encountered general acceptance, the celestial paradise used to be seen above the terrestrial one, and the Fall of the Damned on top of the representation of hell. Bosch followed here an older iconography, as we know it from, for example, the altarpiece of *The Last Supper* by Dierik Bouts in Louvain. Another such indication is the fact that in the terrestrial paradise, depravity and de-

terioration had come to the fore. We see, for instance, one lion devouring another. Thus, according to Tolnay, the disintegration had begun already in the terrestrial paradise, and Bosch pursued that thought in the left wing of his altarpiece *The Garden of Delights* (Cat. No. 31).

In his representation of the Fall of the Damned, Bosch significantly reduces the number of figures, when compared, among others, with works by Jan van Eyck, Dierik Bouts, and Memlinc. Consequently, it is the somber, empty space of the universe that becomes the main theme of the scene.

Altogether, we encounter in these wings a new development in the artist's imagination and visualization of hell and paradise.

To be dated ca. 1480–82.

Cat. 17 The Sinners in Hell (FRAG.)

17

The Sinners in Hell
(Fragment of the Last Judgment)

*Panel, 60 x 114 cm.
Alte Pinakothek, Munich.
No. 5752.*

Formerly, in 1822, at the Staatsgalerie, Nürnberg. From 1877 to 1920 at the Germanische Museum, Nürnberg; since

Cat. 17 The Sinners in Hell

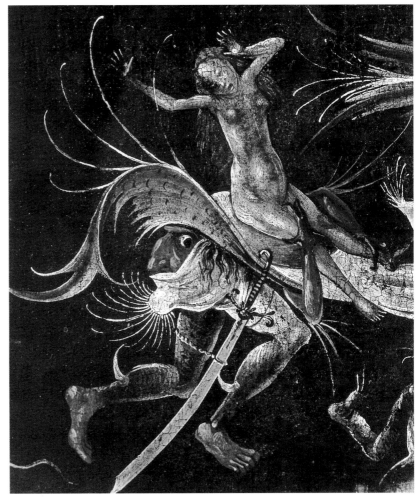

then part of the reserves of the Alte Pinakothek and rediscovered by Buchner in 1934.

We most probably have here the lower-right part of a panel that was originally twice as wide as the present fragment. Tolnay, without any justification, proposes that this is a vestige of the Last Judgment commissioned in 1504 by Philip the Handsome.

As pointed out previously, we know nothing of the whereabouts of this commission, other than that it was a Last Judgment, and its size. All proposed identifications are therefore pure fantasy.

The devil at the right, seen from the rear, and the monster beneath him, correspond with the preliminary drawing at the Ashmolean Museum, Oxford (Tolnay, 1989, Drawing No. 12). To be dated ca. 1485.

18

The Hay Wain

Triptych.
On the verso of the wings: A Vagabond.
Left shutter: The Fall of the Angels,
The Garden of Eden.
Right shutter: Hell.
Panel, 135 x 100 - 45 cm.
Museo del Prado, Madrid, No. 2052.

Signed on the centerpiece. There exists another, slightly bigger (140 x 100 - 147 x 66 cm) version at the Escorial, No. 378, which is a copy, skinned and overpainted in large areas. It is incomprehensible how this inferior work could seriously have been considered the original by some otherwise reliable authors. The original triptych, now at the Prado, was part of six panels bought by Philip II from Guevara and sent in 1574 to the Escorial.

The Prado version presents itself as a work of Boschian quality where the original paint has survived. Here, too, large areas of the pictorial surface have been overcleaned, and often overpainted. Others have remained free of the restorers' additions, and look what they are: skinned. A good example is the hay wain of the center piece, where the hay has become a single yellowish mass, deprived of any detail. The dam-

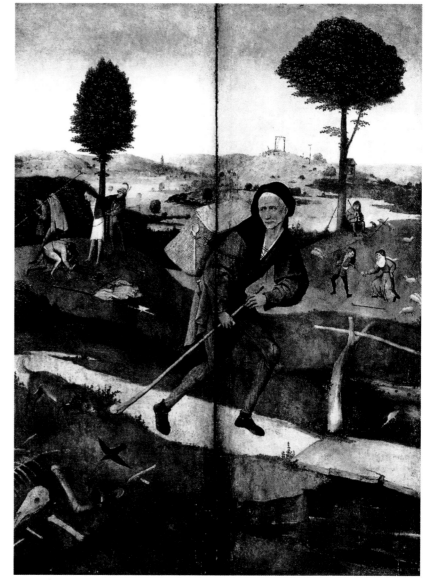

Cat. 18 The Hay Wain, on the verso of the wings

age is due to the misunderstanding of Bosch's painting technique, which consisted, as explained in more detail earlier, of layers of oil-and-varnish glazes containing small quantities of pigments, super-imposed upon the solid tempera underpaint. It was these glazes by means of which details like separate stalks of the dried wheat were realized that proved to be exceedingly vulnerable to nonprofessional cleaning and erasure.

The same fate befell a famous work of almost one hundred years later, that by

Pieter Bruegel the Elder at the Metropolitan Museum in New York, one of twelve panels depicting the months of the year. The one in question is called *The Harvesters* (July) and shows men harvesting a field of wheat. Because of overcleaning, the field has become a dull mass lacking any particulars whatsoever, into which the mowers lustily swing their scythes. A big tree, off center, divides the composition into two parts. Its trunk, comprising the lower part of its height, is now almost completely bereft of its original brownish

pigment, and all that remains are the outlines. Apparently, the coloring agent used by Bruegel was, as was customary at the time, dried mummy, which, on account of the bitumen contained therein, is nondrying.

The too-eager cleaners of the painting wrought irreparable damage through their ignorance of Flemish painting techniques, in spite of the fact that the techniques were described in great detail by Van Mander at the beginning of the seventeenth century. Alas! Few works by Bosch in Spain escaped similar treatment and mutilation.

As we have seen in Bosch's representations of the Last Judgment, the artist approaches mankind's prospects in a truly pessimistic vein. In *The Hay Wain*, we encounter in the left inner wing, just as in the piece at the Vienna Akademie, the Creation and the Fall of Man. The sequence is, however, reversed, with the Expulsion at the bottom, the Temptation in the middle, and the Creation on top, crowned by our Lord throning in the clouds and expulsing the fallen angels toward earth. The right inner shutter introduces us to hell in a composition that is more narrative than the more abstract rendition in Venice. The artist has introduced here a new motif, a circular tower in the process of construction, which has been variously interpreted as a symbol of the reception of all those condemned to enter hell, or as a reminiscence of the Tower of Babel, by which men attempted to reach heaven by their own means.

Although towers appear frequently in medieval representations of hell, this seems to be a first instance in which one is shown the process of building. New also is the iconography of the centerpiece, which has been variously interpreted as the triumph of Avarice (Gibson), transitoriness (L. Lebeer and J. Grauls, 1938), intemperance, and lasciviousness (by others). A hay wain is being drawn by devils in the direction of hell, horizontally across the surface and placed into a wide landscape. Thus, the composition is designed to be read from the left, where we see a pope and an emperor on horseback, with a following of nobles accompanying the hay wain. In the center, peasants and burghers, as well as nuns and monks, run alongside the cumbersome vehicle, on whose top a pair of lovers seem oblivious to the goings-on below. An angel, left, rounds out the group and seems to be praying for all concerned, while above, amid golden clouds, Christ watches over the whole happening on its way toward damnation (hell, to the right).

The outstanding feature in this panel is the hay, symbol of the worthlessness of all worldly possessions. The pursuit of such empty illusions leads inevitably to the arms of Satan. As a Dutch song of the period used to teach: "in the end it is *al hoy* [all hay]." As several scholars (among them, Tolnay and Gibson) have pointed out, Bosch's *Hay Wain*, with its many allegorical attendants, recalls the allegorical processions of Petrarch's *Trionfi*, which furnished the subject matter for a great number of tapestries of the fifteenth and sixteenth centuries. Bosch translated these heroic conceptions into a satirical and rural language.

The Vagabond on the verso is not, as often asserted, a preliminary version of the *Parable of the Prodigal Son*, but a mediocre workshop copy after it. The cartoon for this composition must have existed in the studio by this time. See the following entry.

The triptych can be dated ca. 1485–90.

19

The Prodigal Son
Panel, 71 x 70.6 cm.
Tondo, diameter 64.6 cm.
Museum Boymans-van Beuningen,
No. 1079.
Provenance:
collection of Theodor Schiff, Vienna;
collection of Dr. A. Figdor, Vienna.

Glück, Hannema, Friedländer, and Tolnay interpret this composition as the parable of the Prodigal Son "at the mo-

Cat. 19 The Prodigal Son

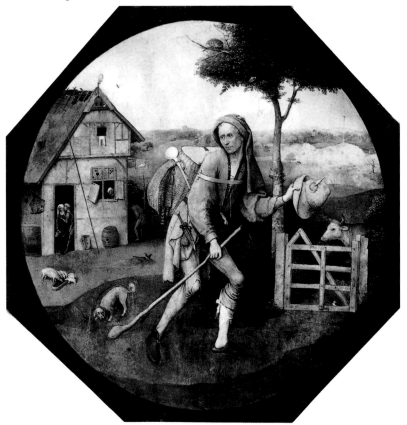

ment of his enlightenment," a theory with which I concur. Baldass, and after him, Sudek, consider it simply a moralizing proverb. Pigler thinks that the vagabond or beggar must be seen as a child of Saturn, a hypothesis with which Lotte Brand-Philip concurs, although the planet itself is lacking in the picture. The American scholar's further explanation of the main figure as a peddler who is basically a villain against whom Bosch the moralizer proffers a warning in the name of mankind has been refuted by D. Bax and Tolnay. Gibson's theory, that the unfortunate must be a symbol of man, "the pilgrim making his way through the treacherous world whose vicissitudes are represented in the landscape," echoes the original Boschian idea, which he then elevated to a more sophisticated level, that of teaching us through the well-known parable of the Prodigal Son. That this is so is proven by the presence of the motif of the swine at the trough. The Prodigal has just left a bad house and returns to the gate of his father's home. He personifies the sorrowful situation of the human soul on earth, and his lack of will power in the choice between vice and virtue.

The large composition on the verso of the shutters of *The Hay Wain* is nothing but a simplified workshop copy of the present composition. A number of critics, with the exception of Baldass (1917), who thinks that Cat. No. 19 is contemporaneous with *The Hay Wain* wings (which is also my opinion), have therefore asserted that there must be a difference in time of about ten years between the different works, proposing consequently that *The Hay Wain* shutters constitute a preliminary stage of the composition.

In my opinion, such an assumption is erroneous. The difference in quality between wings and tondo stems from the fact that the latter is an authentic work by Bosch, whereas the wings are mediocre productions by another hand. Given this fact, the cartoon for *The Prodigal Son* must have existed in Bosch's studio by the time *The Hay Wain* was produced, and the tondo now at the Rotterdam museum was

therefore executed at approximately the same time. It thus dates from about 1485–90.

20

The Altar of the Hermits. Saints Jerome, Anthony, and Giles.

Panel, 86.5 x 60 - 29 cm.
Signed in the lower-right corner of the centerpiece: JHERONIMUS BOSCH.
Palazzo Ducale, Venice.
Provenance:
from the Imperial Museum, Vienna, first exhibited there in 1893; since 1919 at the Palazzo Ducale.

Badly damaged, most probably by fire. Landscape and sky of the centerpiece are overpainted, as well as the head and torso of Saint Jerome. The upper border of the center panel has been cut down. It was originally rounded, and the two upper corners are later additions. The work was first mentioned by Zanetti, Della Pittura Veneziana, 1771, "*Nella istessa Stanza dell'Eccelso Tribunale sono...S. Girolamo nel mezzo ed altri Santi dai lati.*"

The three anchorites, Anthony, Jerome, and Giles, constitute the theme of this altarpiece, each shown separately at prayer or exposed to temptation. On the left shutter, see Saint Anthony apparently aroused from sleep by a fire that broke out in the village in the background. He draws water from a swamp to slacken his thirst. His is a motif that was encountered in several other Bosch or Bosch-related compositions in connection with this particular saint (See Unverfehrt, 1980, Cat. Nos. 34, 34a–c, 35). The author has proposed a separate anonymous "Master of Saint Anthony drawing water" to whom he attributes, among others, the left wing of *The Altar of the Hermits* at the Palazzo Ducale, Venice; (see our Cat. No. 20). Saint Anthony looks sleepy in this representation, and it is thus that we see him surrounded and tormented by demons and the amorous Devil-Queen, who can be explained in Freudian terms as having appeared from his subliminal perceptions but still below the threshold of consciousness. In other words, Freud having been unknown at the time, Bosch showed the temptations, desires, and longings by which even a saint can be plagued if and when he lets down his guard.

This left shutter is extensively damaged, which has given rise to doubts as to its authenticity. Evidently, the restorations are by another hand, probably an Italian artist called upon to overpaint the areas harmed by fire.

The center panel is reserved for the representation of Saint Jerome, who kneels before a crucifix, which gives him security against the evils around him. The crucifix appears suspended over the seat of an antique damaged marble throne, while remains of what was a Roman temple enclose Jerome from all sides. Pagan reminiscences signified the evil world at the time, and it is therefore no surprise that this environment was peopled with demons, monsters, and fantastic visions representative of the saint's tumultuous inner life. Behind him is a formation of rocks, which in his imagination has become a kind of hut through whose chimney smoke rises.

Saint Giles prays before an altar on the right wing. A grotto serves as his chapel. An arrow pierces his breast, reminding the viewer of the time that he was accidentally shot by a hunter. At his feet, a tame deer seems to listen to his communication with his maker, and his intercession for the sinners whose names appear on a long parchment roll lying next to the closed book. This altar seems to have been painted exclusively with the following in mind: the focus upon the inner life and vision of the Holy Fathers, hermits, and the like, who remained in the desert and attempted there to gain spiritual progress through mortification of the flesh, prayer, and meditation. In these attempts, they were often assaulted by the devil and had to fight off his temptations. Bosch's sources for these themes were, as we have explained earlier, manifold. As the principal one, we can cite the *Imitation of Christ*, which brings the monastic ideal into prominence.

Tolnay considers the Saint Anthony on

the left wing a further development of the *Saint Anthony in a Temptation* in the collection of Walter P. Chrysler, New York (his No. 21a), as well as of the Saint Anthony on the Lisbon altarpiece (our Cat. No. 28).

In my opinion, the Chrysler painting is a later imitation, and the comparison of Cat. No. 20 with the Lisbon triptych can hardly be called convincing. To be dated ca. 1490–95.

21

The Martyrdom of Saint Julia

Left shutter, Saint Anthony.
Right shutter, a soldier, led by a monk.
Panel, 104 x 63 - 28 cm.
Palazzo Ducale, Venice.
Signed on the centerpiece in the lower-left corner: JHERONYMUS BOSCH.
Provenance: from the Imperial Museum, Vienna, exhibited there since 1893.
Since 1919 at its current location.

Mentioned by Zanetti, *Della Pintura Veneziana,* 1771, "Nella stanza dell'-Eccelso Tribunale…la crocefissione d'un Santo o Santa martire." Severely damaged (probably by fire).

As far as is possible to ascertain, this altarpiece seems to be closely related in composition and execution to the preceding entry, at least as far as the centerpiece is concerned. The two wings seem more primitive and less fluid in the execution. Baldass has therefore proposed that the wings were originally done for another triptych, and only belatedly joined to this centerpiece. Tolnay agrees as far as the composition is concerned, but holds that the technique is the same—a fact that is most difficult to judge in view of the poor state of preservation. I therefore am inclined to concur with Baldass.

From x-ray examination, we can see that figures of kneeling donors were originally present on the wings, but overpainted by Bosch himself at a later stage. On the left wing, a tower took the place of the donor; on the right wing, it became a rock. Consequently, Bosch made use of panels for these wings, upon which he had already begun another composition.

To the left, we find Saint Anthony seated in the foreground on a stone bench, engulfed in prayer and meditation. Behind him is a shed occupied by an army of demons who are setting up pulleys, crowbars, ladders, and other siege materials. In the background, the assaulted town is burning, and its inhabitants are fleeing in despair, trying to save their meager belongings. Gossart remarks, appropriately, that Bosch has rendered these disasters very realistically, apparently drawing upon personal experiences. Similar conflagrations were numerous at the time.

Saint Julia on the Cross dominates the center. The governor and his counselors, as well as the surrounding populace, are seized with terror when she suddenly radiates power because of her newly conferred sainthood. Her red dress seems to encompass the whole picture with this color, as if foretelling radical political or social change, and possible fiery revolution.

The right wing is but a continuation of the left one, within the background the remainders of the nocturnal horror. In the foreground, the two figures have been identified by several scholars as slave traders who, according to legend, sold the saint to Eusebius. *Se non è vero…*

To be dated, in my opinion, after *The Altar of the Hermits,* thus ca. 1495.

22

Saint Jerome at Prayer

Panel, 81 x 61 cm.
Ghent, Musée des Beaux-Arts.
No. 1908-H.
Acquired for the museum in 1908 by Hulin de Loo.
No other known provenance.

The saint lies, praying, in a shell-like opening of a rock formation. He is shown as an emaciated penitent, holding the crucifix in his arms, and utterly absorbed in his communion with God. Hence, the devil does not plague him excessively with temptations, apparently conceding defeat. In the background is a cosmic landscape reminiscent of Patinir, although not as divided into different

sections, and with more blending in the shades of coloring. The palette is vivid, the background toward the horizon in greenish instead of the to-be-expected bluish tints.

This is the first time that one encounters the saint in a flat, horizontal position. He is usually shown kneeling, in prayers. To be dated ca. 1495–1500.

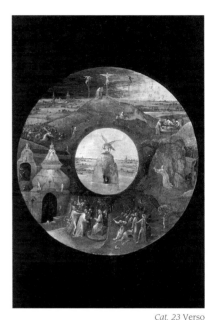

Cat. 23 Verso

23

Saint John on Patmos

Panel, 63 x 43.3 cm.
Verso, in grisaille, scenes from the Passion, arranged in a ring.
Gemäldegalerie der Staatlichen Museen, Berlin-Dahlem.
From the W. Fuller Maitland collection.
Signed in the lower-right corner (partly worn away): JHERONIMUS BOSCH.

The saint is seated in the foreground on rising ground, and apparently lost in deep meditation. Directly behind him is a large rock, upon which an angel draws his attention to the apparition of the Virgin in a solar disk (top-left corner). The boulder with the angel separates him from the world, exemplified by a river and a town in the background. P. Wescher thought that this might be a view of Nijmegen. On the river is a ship and a shipwreck. In the lower right is a devilish roach that tries to steal Saint

John's inkwell with a rake. The composition avows obvious borrowings from a Schongauer print representing Saint John, as well as the *Saint John on Patmos* painting by Dierik Bouts at the Rotterdam museum. This is another proof that Bosch was by far not a solitary artist working in the provinces who was not touched by the contemporary artistic currents. German and Netherlandish influences can be shown in his conceptions again and again. (See also Dvorcak, *Kunstgeschichte als Geistesgeschichte*, for the aforementioned.)
To be dated 1500–1505.

24

Saint John the Baptist in the Desert

Panel, 48.5 x 40 cm.
Museo de la Fundación Lázaro-Galdiano, Madrid.
From the collection D. José Lázaro, Madrid.
First exhibited,
J. Bosch,
Boymans Museum, Rotterdam, 1936, No. 54.

The panel is cut down on both sides, and the painting surface is partly damaged, especially in the center.
The saint is shown facing the spectator, lying down with his elbows propped upon the smooth slope of a rock. He meditates, with half-closed eyes, before a fantastic plant with a surrealistic large fruit.
The open seeds being picked at by birds could be interpreted either as a symbol of fertility, or simply, Nature. The Baptist's right hand points to the lamb in the lower-right corner, identifying himself thus as the precursor of Christ. Bosch explains herewith the alternatives open to man: the spiritual life, or the one of the flesh and sensuality, symbolized by the fruit of the plant.
In the background are curious rock formations that Fraenger has interpreted as the prison of the saint.
A very modern landscape rounds out the composition, consisting mainly of trees and fields, which are united through *sfumato* treatment and indicate depth by

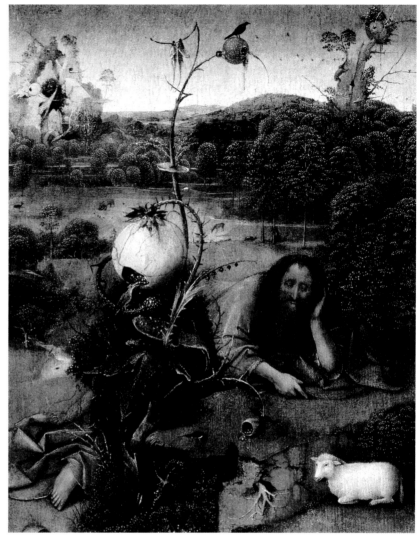

Cat 24 Saint John the Baptist in the desert

means of an aerial perspective.
Bosch owes debts in the invention to various other masters: to Geertgen tot Sint Jans's *Saint John the Baptist in the Wilderness* in Berlin; and a German copper engraving from the fifteenth century by the Master of John the Baptist, from which he almost literally borrowed the motif of the saint pointing at the lamb of God, and the composition of the landscape.
In opposition to our Cat. No. 23, the palette of this painting features somber tonalities, and, as Tolnay remarked, "a wonderful harmony between deep reds and light greens."
To be dated ca. 1500–1505.

25

Saint Christopher

Panel, 113 x 71.5 cm.
Signed lower-left corner:
JHERONIMUS BOSCH.
Museum Boymans-van Beuningen, Rotterdam. No. St. 26.
From the Koenigs collection, Haarlem.
Overcleaned and damaged in several parts.

Saint Christopher is depicted in the foreground, crossing a river, and carrying on his back the Christ child. His bunched cloak stands out in glowing carmine, in opposition to the darker vermilion of the

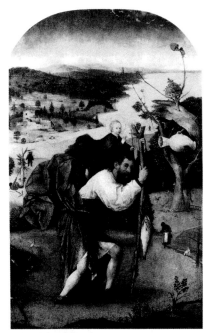

Cat 25 Saint Christopher

robe of the Christ child, "the combination of reds forming a striking harmony with the blues of belt and landscape, and the mother-of-pearl tonalities of the big trees to the right" (Tolnay). Here, too, Bosch drew upon an engraving by the Master of John the Baptist for the composition (compare with Lehrs 10). According to legend, the saint was converted to Christianity by a hermit, whom we find standing at the lower right at the edge of the water, not far from his treehouse, of which however, he has been dispossessed by devils who have turned it into a tavern in the shape of a broken jug. The painting contains many symbols of evil: a shipwreck in the middle-ground left; a dragon lodging in a ruin in the background left; and a burning town behind. Among the various sources for the composition, the *Legenda Aurea* certainly played a major part in this composition, such as Christopher's staff sprouting shoots.

To be dated ca. 1505–10.

26

Saint Christopher
Panel, 45 x 20 cm.
Signed.
Private collection, Madrid.

First published by D. Angulo-Iñignez, *The Burlington Magazine*, 1940, I, p. 3. Not cataloged by Friedländer, as erroneously asserted by the owner (oral communication, Aída Padrón). Accepted by Tolnay (No. 27a), who, however, judges only from the reproduction. I was not allowed to see the painting. According to recent research (Unverfehrt, 1980, Cat. No. 39, p. 259, fig. 106), we have here a repetition after the left quarter of a drawing at the Ashmolean Museum, Oxford (Unverfehrt, ibid., Cat. No. 28), which is probably a copy after a lost original by Bosch. Cinotti (1967) could not arrive at a clear decision concerning the painting's authenticity. Reuterswärd (1970) and Unverfehrt (1980) do not accept Bosch's authorship. Judging only from a reproduction, I must reserve my opinion.

Cat 26 Saint Christopher

Evidently, the owner is afraid to submit his painting to free scholarly examination. It therefore could not be illustrated here.

The painting is more than twice as high as it is wide. It is probable that it was cut down on both sides. We see in the center the figure of the saint, curiously twisted, with the Christ child on his back enclosed in a glass sphere. Angulo compares the composition with a Saint Christopher in a Berlin private collection, then attributed to the Master of Frankfurt by Winkler (1924). I very much doubt that this early ascription can now still be maintained, although both works undoubtedly have the same source—probably a German one.

In the foreground is an army of demons, on whose banner the half-moon—the symbol of the adversaries of Christianity—is inscribed.

The landscape is undifferentiated and of lesser quality than that of our preceding entry.

Given the circumstances, it is very difficult to assign a date to this work. If authentic, it must be very late, about 1515–16.

27

The Temptation of Saint Anthony
Panel, 70 x 51 cm.
Museo del Prado, Madrid.
No. 2049.
Formerly at the Escorial.
The painting is well preserved.
The preliminary drawing is partly visible through the glazes.

The saint is seated in the foreground in the hollow of a tree. He wears the Saint Anthony cross on the right shoulder of his robe. A pig reposes, stretched out, next to him. Surrounding him are many monsters, distributed over the whole landscape. In the middle and backgrounds, we see buildings, such as the house on fire directly behind the saint, which probably can be identified with one of Anthony's attributes. This version of the theme belongs to the most mature renderings of the various temptations that issued from the brush of

Bosch himself and his workshop. It differs remarkably from our next entry, the Lisbon altarpiece, in which the saint has not yet attained, according to Tolnay, the "last level of wisdom" that characterizes this painting. The structure of the landscape, graded into terraces, appears unusual for the artist at this point of his career, and constitutes a backsliding into a more archaic conception. However, the color gamut, tender light-greenish and bluish tints, as opposed to the beige of the foreground, speaks of a later date

and allows parallels with the Prado *Epiphany* (our Cat. No. 29). It should therefore stem from the master's last period, about 1505–10, as also proposed by Tolnay, Baldass, Combe, et al.

28

The Temptation of Saint Anthony

Altarpiece. Panel, 131 x 119 -53 cm. Signed on the lower left of the center panel: JHERONIMUS BOSCH.

Cat 27 The Temptation of Saint Anthony

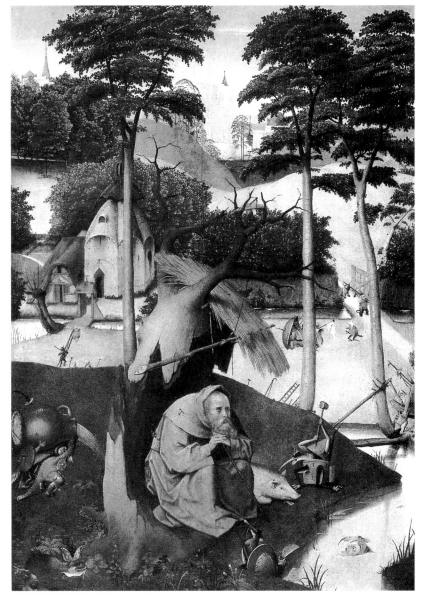

In grisaille, *on the verso of the shutters: The Taking of Christ and Christ Carrying the Cross. Lisbon, Museu Nacional de Arte Antiga. No. 1498. Provenance: from the Ajuda Palace, as a gift of King Manuel to the nation of Portugal.*

The earlier ownership of the work remains open to discussion, such as the attempt to identify it as one of the three *Temptations of Saint Anthony* that Philip II sent in 1574 to the Escorial, or its possible prior (between 1523–45) presence in the collection of the Portuguese diplomat Damião de Goes, who bought a Temptation (not necessarily this one) for 100 cruzados (see Unverfehrt, 1980, pp. 19–20).

Unfortunately, as with so many works by Bosch, the state of preservation of this altarpiece leaves much to be desired. The lower part of the center panel was heavily damaged and has now been restored. Other areas of the work have suffered likewise.

This altarpiece is the most important rendering by Bosch of his conception of the legend of Saint Anthony, or of any other hermit whom he had chosen as subject matter. We can consider it as the synthesis of the artist's numerous attempts at interpretation. Up to now, the epic character had prevailed in the works that we have previously considered or shall study in the subsequent subdivision of copies and imitations. In the present instance, the painter induces us to participate in a dramatic action, constructed in a triangular mode. Starting with the wings, where the most important groups of figures are crowded into the foreground, the diagonals recede toward the highest point, centered in the middle panel. On the left wing, one perceives Saint Anthony flying, laying on an impure (in its biblical connotation) beast with bat wings, harassed by demons. Around him, there are other malevolent creatures astride on fish or sailing in a boat supported by a winged toad. In the foreground, we find the saint hermit restored to his disciples, but in a complete state of exhaustion. He is supported by two of his followers, who endeavor to lead him back to his hut. This retreat has cast itself in the meantime into a vaguely human, squatting figure,

Cat 28 Verso of the left shutter

Cat 28 Verso of the right shutter

loopholes and extending toward a cone of stonework. The latter is covered by a cupola, from which emanate veils that partially hide the remainder of the edifice. The infernal train of Saint Anthony, suitable to instill fear for want of being able to tempt him, is composed of everything that the artist could conceive of in the realm of collected horrors. A woman whose body ends in the long tail of a saurian presents the saint with a cupful of an intoxicating cordial. A demon is dressed in the habit of a priest; in the uplifted chalice, a toad carries the consecrated wafer. In the skies and on earth, fish fly, devils disguise themselves, and demons appear in composite forms. In the background, a village is on fire.

When everything else seems to fail, the devil attempts to win his victory by means that Saint Athanasius pertinently described as the "navel of the belly." Thus, in the right wing, the Tempter has cast himself into a naked and very desirable woman. A toad, faithful servant, sets aside the veil; and Luxury, emerging from the hollow of a tree, makes the supreme assault upon the virtue of the saint. He, however, turns disdainfully away, and remains absorbed in his meditations. In the foreground, demons carry a table upon which bread and a jug have been placed; from the latter escapes a pig's foot. To the right is a nude belly into which a knife is stuck. In the background is a Flemish town, and in the skies a couple are astride a fish.

Taken as a whole, this altarpiece is very impressive, owing to a certain eclecticism in the composition, which disdains crowding in favor of simplification and the judicious use of space. The truly cosmic landscape, of great allure, contributes to the universal character of the conception. In Bosch's comprehension of the tribulations of the saint, it becomes clear that his sufferings and temptations are not applicable to a particular human being but encompass humanity in general. Thus, his characters approach tragedy. His chimerical constructions: life in its entirety.

Notwithstanding current scholarship, which places this work in Bosch's middle period, we concur with earlier opinions that had proposed a later date, about 1505–10.

whose posterior stimulates the opening and entry to the habitation. Demons, arrayed in multifarious form from bird-devils to figures with stag heads, fill earth and skies.

The central panel brings the innovation of a platform paved with flagstones that is raised in the middle-ground, comparable with the stage of a theater. Close to a low wall, Saint Anthony is kneeling, while a bizarre procession crowds his sides. To his right, we note a little chapel through whose open door one notices a crucifix illuminated by candlelight, and the apparition of our Savior extending his arm in a gesture of blessing. The chapel is part of a tower fallen into ruins, prolonged by a thick wall pierced with

There exist a great number of copies, either of the entire altarpiece or of the centerpiece or the shutters. (See Friedländer, passim, and Unverfehrt). Friedländer accepts three replicas by the master's own hand. We do not concur with his opinion in this respect and think there exists a one and only original—the present one.

29

The Adoration of the Magi (Epiphany)

Altarpiece. Panel, 138 x 72 - 33 cm.
Left shutter, Saint Peter, with the patron; *right shutter,* Saint Agnes with the patroness. *Verso, in* grisaille, the Mass of

Pope Gregory, *with two further donor figures and scenes from the* Passion *in the framework.*

Cat 29 Verso of the right and left shutters

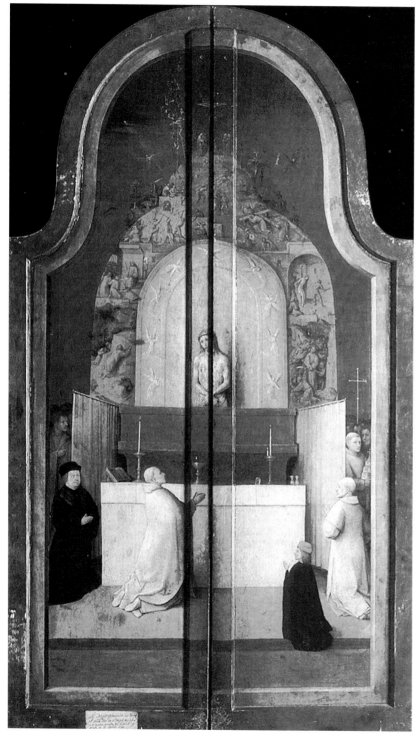

Museo del Prado, Madrid. No. 2048. Signed on the centerpiece, lower left: JHERONIMUS BOSCH *(in gilt letters).*

Inscribed on the left wing: EEN VOOR AL *(one for all). Below: the coat of arms of the families Bronchorst and Bosschuyse.*

This triptych is, rather exceptionally, in a very good state of preservation. As it is often in this period, the frame and panels constitute an entity. In this instance, the original frame has been preserved. On the verso, "the vertical elements of the frame form an integral part of the depicted scene" (Marijnissen, 1987, passim). In light of a technical examination carried out at the Prado, the two supplementary donor figures of the verso are additions on top of the *grisaille*. Provenance: there exists a document with the precise description of this work, dating from 1567. It is the inventory of the goods of Sir de Backersele Jehan de Kassenbroot, in Brussels, made at the occasion of the confiscation of his possessions. The unfortunate owner was the secretary of the count of Egmont, arrested with his master in 1567. After repeated torture, he was beheaded at Vilvoorde a year later. He was married to Wilhelmina Bronchorst, whose arms appear on the triptych—thus establishing the lineage of the work without a doubt. It seems that the duke of Alba sent his liege Philip II this altarpiece together with other confiscated art back to Spain, where a painting corresponding to the description entered upon the king's orders the collections of the Escorial in 1574. It was then thought to represent the birth of Christ. It was sent from the Escorial to the Prado in 1839. Jean-Baptiste Gramaye, the official historian of the archdukes, wrote in 1610 a history of a number of cities in the Catholic, thus Spanish, Low Countries, among them

's Hertogenbosch, which belonged to Spain until 1629. He cites in his list of Bosch's paintings at the Cathedral of Saint John an *Epiphany*. A number of critics, among them the author of the Prado catalog of 1963, identify the present altarpiece with the one formerly at Saint John's. There exists, however, no evidence that the two paintings are identical. The Prado work must have been in Spain long before Gramay saw the same subject painted by Bosch in 's Hertogenbosch prior to 1610, when he

published his *History*. This can serve as an example of the fact that art critics, then and now, are often ignorant of the rules of historical proof.

We have here a mature, well-balanced work, traditional in conception and showing us the artist at the peak of his development and artistic powers. Friedländer considers the painting his masterpiece, and he is not far from wrong in his appreciation. Flemish influences prevail in the choice of types and forms. Critics have pointed to similarities with such works as the panel by the Master of Flémalle in Dijon. Others (see Dollmayr) trace the types of the Holy Family and of the donors back to Rogier van der Weyden. At first glance, one would place the painting in the early part of Bosch's career, were it not for the costumes, which make a much later dating mandatory. Tolnay correctly compares them with the *Portrait of a Man* by Jan Mostaert at the Brussels Musée Ancien. Thus, Bosch, during his last years, returned to the concepts and simplicity of presentation of his beginnings. It is in the perfection of the execution, and the harmony and balance of the panoramic landscape in the background, that the essential differences between the young and the mature artist come to the fore, and we can admire the inner growth that has taken place during these years of evolution.

Pfister (1922) wrote almost three-quarters of a century ago that "the painter responds to the charming legend in the same childlike, pious way as Saint Francis." In fact, the scene appears well balanced, with the Madonna holding the child in her lap, seated to the right in the center panel. Joseph watches from behind a wall of the ramshackle hut that serves as background to the happening. The three kings present gifts to the child and pay homage to him. In the aperture to the hut or stable stand three personages, who have given rise to the most variegated interpretations. The most bizarre among them is a half-naked figure, wearing a turban, who thrusts himself halfway into the open. The iconologists had a field day. Brand-Philip holds that a complex piece of Jewish symbolism is represented here with the Antichrist, the Messiah, and the syna-

gogue—the last in the guise of the stable. Fraenger, ignoring Brand-Philip's earlier publication, identifies the man in the doorway as the fourth king (the Messiah), and promptly turns the Bronchorst-Bosschuyse couple, the donors of the altarpiece, into members of a Judaizing sect (!). The fact that there is not the slightest proof for such an assumption has never deterred Fraenger from his usual unfounded suppositions. Tolnay derives the whole iconography of the work from the Mass on the verso, and Gombrich suggests Herod as the personality shown in the doorway.

These are the main theses, but by no means the only ones purporting to explain the mystery. Gibson goes so far as to interpret the figure in the doorway as the pagan sorcerer Balaam! There is no doubt that in the game of iconological explanation, the fantasy of the critics is hardly inferior to that of Bosch himself.

Let us therefore accept the view of De Sigüenza, who sees nothing out of the ordinary in the iconography of the work. It is a simple profession of faith on the part of the donors: first, that Christ is really the son of God; and that the Mass on the verso signifies transubstantiation. The wings with the donors bear out the contention. Bosch beautifully realized and conveyed these basic truths by means of an inspired brush.
To be dated ca. 1510–16.

30

Christ Carrying the Cross

Panel,
76.7 x 83.5 cm.
Musée des Beaux-Arts, Ghent.
No. 1902-H.
Acquired 1902 for the museum
by Hulin de Loo.

As in our Nos. 12 and 13, *Christ Mocked* at the London National Gallery, and *Christ Crowned with Thorns* from the Escorial, Bosch used a half-length figure composition in this painting, while raising the Passion scene to an almost hysterical pitch. We are far from the earlier monumentality of *Christ Mocked*. The only heads that express calm are those of Christ, in the center, and of Saint Veronica, at the bottom left of the pic-

ture. All the rest is filled with caricatural heads that suggest in their distortions and grimaces psychopathic personalities at the climax of excitement. The obvious aim appears to be the vilification and humiliation of Christ, who, eyes closed, seems oblivious of the unholy commotion.

Saint Veronica turns away in contempt and displays the cloth with Christ's image miraculously obtained when she wiped his brow while he struggled carrying the cross. Never was a mob rendered with such incisiveness, and it is therefore no wonder that many critics have suggested Leonardesque influences in the conception of these grotesque heads. It is of no import whence the inspiration came: from the Italian genius, or from Germany, as suggested by Gibson. The fact remains that the diabolic and phantasmic streak of Bosch's imagination has reached in this painting the culmination of painterly rendition. It is here that the artist's innate pessimism, and doubt as to the actual possibility of salvation, find their ultimate expression.
To be dated ca. 1510–1516.

31

The Garden of Delights

Triptych.
Panel,
220 x 195 - 97 cm.
Left shutter,
The Garden of Eden.
Right shutter, Hell.
On the verso,
The Creation of the World, grisaille.
From the Escorial.
Museo del Prado, Madrid,
No. 2823.

Bought in the estate sale of Father Prior D. Fernando of the Order of San Juan, natural son of the Grand Duke of Alba (died 1591).
Entered the Escorial in 1593 with the mention "*Una pintura de la variedad del mundo, cifrada con diversos disparates de Hierónimo Bosco que llaman del Madroño etc.*" as property of Philip II.
Exhibited at the Prado upon order of the late General Franco, and has since

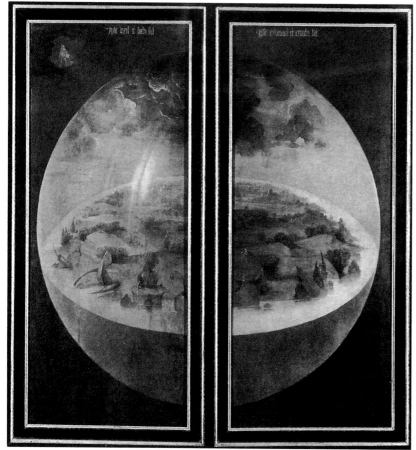

Cat 31 Verso of the right and left shutters

remained part of the museum's collections.

The theme of the center panel, while unique in the oeuvre of Bosch, is not unknown in medieval painting or literature. Starting with the *Roman de la Rose*, we encounter many representations of love gardens used as a setting for lovers and lovemaking. Eroticism and even the representation of the sexual act are not uncommon in paintings, engravings, and book illuminations of the period. What counts is the interpretation of the representation of the scene. Sigüenza calls the triptych a kind of didactic sermon against the carnal pleasures. Others find it an apotheosis of innocent sexuality. This explanation is hardly acceptable, for during the Middle Ages, sexuality was not considered innocent by the Church.

It was accepted as a necessary evil leading to procreation in the holy state of matrimony, or as a deadly sin outside these boundaries. This is also indicated by the garden of love being placed between the shutters showing us Eden and hell, the beginning and the end of original sin. Thus, the central panel seems to be devoted to the representation and castigation of lust, a deadly sin, of which the onlooker has to be warned as much as *The Hay Wain* minded us not to fall prey to avarice.

Among the extravagances of interpretations that have blossomed with respect to the phantasmic paintings of Bosch, we mention Fraenger's thesis, which sees in the central panel paradise as it was before the Fall, and as it is going to be again under the law of the heretical sect of the Brothers of the Free Spirit.

It shows the holy prostitution according to the doctrines of gnosticism and was—according to Fraenger—commissioned by the grandmaster of the sect whose followers called themselves Adamites. Their last leader was a certain Jacob van Almaengien. Fraenger's theories (see above) were radically rejected by his contemporaries and range now merely as curiosa. Bax, Von Holten, and Van Puyvelde pointed out that there is no proof that the sect of the Adamites still existed in Bosch's time, or that Bosch had ever been one of its members or that Almaengien commissioned the triptych, in which case the artist would have been no more than the mechanical executor of the grandmaster's instruction and ideas!

Bosch's construction of paradise, or, as he saw it, a love garden, is unique. He places a pool of maidens in the center of a large park, around which a large circle of riders revolve counterclockwise. The foreground is filled with nude men and women, peacefully frolicking and enjoying the presence of birds, plants, and companions of the other sex.

Occasionally, a black figure extols the contrast with the overwhelming majority of pale bodies. Gibson compares the scene to the Golden Age described by Hesiod "when men and beasts dwelt in peace together," or, in a more modern vein, "to a universal love-in." The abundance of forms and their interactions have been carefully identified by D. Bax, who brought out the symbolism intended and their provenance from contemporaneous songs, sayings, and vehicular language of Bosch's time.

Erotic connotations abound in plants and fruit, as well as metaphors of the sexual organs.

The upper part of the panel is given over to dreamlike forms of fountains and pavilions around a lake pushed far back toward the horizon, while right and left unexplained figures with delicate wings have taken to the air.

This painting, like *The Hay Wain*, must be read from left to right. Thus, the left wing represents the last three days of Creation, with, in the center, the Fountain of Life. Living and fabulous

animals, the latter drawn from bestiaries that go back to Alexandrian prototypes, fill the scene. In the foreground, God introduces Eve to Adam, who has just awakened from sleep and inspects the companion created out of his rib with a goodly measure of astonishment. As mentioned by several critics, God appears here more youthful than usual, Christlike, and blessing the first couple in the words of Gen. 1:28, "Be fruitful and multiply." Then follows the center panel with Bosch's conception of paradise: either his own, according to Eastern thought and imagination; or the Church's dogma, which condemns carnal lust, links it to original sin, and thereby forced the artist to accept its interpretation under pain of being adjudged heretic. On the right shutter is a Boschian vision of hell, similar to what we have seen in the Vienna *Last Judgment* (Cat. No. 14), but reinforced in its horrors. Its literary source is the *Vision of Tundale*, and from it the artist derived the concept of hell as the place of contrast between ice and fire. In the middle, we find the so-called Tree Man, known from a Bosch drawing in the Albertina at Vienna. His torso is egg-shaped, and the lower part of his body consists of rotting tree trunks. His feet are stuck into boats, replacing the well-known Dutch wooden shoes. Bosch has taken up in this wing the metamorphosis of man into beast, which is a well-known medieval tradition for depicting deserved punishment of vices and depravities. In the intensity with which the painter stresses here the chastisement meted out to sinners, he outdoes himself and reaches a zenith in the pictorial description of possible repulsiveness.

One might be led to suspect that this hell panel was executed as a kind of self-flagellation for having enjoyed too much the invention and execution of a paradise that cannot be.

On the verso of the triptych, Bosch painted in *grisaille* the Creation of the world, enclosed in a crystal globe and seen as of the third day of Genesis. Such a representation appeared on the Madrid tabletop *The Seven Deadly Sins* (Cat. No. 5), and many of the vices detailed in this painting find their place again in the wing devoted to hell in the present triptych.

In summary, we can say that this painting constitutes a moralizing sermon, depicting mankind as lost in sin. The treatment of the theme betrays a bent for the use of allegories understandable to a limited audience only, and an iconography far from universal but shaped to the taste of an elite. Henceforth, Bosch certainly did not paint this work for a church, where it would have been viewed by the masses, but for an intellectual and highly educated lay patron. Gibson mentions Hendrick III of Nassau in this context, and proposes that the Italian Antonio de Beatis described this triptych in 1517 at the occasion of a visit to Hendrick's palace in Brussels. We ignore how the work eventually reached Spain.

The state of preservation of this work is unfortunately mediocre. It is brutally overcleaned, and most of the figures are therefore flat and pale, whereas they were most probably initially much better modeled and more colorfully executed. Stylistically, the numerous nudes appear reminiscent of the pre-Eyckian Gothic soft style, dependent upon book illuminations of the period, and far removed from the plastically rounded nudes of Jan van Eyck and Memlinc.

It is probable that Bosch adopted the manner with the intention of removing the representations from daily actuality and placing his subject matter into the framework of a remote past. In spite of these archaisms, what is left of the color scheme, as well as the advanced conception, makes it mandatory to assign this painting late in the artist's evolution.

We would therefore date the work at the end of Bosch's career, about 1514–16. I am concurring in this respect with Tolnay.

A close replica of the left wing belongs to the Escorial. Panel, 186 x 77 cm. A good copy of the centerpiece is attributed with great verisimilitude to Michiel Coxie (1499–1592) by Isabel Mateo Gómez (1967); it is part of the collection of Count de Pomereu, Paris.

32

The Death of the Miser
Panel, 92.6 x 30.8 cm.
No.1112.
National Gallery of Art,
Washington, D.C.
Samuel H. Kress collection.
From the collection of Baron van der Elst, Vienna.

The painting is a wing from a lost altarpiece. Its state of preservation appears satisfactory. The preliminary drawing in black lines remains visible in many parts. Technically, we are dealing with a *grisaille*, heightened with oil glazes in such parts as the clear red of the bed and the olive green of the dress of the figure at the foot of the bed. Tolnay therefore thinks that this is the verso of the left shutter of a triptych.

The theme of the work derives form a devotional treatise well known during the fifteenth century—the *Ars Moriendi* (see above)—which was very popular at the time and illustrated by various artists, such as the anonymous Master E. S. (see Lehrs, 1899). Bosch shows us the miser lying on his narrow bed, almost dying but still undecided whether to choose the crucifix—thus, salvation—or the moneybag full of gold offered him by a demon appearing from behind a curtain. Death has entered from the left, thus stressing the urgency of the decision, but the struggle between the angel to the right and the demons still hangs in the balance. In its dreamlike quality of the treatment of space, the artist refers back to conceptions first made use of by Rogier van der Weyden and the Master of Flémalle, consciously blurring, however, their stark realism. All contributes to the uncertainty of the outcome, and the free will of the miser. Does he want to go to heaven, or does he prefer the sound of his jingling coins?

The man in the foreground fingering a rosary and filling his bag held by a little devil with gold might further symbolize the miser's indecision. Bosch had treated the same subject earlier, in his Prado tabletop (upper-left corner). This time, however, the artist's imagination takes him much further down the road to doubt.

Cat 32 The Death of the Miser

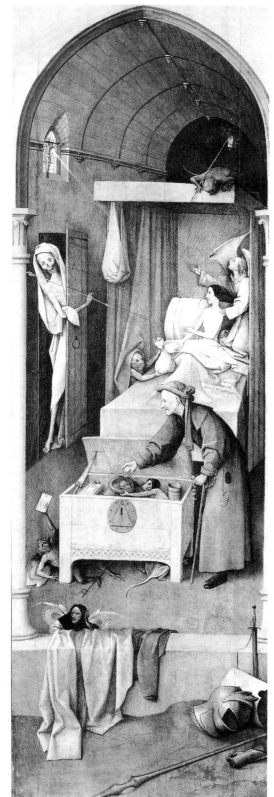

There exists at the Louvre (Inv. No. 6947) a drawing with slight variations of this scene, which has been ascribed by some critics to the master's own hand, while others, myself included, hold it to be a copy. The drawing, as Tolnay pointed out, is much too indecisive in the treatment of the faces and pedantically repetitive in the folds. It is certainly by the same hand as the one at the same museum after *The Ship of Fools* (our Cat. No. 52).

To be dated ca. 1510–16.

B) Paintings from Bosch's Workshop: Old Copies or Imitators

We only cite the most important material. For a complete list, see Gerd Unverfehrt, *Hieronymus Bosch: Die Rezeption seiner Kunst im frühen16. Jahrhundert.* Berlin, 1980, pp.15–64, et passim.

33

Ecce Homo

Panel, 73 x 58 cm.
Shutters, 68.6 x 26 cm.
Predella, 14 x 66.2 cm.
Museum of Fine Arts, Boston.
Acc. No. 52.2027.

The painting is a second, partly different version of the Frankfurt *Ecce Homo* (our Cat. No. 4), which has been attributed to the master first by H. Swarzenski (1955), then by E. Panofsky (1956). Although the work may be of iconographic importance, as stressed by Panofsky, insofar as Christ is represented here *de face* for the first time since Duccio, instead of the customary three-quarter profile, the level of craftsmanship does not exceed that of Bosch's workshop at best. The wings are obviously not by the same hand as the center panel, as ascertained by C. Eisler (1961), who also identified (?) the coat of arms as that of the Van Oss family in 's Hertogenbosch—a fact that has been variously called into question. In any case, the wings are better than the center panel, and the entire triptych stems either from the posthumous Bosch workshop around 1520 or from another master from 's Hertogenbosch who was in close contact with Bosch (see also Tolnay, 1989). Panofsky was correct in recognizing the subject matter as an *Ostentatio Christi* rather than an *Ecce Homo*.

34

Christ before Pilate

Panel, 84.5 x 108 cm. Princeton University Art Museum, New Jersey.
Bought by Allen Marquand from a dealer in London in 1891. Bequested by the same to Princeton University.

The painting is very questionable, and as confirmed by Hulin de Loo in the 1930s, not by the hand of Bosch. Baldass agreed with the Belgian scholar, and did not even mention it in this 1959 edition. The work is stylistically close to the Ghent *Christ Carrying the Cross*, and borrows some physiognomies from it. On the whole, it is a free imitation of the Bosch composition and was probably executed in Antwerp around 1520 (see Unverfehrt, 1980, Cat.

No. 32, and our Cat. No. 30). The painting of the same subject at the Boymans-Van Beuningen Museum in Rotterdam, No. 2438, panel, 46.5 x 36.5 cm, is nothing but a derivative from our Cat. No. 34.

35

Job

Altarpiece. On the shutters, Saints Anthony and Jerome.
Panel, 98.3 x 72.1 cm.
Right shutter, 98.8 x 30.2 cm.
Left shutter, 98.1 x 30.5 cm.
Musée Communal, Bruges, No. 209.
On loan from the church at Houcke,
West Flanders, District of Bruges.

In a very bad state of preservation. Almost entirely overpainted.
The theme of Job has been treated by Bosch at least once more, as we know from a contemporary document. Damian de Gões, agent of Juan III, acquired a painting of this subject matter in 1523–24 (see Bax, 1949).
I concur with Tolnay that this altarpiece must be a copy after a lost work by the master.

36

Saint James of Compostela and Hermogenes the Sage

Verso, The Temptation of Saint Anthony.
Panel, 62 x 41 cm.
Museum of Valenciennes, No. 176.

In painterly quality, the work ranks far below Bosch. According to the costumes, it can be dated ca. 1520–30, probably Dutch. It is considered an old copy by Tolnay, Baldass, and Combe. In my opinion, it is by a later imitator.

37

Two Shutters. Paradise, Hell

Panel, 34.5 x 21 cm and 33.4 x 19.6 cm.
Formerly Wildenstein Gallery, New York.
From the Bromberg Collection, Bremen.

These are the wings of a triptych whose centerpiece was a Last Judgment. It was first reconstituted by L. Maeterlinck (1903), who ascribed the work to Herri

met de Bles. The attribution was later confirmed by Lafond (1914) and is the correct one, in my opinion. Tolnay considers the wings to be works by Bosch from his early period, the original centerpiece being lost. No modern critic has upheld Tolnay's attribution, the consensus being that we are dealing with a rather poor Bosch follower from about 1500 (Unverfehrt, 1980, Cat. 13). My opinion concurs with those of Maeterlinck and Lafond.

38

Two Panels from an Adoration of the Magi
Each panel, 33 x 21.6 cm.
John G. Johnson Collection,
Museum of Fine Arts, Philadephia.
Nos. 1275/76.
Bought 1913 from Böhler (dealer), Munich.

The paintings are cut down on all sides. They are fragments of copies after Bosch. The original must have been a lost *Epiphany* by the master dating from about 1490.

39

The Last Judgment
Triptych. Panel, 99 x 60.3 cm.
Shutters, panel, 99.5 x 28.8 cm each.
Musée Communal, Bruges. No. 208.

The central panel is rounded at the top and signed: Jheronimus Bosch. From the E. Gravet Collection, Paris, No. 2 in the Paris auction of 1906. Then, Seligmann, Paris. Acquired 1907 by Auguste Beernaert and bequeathed to the city of Bruges.
On the verso of the wings is a *Crowning with Thorns* in *grisaille*, badly damaged. Friedländer and Tolnay consider the altarpiece authentic although in bad state of conservation. Many other critics, beginning with Maeterlinck and ending with the recent Bosch scholarship, are convinced that the work shows another hand and spirit than Hieronymus. Baldass thinks it is a pasticcio, which is most probable.
In our opinion, it is a work in the style, more or less, of Bosch but executed as late as about 1520–25.

40

The Adoration of the Magi
Altarpiece.
Panel, 78 x 62 cm.
Each panel, 80.5 x 26.5 cm.
Collegiale Kerk van Saint Pieter en Guido, Anderlecht, Belgium.

Bequeathed 1844 to the church by Canon E. H. Moens. Earlier provenance unknown, but seemingly exhibited at the church at the time of the French Revolution.
The altarpiece recalls the Prado *Epiphany* (our Cat. No. 29) very closely, but in reverse.
Consequently, we are dealing with a free copy, possibly after a lost print. The wings are, as Tolnay correctly notes, italianizing. The apposite literature since Van Puyvelde (1958) contests the earlier attribution to Bosch. In my opinion, it is a work by an imitator dating from about 1520–30.

41

Hell
Panel, 53.3 x 116.8 cm.
Metropolitan Museum of Art, New York.
Acquired in 1926 from a private collection in Bohemia.
No. 26.244 (Dick Fund).

As Tolnay states, the nudes are distinctly italianizing, and the painting can therefore hardly date before 1530–50—considerably later than Bosch's death.

42

The Marriage at Cana
Panel, 93 x 72 cm.
Museum Boyman-Van Beuningen, Rotterdam. No. St. 25.
The upper corners have been sawed off.
Provenance:
Koenigs collection, Haarlem.

Tolnay (1989) tentatively proposed the identification of this painting with one soi-disant formerly the property of P. P. Rubens and mentioned in the catalog of his estate *Un banquet dé nocer à la façon de Jheronimus Bosch*, Grete Ring. Tolnay and some other critics derived the infor-

mation from Pinchart (1858) but already Dollmayr (1898) was unable to confirm the apposite passage in the Rubens Inventory. Denucé (1932) re-published the inventory of paintings owned by Rubens at his death, and so did Jeffrey M. Muller (1989), the latter with considerable care, even adding a section devoted to "Pictures in Rubens' collection that are not included in the Specification of 1640." None of these publications mentions the *banquet de noces* recorded by Pinchart. Given the elusiveness of the information cited by Tolnay et al., and the scant probability that the authors of the "Specification" would have confused a simple *banquet de noces* with the *Marriage at Cana*, one must assume that the work now at the Rotterdam is not the same as that putatively in Rubens's collection.
The conception of the painting is curious and far from Bosch in thought and execution. Grouped around a table in the shape of an *L*, the guests stand out by their stiff countenance and foreign costumes. To the left of the table, the miracle of the transubstantiation of water into wine takes place in an atmosphere of general unconcern. In the left foreground are two dogs, one of them enjoying a bone. In style, this work recalls Dierik Bouts in its archaism, but the figures are devoid of modeling and lacking expression in the physiognomies. We therefore agree with Boon (1960), Arndt (1968), and Unverfehrt (1980) that this is without doubt the work of a copyist, conceivably, but not necessarily, after a Bosch original. A drawing at the Louvre published by Boon (1960) provides information about the initial composition.

43

The Hay Wain
Altarpiece.
Panel, 140 x 100 cm.
Wings, 147 x 66 cm each.
Signed on the left shutter:
JHERONIMUS BOSCH.
Monasterio de San Lorenzo de El Escorial, Palacio. No. 378.

The triptych is a later copy after the original in the Prado (our Cat. No. 18).

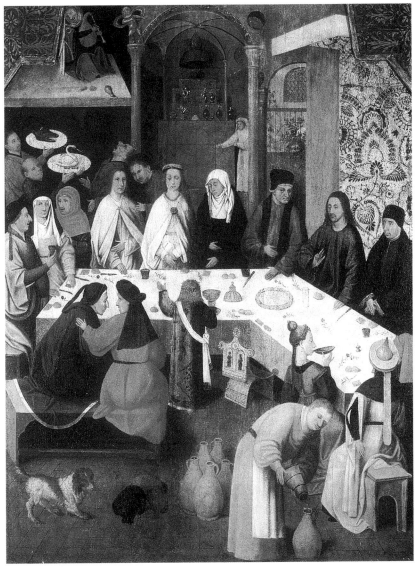

Cat 42 The marriage at Cana

It is badly overpainted and skinned. The reason for a separate catalog entry results simply from the fact that many otherwise reliable connoisseurs preferred this work to the Prado version—an error in judgment due, in my opinion, to the fact that our Cat. No. 43 was not available for close examination until recently.

This writer has studied this copy thoroughly, only a few months ago, in its current setting.

Aside from its much worse state of preservation than the Prado version, it is decidedly inferior in technique and execution.

Thus, the nudes are timidly drawn, far from the resolute Boschian handling at the Prado.

In all areas that still permit to judge the original paint, one can easily see the difference between the slavish dependence of the Escorial master and the glowing brushstrokes interpreting the imagination of Bosch himself. Reuterswürd (1970) and Unverfehrt (1980) share my opinion, the former dating No. 43 into the beginning of the seventeenth century. *Pace* Friedländer, Tolnay, et al.!

44

The Temptation of Saint Anthony

Panel, 70 x 115 cm.
Museo del Prado, Madrid.
Acquired 1838 in Portugal.

The saint is represented in half-figure, behind him to the right an anthropomorphous house. Good work by a later imitator.

A replica of the painting at the Escorial, where the house is replaced by a crucifix.

45

The Temptation of Saint Anthony

Panel, 63 x 82 cm.
Signed in the lower right:
JHERONIMUS BOSCH.
Rijksmuseum, Amsterdam. No. A 3240.
From the Collection Schmidt-Degener, Amsterdam. A version identical to No. 44.

Generally accepted as a copy, with differences of opinion as to whether it is a copy after Bosch or a free imitation.

46

The Temptation of Saint Anthony

Panel, 40 x 26.5 cm.
Berlin, Staatliche Museen Stiftung preussischer Kulturbesitz, Gemäldegalerie. No. 1647.

Acquired 1904 from an English private collection.
Considered an imitation since Glück (1935). Probably Flemish ca. 1520-25.

47

The Temptation of Saint Anthony

Panel, 38.4 x 24.3 cm. William Rockhill Nelson Gallery of Art, Kansas City, Mo.

Listed by Tolnay (No. 61) among the disputed works. It is, however, as established by Unverfehrt (1980, Cat. No. 34b), a copy in reverse of his Cat. No. 34. To be dated c. 1520.

48

The Temptation
of Saint Anthony

Panel, 58 x 50 cm.
Collection F. van Lanschot,
's Hertogenbosch.
Provenance: Munich 1927
(art trade, P. Drey).
Collection Count Dohna-Schlodien.
Lugano, Castle Rohoncz,
Collection Thyssen Bornemisza.

This painting is probably an old paintover over a representation of two saints. Its current aspect is a pasticcio from various Bosch motifs by an imitator from about 1530.

49

Saint Christopher

Panel, 23 x 36 cm.
Oskar Reinhart Sammlung am
Romerholz, Winterthur.

We concur with Tolnay (Cat. No. 56) that the almost monochrome palette of the painting points to a date of execution of about 1540. Unverfehrt (1980) agrees, citing arguments based not only on color but on composition.
The work belongs to the circle of Herri met de Bles.

50

The Adoration
of the Shepherds

Half-Length.
Panel, 105 x 84 cm.
Wallraf-Richartz Museum, Cologne.
No. WRM 474.

This composition seems based upon a Bosch original from his later years. See for this assumption the use of half-length figures.
The draftsmanship appears hard and the color scheme subdued. We follow Friedländer in the attribution "not quite convincing as an original" and date the work as a copy from about twenty years after Bosch's death.
A smaller replica, also a copy, belongs to the Musées Royaux des Beaux-Arts,

Brussels (Inv. No. 368).
Panel, 64 x 60 cm.
To be dated after 1530.

51

The Prestidigitator

Panel,
53 x 65 cm.
Musée Municipal,
Inv. No. 872/1/87.
Saint-Germain-en-Laye.
Bequeathed to the museum in 1872
by Monsieur Ducastel.

This painting seems to be the prototype of four extant copies, an engraving, and an original drawing at the Louvre, without being itself by the hand of Bosch. Its attribution has been in dispute almost since the first publication. Baldass thought it first an original (1917), then in 1959, a copy.
In the case of Tolnay, the reverse thought process took place: the Hungarian author described the painting as a copy in 1937, then reversed himself in 1965 and accepted it as an original. Ring, Friedländer, Brand-Philip, Arndt, and Unverfehrt consider the work a

copy, and I concur with them entirely. We have here a simplified imitation after the Louvre drawing, though of relatively good quality. Probably executed in Bosch's studio, shortly before or after the master's death.
The scene is typical for Bosch's approach to the world and its troubles. A number of simple and foolish spectators are grouped on the left of a table. The prestidigitator stands alone on the other side and makes frogs jump out of the mouth of a simpleton while a dwarf—an accomplice—steals his purse.
Bosch certainly does not want merely to amuse us with an anecdote, but castigates the credulity of ordinary people. In the Netherlandish vernacular, "swallowing a frog" signifies the easy acceptance of some imaginary tale as truth.

52

The Ship of Fools

Panel, 58 x 32 cm.
Louvre, Paris.
Inv. No. RF 2218. Cat. No. 4004.
Bequest of C. Benoit in 1918.

Cat 51 The Prestidigitator

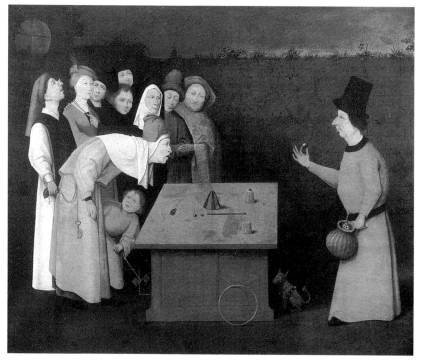

The branch on top of the mast of the vessel (a nutshell) is a much later addition.

It does not exist yet on the Louvre drawing, heightened in white, which is itself a copy after the original composition. We see two nuns, a monk, and some peasants carousing in a boat, while a fool, at right, is sitting in the rigging.

Tolnay proposes that the panel is a wing of a diptych or triptych representing other ships of fools, with the theme based on Sebastian Brant's *Ship of Fools*, first published in 1494.

However, the basic idea came to the fore in the fourteenth century, the ship being linked to members of the clergy who have abandoned their duties to give themselves over to a sinful life and especially, to lust. It is essentially a satire criticizing the clergy, whose excesses caused general anger and vexation at the time, until finally leading to the Reformation.

We think that the original of the composition is lost, just as in the case of the following (Cat. No. 53): the fragment and part-copy of a Bosch composition at the Yale University Art Gallery (*Allegory of Intemperance and Debauchery*), which we did not deem of sufficient interest to deserve illustration.

53

The Concert in the Egg
Canvas,
108.5 x 126.5 cm.
Musée des Beaux-Arts,
Lille,
No. 816. Acquired 1890.

The composition derives from the preceding Bosch composition, the egg replacing the nutshell in *The Ship of Fools*. There is a drawing at the Berlin Print Cabinet, which is not, as often erroneously assumed, by Bosch himself, but an imitation. It could have a preparatory connection with this canvas.

Another version of this painting exists in the collection of the Countess Balny d'Avricourt, Paris (ex-collection Baron de Pontalba, Senlis) panel, 107 x 73 cm.

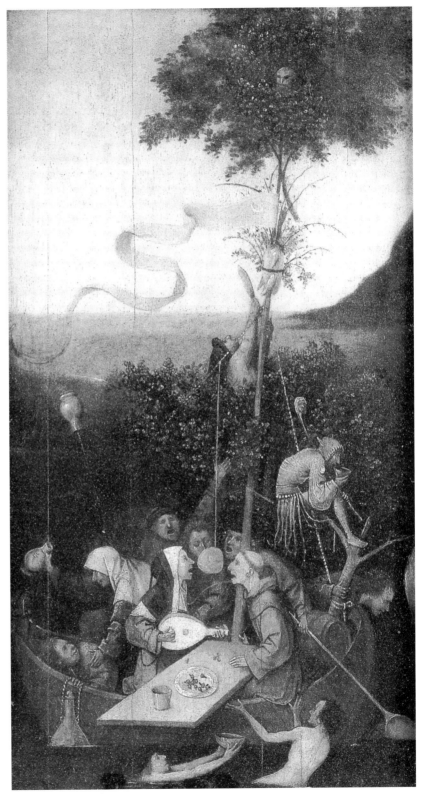

Cat 52 The Ship of Fools

54

The Child Jesus in the Temple

Also sometimes identified as Jesus among the doctors.
Panel, 74 x 58 cm.
Louvre, Paris, No. RF 970.
From the Musée Cluny.
In the Louvre since 1896.

The painting is a copy after a lost original by Bosch from his late years. There are a number of other copies, but the Louvre one seems to us the best. Demonts (1922) and Michel (1953) attribute the painting to a Spanish or a Portuguese artist. All other competent critics maintain Bosch as author of the composition, an opinion with which I concur.

55

Christ Driving
the Money Changers
from the Temple

Panel, 102 x 156 cm.
Statens Museum for Kunst,
Copenhagen, No. 3924.

The painting exists in three versions: one at the Art Gallery and Museum, Glasgow, is composed in height (panel, 77.7 x 60 cm) and signed in the lower-right corner: JHIEROMUS BOSCHE (evidently a later addition); one is our No. 55; and the other is a rather coarse production from the end of the sixteenth century (in the 1930s at a dealer's in The Hague) and is composed in width. Motifs from both Bosch and Pieter Bruegel the Elder were made use of. The Copenhagen version has been accepted as an authentic work by the latter by Glück, Friedländer, Held, and Ring. I concur with their opinions. Pieter Bruegel's dependence upon Boschian inventions is thereby clearly established. The whole group should date from about 1560.

Drawings

There is a group of about thirty drawings, by or close to Bosch. The attributions vary even more than in the case of paintings. We reproduce a few sheets only, to show the master's creative process, presumed drawing style, and possible connections with specific works.

D1

Group of Executioners

New York, Pierpont Morgan Library.

D2

The Burial of Christ

London, British Museum.

D3

Preliminary Study for the painting "The Prestidigitator"

Paris, Musée de Louvre.
No. 19.197.

D4

The Ship of Fools in Flames

Vienna, Akademie der Bildenden Künste.

D5

Sketches and the Temptation of Saint Anthony

Recto and verso.
Paris, Musée de Louvre.
No. 20871.

D6

The Tree Man

Vienna, Albertina.

Copper Engravings

There are no known engravings by Bosch's own hand. Those formerly attributed to him on the basis of what one used to consider a signature, Bosch, are by his contemporary *Allaert du Hameel* ('s Hertogenbosch, ca. 1449–ca. 1509). The indications Bos, Bosch, and Bosche are references to the locality: 's Hertogenbosch. Several of these engravings are, however, after drawings or paintings by Hieronymus Bosch. Here, two examples at random:

E1

The Last Judgment

Lehrs, VII, No. 2.

E2

The Elephant with a Tower on His Back

Lehrs, VII, No. 6.

Topographic Index

Hieronymus Bosch

Historical Dates of the Epoch

1419–67

Philip III, the Good. Duke of Burgundy. He acquires the provinces of Hainaut, Holland, Zeeland, Picardy, and Brabant. Zenith of Burgundy's power. He was responsible for Burgundy becoming a European cultural and economic center.

1431

Joan of Arc, the Maid of Orleans and national heroine, burned at the stake for witchcraft and heresy.

1380–1471

Life of the famous German mystic Thomas a Kempis. Generally considered the author of *The Imitation of Christ.*

1418

A furrier named Jan van Aaken dies in 's Hertogenbosch. He had obtained the freedom of the city in 1399. Ancestor of Hieronymus?

1423–34

Another Jan van Aaken is mentioned several times in the archives of the cathedral. It is now assumed that he was a painter and perhaps the grandfather of Hieronymus.

1450–55

Probable period of birth of Hieronymus Bosch in 's Hertogenbosch.

1453

Year of birth of Aleyt Goyaerts van den Meervenne, subsequently wife of Hieronymus Bosch, in the same city.

1474

First mention of Hieronymus Bosch (identified as Jeronimus called Joen). He cosigns with his father Anthonis Janss(oon) die Maelre (the painter) a promissory note in the amount of 25 Rhenish guilders.

1475–76

Mention in the records of the Brotherhood of Our Lady of a meeting with the sculptor Adriaan van Wesel "to discuss and determine the design and means whereby the altarpiece should be commissioned. Thonys the painter and his sons were also present." Thonys and Antonius were obviously the same person. Hieronymus is not mentioned by name.

1477

The new altarpiece of the Brotherhood of Our Lady in the Cathedral of Saint John is finished and replaces the old one.
Death of Charles the Bold of Burgundy in the battle of Nancy against Lorraine and the Swiss Confederation. Marriage of Maximilian of Austria and Mary of Burgundy.

1480–81

"Jeroen die maelre" buys two wings of the old altarpiece. His father dies about this time.

1480

A document refers to Hieronymus Bosch as being married.

3 January 1481

Hieronymus gives his brother Goossen a one-fourth of a house and grounds in the "Bossche Markt." The siblings settle their father's estate among themselves. Hieronymus is for the first time referred to in this document with the patronymic *Van Aken.*

1481

Lawsuit between Bosch and his wife Aleyt's brother over family property.

1486-1487

Hieronymous Bosch becomes a member of the Brotherhood of Our Lady.

1486–90

Publication of the *Malleus Maleficarum* (Witches' Hammer) by the Inquisitors Heinrich Institoris and Jakob Sprenger. Basis for witchcraft trials.

1488

Hieronymus Bosch was co-opted to the Committee of the Brotherhood of Our Lady.

1493–94

H. Bosch furnishes a drawing for a stained-glass window in the new chapel of the Brotherhood of Our Lady in the Cathedral of Saint John.

1492

Expulsion of the Jews and Moriscos from Spain, and in 1497 from Portugal.

1494

Publication of *The Ship of Fools* by Sebastian Brant.

1500

First permanent postal traffic between Vienna and Brussels.

1504

Philip the Fair, husband of Joan the Mad of Castile, com-

missions H. Bosch to paint a large altarpiece of the Last Judgment. He pays the sum of 36 pounds on account. The artist is there identified for the first time as "A Jeronimus van Acken, called Bosch, who lives in Bois-le-Duc ('s Hertogenbosch)."

ca. 1510

Manufacture of the first pocket watches by Peter Henlein.

1511–12

Hieronymus Bosch is paid by the Brotherhood of Our Lady for furnishing a design for a crucifix for the new chapel.

1511

Holy League of the pope (Julius II) with Venice against France.

1512-13

Hieronymus Bosch receives payment from the Brotherhood of Our Lady for a drawing for a chandelier for the new chapel.

1513

Macchiavelli writes *Il Principe*.

1516

Death of Hieronymus Bosch, mentioned in the register of the Brotherhood of Our Lady as follows: *"Obitus fratrum anno 1516 Hieronymus Aquen alias Bosch insignis pictor."* Erasmus of Rotterdam published the original Greek text of the New Testament with translation into Latin. The son of Philip the Fair becomes king of Spain under the name Charles I. Beginning in 1519, he is emperor as Charles V. Thomas Morus publishes *Utopia*. An inventory of paintings belonging to Margaret of Austria, governess of the Low Countries, drawn up; records a panel representing Saint Anthony *"qui est fait de Jheronimus Bosch."*

1517

Beginning of the Reformation. Martin Luther affixes his 95 theses to the door of the Castle-Church of Wittenberg.

1519

Death of Leonardo da Vinci. Emperor Charles V (Charles I as king of Spain) inherits from his grandfather Maximilian I the patrimonial dominions of the Hapsburgs, among them the Low Countries.

1521–22

Martin Luther translates the New Testament and the Vulgata into German, basing himself for this undertaking upon Erasmus's publication of the original Greek text. Luther thereby creates the foundation for the new High German literary language.

1524

In the inventory of paintings belonging to the Archduchess Margaret of Austria, a Saint Anthony is again recorded, with a more detailed description. However, the document does not mention the name of its author. It remains, therefore, an open question as to whether the painting is identical with the one enumerated in 1516.

1527

Death of Niccolo Macchiavelli.

1528

Death of the German painter Mathis Neithardt, alias Grünewald. Death of the famous German painter and engraver Albrecht Dürer. The Netherlands gain the provinces of Utrecht and Overijssel.

1530

Charles V is crowned emperor by the pope in Bologna. Last such crowning by the pope of a German-Roman emperor.

1531

Aleyt Goyaerts is mentioned in a document connected with the settlement of her estate as "the widow of Jheronimus van Aken."

1534

Martin Luther's translation of the Old Testament from the Hebrew appears in print. Foundation of the Order of the Society of Jesus by Ignatius of Loyola. Beginning of the Counter Reformation.

Selected Bibliography

Baldass, Ludwig von.
Die Chronologie der Gemälde des Hieronymus Bosch. Jb.d. preuss. Kunstsammlungen, 38, 1917, pp. 177–95;
Betrachtungen zum Werke des Hieronymus Bosch. Jahrbuch der Kunsthistorischen Sammlungen in Wien. n.s.1., 1926, pp. 103–22;
Jheronimus Bosch. Vienna, 1943.
Hieronimus Bosch. Revised ed. with notes and bibliography by Günther Heinz. Vienna, 1959;
Hieronimus Bosch. Eng. ed., New York and London, 1960.

Bax, Dirk.
Ontcijfering van Jeroen Bosch. The Hague. 1949.
Bezwaren tegen L. Brand Philips interpretatie van Jeroen Bosch' marskramer, goochelaar, keisnijder en voorgrond van hooiwagenpaneel, in Nederlands kunsthistorisch jaarboek, 13, 1962, pp. 1–54.

Bianconi, Piero.
Bosch. Milan, 1967. Reprint ca. 1976.

Boschère, Jean de.
Jérôme Bosch. Brussels, 1947.

Brand-Philip, Lotte.
The Peddler by Hieronymus Bosch, a Study in Detection, in Nederlands kunsthistorisch Jaarboek, 9, 1958, pp. 1–81.

Brion, Marcel.
Bosch. Paris, 1938.

Buzzati, Dino, and Cinotti Mia.
L'opera completa di Bosch. Milan, 1966.

Combe, Jacques.
Jérôme Bosch. Paris, 1946
English ed., *Jheronimus Bosch.* Paris and London, 1946. Reprint, New York, 1957.

✓ **Cuttler, Charles D.**
Northern Painting, from Pucelle to Bruegel. New York, 1968.

Delevoy, Robert L.
Bosch: Biographical and Critical Study. Geneva, 1960. Reprint. 1972.
French ed.: *Jheronimus Bosch: Etude biografique et critique.* Geneva, 1960.
Italian ed.: *Bosch: Studio critico-biografico.* Geneva, 1967.
German ed.: *Hieronymus Bosch.* Geneva, 1960.

Dixon, L.S.
"Bosch's 'St. Anthony Triptych' - An Apothecary's Apoth-

esis," *The Art Journal*, Summer 1984, pp. 119 et seq.

Dollmayr, Hermann.
Hieronymus Bosch und die Darstellung der Vier Letzten Dinge in der niederländischen Malerei des XV. und XVI. Jahrhunderts, in Jahrbuch der Kunsthistorischen Sammlungen des allerhöchsten Kaiserhauses, 19, 1898, pp. 294–343.

Eigenberger, Robert.
Die Gemäldegalerie der Akademie der bildenden Künste in Wien. 2 vols. Vienna and Leipzig, 1927 (passim).

Fierens, Paul.
Le fantastique dans l'art flamand. Brussels, s.d.

Filedt Kok, Jan Piet.
Underdrawing and Drawing in the Work of Hieronymus Bosch: A Provisional Survey in Connection with Paintings by Him in Rotterdam, in Simiolus, 6, 1972–73, pp. 133–62.

Folie, Jacqueline.
Les oeuvres authentifiées des primitifs flamands. Bulletin, Institut royal du patrimoine artistique, 6, 1963, pp. 183–256.

Fraenger, Wilhelm.
Hieronymus Bosch. Dresden, 1975. Reprint: Gütersloh, ca. 1977.

Franz, Heinrich Gerhard.
Niederländische Landschaftsmalerei im Zeitalter des Manierismus. 2 vols. Graz, 1969. I, pp. 21–28.

Friedländer, Max J.
Die altniederländische Malerei. 14 vols. Vol. 5, *Geertgen van Haarlem und Hieronymus Bosch*. Berlin, 1927.
Die altniederländische Malerei. 14 vols. Vol. 14, *Pieter Bruegel und Nachträge zu den früheren Bänden*. Leiden, 1937. Additions and corrections to the catalog that was published in 1927.
English ed.: *Early Netherlandish Painting*. 14 vols. Vol. 5, *Geertgen tot Sint Jans and Jerome Bosch*. Comments and notes by G. Lemmens. Leiden-Brussels, 1969. Supplements issued with vol. 12 of the series, 1976.
Von Eyck bis Bruegel: Studien zur Geschichte der niederländischen Malerei. Berlin, 1916. 2d enlarged and revised ed., ca. 1921.
Die frühen niederländischen Maler von Eyck bis Bruegel. Edited, with notes, by Fritz Grossmann. Cologne, 1956.
English ed.: *From Van Eyck to Bruegel. Early Netherlandish Painting*. With notes by Fritz Grossmann. London, 1956. Paperback ed.: London and Ithaca, N.Y., 1981.

Genaille, Robert.
Bosch. Paris, 1965.

Flemish Painting from Van Eyck to Brueghel. New York and Paris, 1954.
French ed.: *De Van Eyck à Bruegel*. Paris, 1954.
German ed.: *Die flämische Malerei: Die Geschichte der flämischen Malerei von van Eyck bis Bruegel*. Stuttgart, 1961.

Gibson, Walter S.
Hieronymus Bosch. London and New York, 1973.
Hieronymus Bosch, an annotated bibliography. Boston, 1983.

Glück, Gustav.
Das jüngste Gericht der Wiener Akademie, in Kunstchronik. n.s. 7, 1895–96, pp. 195–96.
Die Darstellungen des Karnevals und der Fasten von Bosch und Bruegel, in *Gedenkboek A. Vermeylen: Aangeboden aan August Vermeylen ter gelegenheid van zijn zestigsten verjaardag 12 mei 1932*. Bruges, 1932.

Guevara, Felipe de.
Comentarios de la pintura. ca. 1560. Ed. Antonio Pons. Madrid, 1788.

Heidenreich, H.
"Hieronymus Bosch in some Literary Context," in *Journal of the Warburg and Courtauld Institutes*, 33/1970, pp.171 et. Seq.

Justi, Carlos (Carl).
Jerónimo Bosch, in La España moderna, 26, no. 306, June 1914, pp. 5–41.
Die Werke des Hieronymus Bosch in Spanien. Jb. d. preuss. Kunstsamml., 10, 1889, pp. 120–44.

Lampsonius, Domenicus.
Pictorum aliquot celebrium Germaniae inferioris effigies. Antwerp, 1572.
Les effigies des peintres célèbres des Pays-Bas. Edited by Jean Puraye. Liege, 1956.

Lafond, Paul
Hieronymus Bosch: son art, son influence, ses disciples. Brussels and Paris, 1914.

Larsen, Erik.
Les tentations de Saint Antoine de Jérôme Bosch, in Revue belge d'Archéologie et d'Histoire de l'Art, 19, 1950, pp. 3–41.
Les primitifs flamands au Musée métropolitain de New York. Utrecht and Antwerp, 1960, pp. 96–99 and 132–33.

Lehrs, M.
Geschichte und kristischer Katalog des deutschen, niederländischen und französischen Kupferstichs im XV. Jahrhundert. Vienna, 1908-34.

Leite, José Roberto Teixeira.
Jheronimus Bosch. Rio de Janeiro, 1956.

Lennep, J. van.
"Feu Saint-Antoine et Mandragore. A propos de la Tentation de Saint Antoine," in *Bulletin des Musées Royaux des Beaux-Arts*, Bruxelles, 1968, p.115 et seq.

Löhneysen, Hans-Wolfgang von.
Die ältere niederländische Malerei, Künstler und Kritiker. Eisenach and Kassel, 1956.

Loo, Georges Hulin de.
Hieronimus van Aken genaamd Hieronimus Bosch. Kunstkroniek. 3rd ser., 6, 1886, pp. 120–24.

Lyna, Frédéric.
De Jean Pucelle à Jérôme Bosch. Scriptorium, 17, 1963, pp. 310–13.

Maeterlinck, Louis.
Le genre satirique dans la peinture flamande. Academie royale de Belgique, Brussels, 1902–3. Enlarged and revised edition: Brussels, 1907; Paris, 1910.
Le genre satirique, fantastique et licencieux dans la sculpture flamande et wallonne: Les miséricordes des stalles. Paris, 1910.

Mander, Carel Van.
Het schilder-boeck: Het leven der doorluchtighe nederlantsche en hooghduytsche schilders. Alkmaar, 1604. Reprint: Utrecht, 1969. We have made use of the German translation by Hanns Floercke, 2 vols., Munich and Leipzig, 1906.

Marijnissen, Roger H.
Jheronimus Bosch. Foreword by Xavier de Salas, Brussels, 1972. Reprint, 1975.
Hieronymus Bosch. The Complete Works. Assisted by Peter Ruyffelaere. Antwerp, 1987.

Mateo Gómez, Isabel.
El Bosco en España. Madrid, 1965.
El Jardín de las Delicias. A proposito de una copia temprana y un tapiz. Archivo Español de Arte. Nums. 157–60, To. XL, 1967, pp. 47–53.

Michiel, Marcantoni, Anonimo Morelliano.
German ed.: *Der Anonimo Morelliano (Marcanton Michiel's Notizia d'Opera del disegno).*
Text and translation by Theodor Frimmel. Vienna, 1896.

Mosmans, J.
Jeronimus Anthonis - zoon van Aken alias Hieronimus Bosch. Zijn leven en zijn werk. 's Hertogenbosch, 1947.

Panofsky, Erwin.
✓ *Early Netherlandish Painting: Its Origins and Character.* 2 vols. Cambridge, Mass., 1953. Reprint. 1958, 1964. Paperback ed., New York, 1971.

Passavant, Johann David.
Notizen über Hieronymus van Aeken, genannt Bosch, und Alart du Hameel, in Archiv für die zeichnenden Künste mit besonderer Beziehung auf Kupferstecher- und Holzschneidekunst und Ihre Geschichte, 7–8, 1862, pp. 88–92.

Pinchart, Alexandre.
Bosch (Jérôme, Joemen, Joen), in Archives des arts, sciences et lettres. Documents inédits publiés et annotés. Ghent, 1860.
Notes sur Jérôme van Aeken, dit Bosch, peintre et graveur, et sur Alard de Hameel, graveur et architecte, à Bois-le-Duc, in Bulletin de l'Académie royale des sciences, des lettres et des beaux-arts de Belgique. 2d ser., 4, 1858, pp. 497–505.

Poch-Kalous, Margarethe.
Hieronymus Bosch in der Gemäldegalerie der Akademie der bildenden Künste in Wien, in Bildhefte der Akademie der Bildenden Künste in Wien, No.1. Vienna, 1967.

Puyvelde, Leo Van.
De bedoelingen can Bosch. Amsterdam, 1956.

Schöne, Wolfgang.
Die grossen Meister der niederländischen Malerei des 15. Jahrhunderts: Hubert van Eyck bis Quentin Massys. Leipzig, 1939.

Sedlmayr, Hans.
Art du démoniaque et demonie de l'art. Archivio di filosofia 1, Filosofia dell'arte. 1953, pp. 99–114.

Sigüenza, Fray José de.
Historia de la Orden de San Jerónimo. 3 vols. Vol. 3, book 4, Madrid, 1605.

Strzygowski, Josef.
Südliche Macht- und nördliche Landschaftskunst, in Belvedere, 10, No. 2, 1931, pp. 107–9.

Suida, William.
Spigolature giorgionesche, in Arte veneta 8, 1954. pp. 156–60.

Swillens, P. T. A.
De Utrechtse beeldhouwer Adriaen van Wesel, ca. 1420–na 1489, in Oud Holland, 63, 1948, pp. 149–64. Concerns the altarpiece commissioned by the Brotherhood of Our Lady in 's Hertogenbosch in 1475–77.

Tolnay, Charles de.
Hieronymus Bosch, Basel, 1937.
Hieronymus Bosch. Revised and enlarged ed., 2 vols., Baden-Baden, 1966. Eng. ed., New York, 1966. Reprint London, 1975. French ed., Paris, 1967.

Unverfehrt, Gerd.
Hieronymus Bosch: Die Rezeption seiner Kunst im frühen 16. Jahrhundert. Berlin, 1980.

Vermeylen, August.
Hieronymus Bosch. Palet Serie. Amsterdam, 1938–39.

Vogelsang, Willem.
Hieronymus Bosch. Amsterdam, 1951.

Wurzbach, Alfred von.
Niederländisches Künstler-Lexikon. 3 vols. Vienna and Leipzig, 1906–11. Vol. 3 includes a list of additional paintings and information.

Index